PAGAN MEDITATIONS

The Worlds of Aphrodite, Artemis, and Hestia

GINETTE PARIS

Translated from the French
by Gwendolyn Moore

Spring Publications, Inc.
Woodstock, Connecticut

Seventh Printing 1995

Published by Spring Publications, Inc., 299 East Quassett Road,
Woodstock, CT 06281. Manufactured in the United States of America.
Text printed on acid free paper.

The cover photo, "Reticulum," is by Rosamond Wolff Purcell and has
appeared in her book *Half-Life* (Boston: David Godine, 1980).
It appears here courtesy of the artist.
Cover design and production by Maribeth Lipscomb and Patricia Mora,
with color assistance from Sven Doehner and Catherine Meehan.

Distributed in the United States by Continuum Publishing Group;
in Canada by McClelland & Stewart; in the United Kingdom, Eire,
and Europe by Airlift Book Co.; in Europe by Daimon Verlag; in Australia
by Astam Books Pty Ltd; in Japan by United Publishers Service; and in
Africa, Asia, and South America by Feffer and Simons.

Library of Congress Cataloging-in-Publication Data

Paris, Ginette, 1946-
 Pagan meditations.

 1. Aphrodite (Greek deity) 2. Artemis (Greek deity)
3. Hestia (Greek deity) I. Title.
BL820.V5P36 1986 292'.211 86-6675
ISBN 0-88214-330-1

CONTENTS

INTRODUCTION

When I had finished this book I asked myself, "Why have I written this?" What is this current that for a period of more than ten years has carried me far from my original field of social psychology and taken me to strange lands, to the Gods and Goddesses of ancient Greece?

Certainly, the influence of C. G. Jung and the vitality of those, like Marie-Louise von Franz, who are today developing the Jungian perspective attract an ever wider interest in the archetype, the symbol, and the myth; and I was among those to be so attracted. The work of James Hillman, in particular, enabled me to discover a new pertinence in archetypal psychology and the study of myth. He defends wonderfully well the necessity of a "psychological polytheism," and his ideas are both attractive and audacious.

I also recognize the influence of my students, who guided me towards the concepts of ecology. Together, we sought a way of applying the theories and laws elaborated in physical ecology to the fields of psychology and human relations. From physical ecology we retained the ideas of diversity, interdependence, ramification, and equilibrium. And it was when we asked ourselves what model of human organization would correspond to these ecological principles that the "system" (for it is a system) of relationships represented by the antique pantheon of Greece appeared as a fabulous example, one which proved more and more fascinating and capable of inspiring a reconstruction of our "human ecology." At the same time that Greek polytheism appeared to us as an interesting example of ecologism, Judeo-Christianism, as a religion which proclaims that "our kingdom is not of this world," revealed

itself as responsible for our most deep-rooted and anti-ecological attitudes.

Thus, I was carried by the current of ecology as much as by that of archetypal psychology and drifted far away to the land of the ancient Greeks.

But I should also recognize that the climate of ideological pluralism, with its far-flung explorations, and the rejection of the old dogmatisms which marked the finest period of the counter-culture left an indelible impression on me and aroused in my con-science an inalienable sympathy for polytheism. I am not thinking here only of the Dionysiac and orgiastic aspects of the counter-culture; nor do I have in mind some obscure and sectarian eso-tericism, which I avoided in those days, even as I do today; nor do I dwell upon any particular rituals that would correspond to the clichés of pagan ritual—none of that. For there was not, at least in the way that I lived during those years of the sixties and seventies, any determinate religion, no official guru, no dominant faith, ex-cept the faith that comes from the illusion of changing our world. I remember the diversity of people, the originality of solutions, and above all, the impossibility, which was constantly re-confirmed, of imposing any dogma whatsoever. The greatest multiplicity of viewpoints did not impede, through disorder, a certain harmony in human relations and daily life. Seen from afar, those years of living in an anarchistic group of the counterculture appear now as a "fol-ly of youth," but I cannot deny that they were the most intense years of my life.

I have put such effort into forgetting the years passed in this really too-extravagant group that I have had to write this second book on the Greek divinities to remind myself that it was then and there that the pagan archetypes of our unconscious really began to have a meaning for me. There I gained the conviction that the reversal of our Judeo-Christian monotheism may give us all a new vitality.

But it is well known that it is never by looking backwards and wishing to re-live the past (of either the ancient Greeks or the counterculture) that one truly renews oneself. The reactionary movement of a return to the past, which is always bound to fail, should not be confounded with the idea of a renaissance, even if that requires a movement backwards. The word "renaissance," popularized by the nineteenth-century French historian Michelet,

literally means "re-birth" and inevitably involves the imagery of birth. Since there is no birth without heredity, every renaissance implies a link with the past and with the ancestors of our lineage. In a renaissance, individual or collective, there is a turning within, a return to one's origins. Now, turning within, we must see that *we are Greeks* and that this fact has nothing to do with the geography of our birth, nor with the epoch in which we live, but with our Occidental origins, since it is from ancient Greece that our civilization was born. But, just as in therapy, the return into oneself does not reveal its meaning unless, after a period of regression, one again finds a taste for life, so the return to ancient polytheism has for its aim the renewal of the forces which are no longer adequately symbolized by current monotheism.

The re-connection with the past, then, should not be confused with a return to the past. After all, if after decades of neglect, I go for a very emotional re-connection with my father and mother, it does not mean I have to go back to live with them and behave like I did in the past. Again, the re-connection, revival, rebirth we are talking about is more like an actual re-interpretation and regaining of memory than a movement backwards. Mnemosyne is at work in this cultural movement.

The Greek polytheism was not, like Judeo-Christianism, a religion of salvation, nor a dogma, nor an absolute faith. The Greeks themselves were the first to give the word "myth" a double sense: it meant both an archetypal reality, symbolizing the situations of our actual life, and a made-up story to which one should not grant an unshakable faith. It was possible to modify, accommodate, and interpret the myths according to the movements of the collective unconscious. Would we even call it a religion? For there was no promise of future salvation nor anything very attractive after death. Hades, where fell the shades of the dead, had nothing of the prestige that was later attached to the paradise of the Christians and nothing of the terrible importance of Hell. Although the mysteries of Eleusis gave profound significance to the theme of death, the spirit of these mysteries was neither removed from nature nor from life and love in this world. Greek polytheism was not, as Judeo-Christianism is, a religion of after-death; it is not a 'religion' at all, but stands closer to an ecology of the living than to that totalitarianism that underlines the Western idea of religion. Its morality does not support itself on the idea of sin nor the threat of

Hell, nor the value of virtue and its anticipated reward, but on the consequences here and now of our behavior and attitudes. A myth is a support for meditation upon one's relationship with oneself, others, nature, and the sacred.

In contrast to a meditation which, like Buddhist meditation, seeks to find a void, a "pagan" meditation allows all images, all possibilities to arise, all the fabulous personages who inhabit us, until, little by little, we perceive the web of their relations. Then a myth becomes a coherent scenario, and the part we play in the collective drama becomes clearer. A myth or archetype absorbs us until its emotional content is spent or until a hero or a heroine (or our own grasp of heroic consciousness) imprints a new direction upon the action. There is then a progressive shift of consciousness towards another episode of the same myth or towards another myth.

The myth, according to the formula of Joseph Campbell, may be compared to a "collective dream," and, reciprocally, a dream may be the analogue of an "individual myth." A myth expresses the elements proper to a culture and an epoch in the same way that a dream comprises the elements relevant to a particular dreamer. But both dreams and myths express, above all, experiences which may be universal and may have many forms. It is not necessary to be a "pagan" to grasp, for example, the erotic world of Aphrodite or the humor of Hermes, as it is possible to communicate with the fears and wishes of other people without having the same dreams as they do. Just as there is more than one possible interpretation of a dream, so are there many equally valuable interpretations of the same myth. A good or useful interpretation generally produces a liberating and deepening effect, while a false one produces mostly confusion.

There are also some dreams, and some myths, whose function is to reveal to us the absence and the need of values personified by an archetype which has been neglected. The discovery of such a myth may reveal itself as extremely significant in aiding the recognition, for example, that "I am not the Aphrodite type" or "we are no longer familiar with Artemis's ecology." Here, it is not the simplistic typology, but the felt absence of a power that is significant.

Myths are complex. They do not lend themselves to dogmatic teachings. The adventures of mythic persons, Gods and God-

desses, are movements of consciousness; they illustrate our inter- and intra-personal conflicts, our interdependence, and our participation in the sacred. One must follow these movements in the same way one listens to music, or dances, or meditates. Harmony, and not doctrine, finally results, and this harmony resembles, I think, that which we seek under the topic of "human ecology."

From the moment an ancient myth is reborn and is charged with new significance, it begins to evolve again, for no dogma can fix the interpretation of Greek myths, no church or school of thought (not even the Jungians) can claim an exclusive interpretation of them, for these stories are the collective creation of the Occidental imagination, to which there is no copyright. We may now, for example, consider the cat to be an animal representative of Aphrodite, even if the ancient Greeks did not so recognize cats. This kind of addition to, or evolution of, a myth is not decided by an act of individual will, but arises spontaneously when, for example, it becomes evident that many of us project Aphrodisiacal traits upon these sensuous and capricious little beasts. Myths are open stories because, as so elegantly expressed by Claude Mettra: "Beyond memory, there are all the stories yet to come."[1]

Greek Culture: Patriarchal or Matriarchal?

Greek culture, of which our own is the offspring, was an admixture of the Orient and the Occident, of the North and the South, the kind of melting pot which makes any discussion of the origin of this culture very difficult.

One cannot say, either, at what precise moment it was formed, for it gathered together elements from all previous epochs. For example, when in the second century B.C. the Indo-European invaders, nomads and worshipers of a male sky-god, conquered Greece—at that time populated by a sedentary group of mother-goddess worshipers—they could not eliminate the cultural and religious influence of the people whom they had invaded. The feminine divinities took a lot of punishment but continued to manifest in all epochs of Greek history, in the religious and psycho-social underground. For three thousand years, throughout

the Mediterranean basin, the people and their religions not only confronted one another in time as well as in space, but also fertilized and influenced one another.

This constant confrontation between the religion of the Goddess and that of the God was a source of tension, but this tension contributed to the flowering of the most creative culture in Western history.

My purpose here is not to find the historical place or time of perfect equilibrium where masculine and feminine principles would have been in harmony to create a golden age, but to point out the multiple factors of interrelation that were responsible for so much creativity, and to seek them, not in history, but in mythology.

Because Greek mythology is a synthesis, one cannot classify it as strictly "patriarchal" or strictly "matriarchal"; it tells not only of the *conflict* between these opposing principles, but also of their reciprocal *seduction*. Contact with this mythology is not a feminist trip to Utopia—far from it. It is the exploration of an imaginal world which in many ways resembles our own.

Greek myths speak to our present conflicts, partly because the ancient dissension between a religion of Gods and one of Goddesses has again arisen. However, our movement of equilibration is going from the masculine to the feminine, while in the ancient Mediterranean culture the movement was reversed, as the Goddesses gave way to the young male Gods. In the stories of mythology, one can see that this growing patriarchal spirit did violence to the old beliefs of the Neolithic epoch associated with the Mother Goddess and her laws. But to explain this violence by the theory of the "patriarchal invaders" and male domination (described by Merlin Stone, among others) is not enough, since any brusque social change is violent, whatever its content. Moreover, these patriarchal divinities, thirty-five hundred years ago, presented the "new values" of the epoch, and one may guess that they were implanted, not only by force, but also because they offered an escape from the hegemony of the Mother Goddess, perceived by some of her own children as restrictive and retrogressive. The new legislative power, represented by Zeus, and the rational clarities, personified in the classical period by Apollo, were then attractive for all those who wanted to drop out of the family

organization and away from the superstitions then characteristic of the older cults of Goddesses.

When one wonders if the Greek pantheon is sexist or not, I believe it useful to consider, first, in what measure our historians, mythologists, and Hellenists have projected the bias of their own culture, which is more patriarchal (and monotheistic) than the one they were studying. How can we explain, for example, that there has been so much comment on the power of Zeus (the Father God) and so little spoken of the great primordial Goddesses (Gaia, Themis, Rhea, Nyx, Thetis) to whom the ancient myths, for their part, give extreme importance? Beside these great Goddesses, Zeus appears suddenly in the aspect of the son of a matriarch rather than as the all-powerful father, and this fact our modern Hellenists have had a tendency to ignore. The same prejudice may be found in their treatment of the heroines: the whole world has heard of the myth of Sisyphus, a favorite of the Hellenists, yet this myth has a feminine counterpart—the myth of Arachne, the heroine of Colophon, whom Athena transformed into a spider and condemned to begin anew, every day, the weaving of her web, because Arachne had dared to equal the Goddess in weaving a tapestry as beautiful as hers.

For a long time the Hellenists have tended to ignore the dynamic interplay of Gods and Goddesses except when it confirmed their certitude that power is masculine. One is astonished, for example, to find that, in most of their comments on the *Odyssey*, the *Iliad*, and the Trojan War, they have remained quite silent concerning the fact that a Goddess (Athena) rather than a God dominates the whole story of the adventures of Ulysses; or about the fact that, in the *Iliad*, it is finally the will of Hera (favorable to the Greeks) that carries the day against that of her sovereign spouse—Zeus—who is on the side of the vanquished Trojans.

One feels the Judaic reflex when, in giving the genealogy of mythic persons, the Hellenists spontaneously give primacy to the paternal ancestors. Certain genealogies, in which is given only the paternal lineage, even lose all their mythological meaning.

PART ONE

Aphrodite

CHAPTER ONE

The Birth and Rebirth of Aphrodite

> The Sun, hearth of tenderness and life,
> Pours burning love over the delighted earth,
> And, when one lies down in the valley, one smells
> How the earth is nubile and rich in blood;
> How its huge breast, raised by a soul,
> Is made of love, like God, and of flesh, like woman,
> And how it contains, big with sap and rays of light,
> The vast swarming of all embryos!
> And everything grows, and everything rises!
> —O Venus, O Goddess!
>
> Rimbaud, *Soleil et Chair*

The so-called sexual revolution of our day has endeavored to remove the stain of guilt and sin with which Christianity has traditionally associated sex. It has accomplished this by removing sexuality from the domain of religion. Sexuality, being thus secularized, permits contraception, erotic adventure, and pleasure for the sake of pleasure. So far, so good.

But at the same time, the sacred nature of sexuality has been expunged; and this laicized sex has become, in the minds of too many, the equivalent of a hygienic function or a social game. Is not one of the by-products of the sexual revolution the playboy —literally, a boy (rather than a man) who plays?

Sex games certainly have their place among interesting leisure-time activities. But what has happened to sexuality as an initiation into the realm of the sacred? Must we borrow from the Tantric

tradition of the Orient to learn of illumination by the sexual path? No, we have in our own cultural past an alternative to both the Judeo-Christian attitude of sexual repression and its corollary, contemporary sexual promiscuity and the insignificance which accompanies it.

It is this point of view that I propose to develop in the following chapters. But before imagining a rebirth of Aphrodite, let us take a look at the myths surrounding her birth.

The Marriage of Heaven and Earth

> The great and amorous sky curved over the earth,
> and lay upon her as a pure lover.
> The rain, the humid flux descending from heaven
> for both man and animal, for both thick and strong,
> germinated the wheat, swelled the furrows with fecund mud
> and brought forth the buds in the orchards.
> And it is I who empowered these moist espousals,
> I, the great Aphrodite. . . .
>
> Aeschylus, *The Danaïdes*

The numerous myths concerning the birth of Aphrodite vary according to epoch, ideology, and place of origin. Inasmuch as our task is neither that of a hellenist nor that of a historian, we may use and mix many variants of this myth, since each one reveals a different aspect of our consciousness.

The elements of the Aphrodite myth gathered by Charlene Spretnak and rendered in poetic form acquaint us with the Goddess in her most simple aspect, the one closest to the human and to nature:

Life was young and frail when Aphrodite arose with the breath of renewal. Borne by gentle winds on the eastern sea, she alighted on the island of Cyprus. So graceful and alluring was the Goddess that the Seasons rushed to meet her, imploring her always to stay. Aphrodite smiled. Her stay would be never-ending, her work never complete. She crossed the pebbled beach and wandered over the hills

and plains, seeking out all living creatures. Magically she touched them with desire, and sent them off in joyous pairs. She blessed the females' wombs, guarded them as they grew, and warded off love's pains at birth. Everywhere, Aphrodite drew forth the hidden promise of life. Every day she kissed the earth with morning dew. The wanderings of the Goddess carried her far, yet each spring she returned with her doves to Cyprus for her sacred bath at Paphos. There she was attended by her Graces: Flowering, Growth, Beauty, Joy, and Radiance. They crowned her with myrtle and laid a path of rose petals at her feet. Aphrodite walked into the sea, into the pulsing moon rhythms of the tide. When she emerged with her spirit renewed, spring blossomed fully and all beings felt her joy. Through seasons, years, eras, Aphrodite's mysteries remain inviolable, for she alone understands the love that begets life.[1]

Our most sexual Goddess, therefore, was born of the seafoam. If we believe or fancy that every human being has somewhere, buried within his cells, not only the memory of his own intrauterine life, but also the unconscious memory of the origin of all life in ocean's depths, we can see also how sexuality stimulates this fantasy. Do we not very often, and very simply, associate the movements of making love with the movement of the waves, the salty odors of the sea with certain good odors of sex? And do we not feel, on going to the sea, a sense of return to our origin, to the rhythm of the waves, and to the moist?

On the small beach of Paphos, where Aphrodite is reputed to have first sct foot, the manner in which the sea advances upon the round, pink pebbles of the long shoreline produces a peculiarly sensuous rhythm. The penetration of the sea is powerful, the retreat slow and foamy. The rustling water on the pebbles, so powerful that we cannot hear anything else; the penetrating water, the hypnotic cadence, the seductive foam, the enveloping ocean: Aphrodite comes to us.

If sex reminds us of odors, of wetness, and of the original rhythms of the ocean, if we have always known unconsciously that it is in the ocean that life began, then we now know it consciously. Science now tells a story that sounds like the old myths. "When life was young and fragile," says the myth, creatures emerged from the sea, as Aphrodite "set foot" upon the shore. The seasons have been favorable, and our race has ventured to the hills and plains. Life

has multiplied, always bringing desire between male and female. Like the Goddess, we have gone far from the original ocean; and, like her, we must renew our spirit in the sacred bath, by fusion with sexual wetness.

The principle of cellular reproduction is not that of dual sexuality, and life existed before there was sexual reproduction. Of Aphrodite herself, who "in joyous pairs" sends us to couple, I would like to ask: "Why do we reproduce by pairs?" Why should we be two to create new life? One could imagine that it would take three, four, or a hundred. Aphrodite represents this preference for the pair and for all the dualisms related to reproduction: the female who attracts the male, the woman from the water who sets fire to the passions. She revitalizes the tension between opposites and yet permits union between them: nature and culture, body and spirit, sky and ocean, woman and man. It is no surprise that sunrise and sunset are the preferred hours of the Goddess: these moments of day-joining-night mark the meeting of the opposite poles.

In a later version of the birth of Aphrodite, the polarity between sea and sky appears even more strikingly. When the patriarchal spirit gathered strength against the previous matriarchal system, the male semen inscribed itself upon the myth. Aphrodite is still "of the sea-foam," but this foam is enseminated by the Sky (Ouranos). The myth tells how Ouranos oppressed Gaia, who encouraged Cronos, her son, to rebel against his monstrous father. Cronos castrated Ouranos and scattered his father's seed upon the ocean. The sperm, floating on the waves, became the sea-foam. And from this white foam was born the beautiful Aphrodite.

> Great Heaven came, and with him brought the night. Longing for love, he lay around the Earth, spreading out fully. But the hidden boy stretched forth his left hand; in his right he took the great long jagged sickle; eagerly he harvested this father's genitals and threw them off behind. . . . The genitals, cut off with adamant and thrown from the land into the stormy sea, were carried for a long time on the waves, and in it grew a girl. At first it touched on holy Cythera, from there it came to Cyprus, circled by the waves. And there the goddess came forth, lovely, much revered, and grass grew up beneath her delicate feet.[2]

It is appropriate to their functions that the strong and intellectual Athena is born from the head of Zeus, whereas the sexy Aphrodite is born from her father's *genitals*. As soon as Aphrodite appears, her work is to transform the obsessive and brutal genitality of Ouranos, who had a constant and obsessive desire to cover Gaia entirely, into a more subtle and magical art, in which the right mixture of distance and proximity is crucial.

The two poles of Aphrodite's myth are thus symbolized: being "oceanic," she brings back the archaic consciousness of the body, the flood of corporeal energy; being celestial, she opens for us the portals of the heavens. Though she is a daughter of the sky, Aphrodite is no less born of the sea, and the marine creatures often associated with her all refer to an aspect of our sexual life—as, for example, the dolphin, an extremely playful and seductive animal, or the scallop, pink-colored and tender, lodged in a shell, and which, like the genitalia of women, opens up in security and closes at the least alarm.

When Aphrodite leaves the water and sets foot upon the earth, it is the oozing shore that interests her. Goddess of the dew, of earth's moisture, she remains the same when she leads woman to become moist, to produce from her interior the dew which permits the fertilizing unions.

There is indeed an element of fire in all passionate loves, but we shall leave until later the interplay between fire and water, between Ares and Aphrodite. Let us point out, for now, how sexuality has an aquatic aspect and, inversely, how water pertains to sensuality. In this matter, both poets and psychologists agree in describing the experience of desire and sexual pleasure as a flood. This flowing of energy is a prerequisite to all erotic experience and is also an essential element of many a mystic experience. Athena, Zeus or Apollo may teach us how to concentrate energy for combat, competition, or specialization. But Aphrodite will teach the flowing of energy. As the current of emotions begins to circulate in and between us, the tensions and defenses of the personality are dissolved; eyes, gestures, words, and breath soften and deepen, while the pelvis recalls the rhythm of the waves. The sweating and oozing, the lapping and flowing streams of energy increase, until the liquefaction of orgasm and the spurting out of the white foam.

CHAPTER TWO

Civilization and the Beauty of Aphrodite

Having reflected somewhat upon the subject, I
have concluded that you were lucky to live in a
period in which the idea of pleasure remained a
civilized one. In our day, this is no longer so.

Marguerite Yourcenar

As does the beauty of all women, the splendor of the most
beautiful of Goddesses finds an echo in all forms of beauty. Let us
now examine the link between the collective desire for beauty and
the level of civilization of a culture, in order to assess in what way
one may see Aphrodite as a civilizing influence.

It is difficult for the Christian mentality to understand how the
Goddess of beauty and sexual love represents a civilizing power,
since the religions originating in Judaism (Christianity and Islam)
imposed the idea that sexual pleasure is a concession to the animal
instinct and is therefore less than human. God, soul, and mind are
thought to be absent during sexual intimacy, sex being referred to
as a "primitive need." So deeply entrenched is this attitude that,
when we undertake the rehabilitation of sex, it seems natural to
begin by praising nature and bodily love, rather than by proclaim-
ing sexuality as an expression of spirituality and civilization.

Aphrodite's gift of beauty surpasses that which simply pleases
the eye; it is more than formal perfection of the partner. It is rather
the beauty which springs from the deep sexual encounter and
which has the power of transmuting the physical experience into

ecstasy. From sexual love to beauty, from beauty to ecstasy—such is the Aphrodisiacal sequence. Pleasure is of great importance because it is the key, but pleasure can be considered as a means rather than an end, as a path leading to the spirituality of Aphrodite.

When the partner assumes an incandescent beauty, this moment has a peaceful perfection, for one has been granted a vision of eternity by Golden Aphrodite. Despite Judeo-Christianism, this experience is above the human; it is a religious experience. The Belgian poetess Claire Lejeune seems to have seized the nature of this beauty, which is at once both terrible and spiritual:

> This Beauty is sovereign, because it is unforeseeable and inescapable. Against its possible victory, our defeat, we arm ourselves; we turn from terror to terrorism. The ultimate object of human fear is Beauty; nothing is more disarming, more ravishing, than its eruption in our lives. Beauty alone brings us to our knees without abasement, washes away all humiliation, heals us of all rancor, and reconciles us with the universe.[1]

Beauty, as an expression of civilization, is not purely spontaneous. Just as one cultivates a garden by observing a subtle equilibrium between the natural beauty of flowers and the artful discipline of the gardener, one must discover the Aphrodisiacal equilibrium between natural easiness and cultural training.

Aphrodite, who is otherwise so distinct from Apollo, nevertheless shares with him a propensity for civilization. However, the monotheistic and sexist prejudices of our culture have encouraged us to recognize the civilizing values personified by Apollo while distrusting those of Aphrodite. Each of them is nevertheless essential to civilization, and a polytheistic mentality should help us to recognize both, without seeking to pit one against the other. We certainly need the rationality and formal rigor of Apollo, but in actuality, the cult of scientific rationality lacks neither high priests nor faithful followers, nor subsidies. Of what use is Apollo's brightness if we lose everything that makes a culture alive and happy?

Whereas the civilizing spirit of an Apollonian nature is inscribed in durable materials, such as marble architecture or urban planning, or in poetry, in rules and forms which are immutable,

Aphrodite cultivates the ephemeral beauties. Lovely clothing is made to be worn and therefore to be worn out; flowers and desire must be culled at the moment when they are in bloom, for this beauty, although it may be renewed through care, cannot be preserved as are Apollonian works.

The statement that civilization is a male undertaking reveals our ignorance of the work of Aphrodite. Certainly, if one considers a monument, a marble frieze, or an architectural masterpiece as a work of art, but looks upon embroidery, clothing, gardening, and the art of love as unimportant to civilization, one excludes woman from that civilization and classifies her works as "handicrafts," or "decorative art," reserving the broader word "art" for Apollonian productions. There is little difference, really, in embroidering with a chisel on a stone wall and embroidering with a silk thread on a piece of cloth, if not that the one is intended for duration and for history, whereas the other is intended to be enjoyed here and now, to reflect the Divine in its daily aspect. The real difference, then, is in the attitude of each towards time. Aphrodisiacal art is a matter of making everyday life more beautiful and more "civilized." Certainly, this latter beauty is ephemeral rather than lasting; it fades quickly, and in this there is a certain sadness. But the myth of Aphrodite and Adonis teaches us to accept and to give way to this sadness, because from it will be born the impulse of renewal.

Primitive or Civilized Sexuality

Extolling the civilizing influence of Aphrodite or of Apollo gives rise to thoughts of their opposites, of the savage and the primitive, that is, of Artemis and Dionysus. Inspired by the structuralism of Paul Friedrich, who interrelates the pairs of Apollo–Artemis and Aphrodite–Dionysus on the civilized/savage continuum, a diagram can help to understand the interplay among the four archetypes.[2]

	Civilized	*Savage*
Sexual Separation	Apollo	Artemis
Sexual Union	Aphrodite	Dionysus

We have just seen how Aphrodite and Apollo personify complementary aspects of civilization: on the one hand, Aphrodite's beauty, multiple and alive, but ephemeral and personal; and on the other, Apollo and a beauty that is imperishable and universal, but fixed in an impersonal form.

If we now consider the pair Aphrodite–Dionysus, we can see that both agree in according a central position to the spontaneity of the body and to sexuality. Nevertheless, although the knowledge of both Aphrodite and Dionysus requires corporeal abandon and sexual union, they must be approached by different paths. Dionysus's sexual urge appears in a rough and impetuous way, akin to the brutality of the satyr who hustles the nymph or to the wild-haired woman of the Bacchanals who throws herself upon the prey. Far from this tumult, Aphrodite, who dislikes haste, teaches lovers the refinements of voluptuous delays and artistic subtleties unknown to the Dionysian approach.

It is with the fierce Artemis that Dionysus shares his affinity with the natural (as opposed to the cultural) and with the non-civilized. Contrary to Aphrodite, who likes well-tended gardens of flowers, Artemis inhabits the dense and primeval forest, as untouched as herself by man's will, and disdains the luxuries and refinements of civilization which so much please Aphrodite.

As for Apollo–Artemis, who are brother and sister, he the solar God and she the undomesticated lunar Goddess, neither accords great importance to sexuality, insisting rather on autonomy, detachment, and independence as regards the other sex—she by becoming Amazon-like, free, and regarding men *from afar;* he by championing logic and regarding women *from above.*

Aphrodite and Flowers

Among the Graces, Thalia the Flowering crowns the Goddess with flowers and casts rose petals beneath her feet. I have always been fascinated by the symbolism hidden within the web of myths. That Aphrodite, the Goddess of sexual love and beauty, is also the Goddess of flowers appears to me to be the kind of evidence one receives when mythical thought penetrates the mind. Are not

flowers the most beautiful sexual organs of the universe? Many are
the images and expressions which associate the feminine sex with
flowers and, above all, with the pink rose, rich in color and per-
fume, with outspread petals resembling the tenderness of flesh. To
complete its participation in the myth of Aphrodite, the rose comes
with painful thorns, which emphasize the risk of picking it, the
suffering that comes with all sexual passions.

To be preoccupied with flowers or to create a pleasant garden,
as to make love or to "dress up"—these are all ways of honoring
Aphrodite. Gardens express the sensuality of a culture, a type of
sensuality that, for those whose educational background or age
has caused them to ignore sexual vitality, offers the advantage of
being without anxiety. In England, for example, gardening seems
to be one of the most domesticated of passions. The English
devote themselves to it as one devotes oneself to love: passionately
and forever. Gardening is one of the major expressions by which
the British call upon Aphrodite without fear or second thought. In
England, both men and women are moved by the grace of gardens
and of landscapes; but although the roses are allowed to climb
upon the walls of houses, I have rarely seen an Englishwoman dare
to put a rose in her hair. To her, this would seem inappropriately
seductive. Aphrodite must stay in the garden, but there she is
honored without anxiety, without limits.

One finds in the English garden an extreme and admirable care
in dissimulating all trace of artifice, as if the impeccable
maintenance of a flower garden and the long and knowing work of
the gardener ought to be invisible, the intention being to allow
natural beauty to express itself, as if all these flowers and all these
shrubs had grown there spontaneously. The marks of the disci-
pline imposed on nature by the hand of the gardener have dis-
appeared. This equilibrium between nature and art is exactly what
pleases Aphrodite. "The beautiful and venerable Goddess who, all
around Her, and beneath her light feet, causes the grass to grow "[3]
grants her grace to the English for their lawns and gardens,
because they instinctively understand the right mediation between
nature and culture, gardening being an exemplary kind of media-
tion.

The art of perfumes is another example of this mediatory work.
One may enjoy the perfume of a flower in its natural state, just as

the lover enjoys the natural perfume of the person he or she loves. But one can also appreciate the subtlety of perfumes and of the refinements resulting from distillation. The art of perfumery, in capturing the natural perfume of flowers, associates women and flowers once again. For the Greeks of antiquity, the sense of smell was a means of communication with the divine. Their conception of sacrifice included the idea that the odor of the offerings and the aromatic herbs seasoning the meat were pleasing to the Gods. They placed an equally high value on flower perfumes, which they associated with peace, joy, and sensuality; and it was Aphrodite who was thought responsible for the bodily smell of women, as well as that of flowers. Certain very highly scented plants, such as mint and myrrh, were also associated with her or with her lover, Adonis. One of the most famous punishments inflicted by Aphrodite consisted in causing the women of Lemnos, who had offended her, to become malodorous. In one version, it was a case of their sexual odor which, rather than being attractive, became disgusting, while in another version, it was a question of their breath, and in still another version, of their armpits. Husbands and lovers, repulsed by this scourge sent by the Goddess, abandoned the island, never to return.

The Gold of Your Sex

The association of Aphrodite with gold has both a spiritual and a trivial significance. On the one hand, it signifies the mystic gold, symbol of warmth, perfection, and radiance; on the other, there is gold jewelry, which may be Aphrodisiacal in the same way as perfumes, flowers, and beautiful clothing. Jewels are both instruments of seductions and symbols of the Aphrodisiacal powers of women.

Let us begin by scrutinizing more closely the Aphrodisiacal function of gold jewels. Hephaestos, the husband who was belatedly given to Aphrodite, was infirm, but this cripple made the most beautiful golden jewelry on all Olympus. It seems that this is an association that has always been seen: the seductive woman accompanied by a man who is unattractive (or old, boring, or sick)

but who pleases his wife or mistress with jewels and gifts, thus purchasing the right to enjoy her beauty.

The ungraceful but rich men of all times find their patron saint in Hephaestos. This crippled God, sweating, dragging his leg, and slaving in his infernal forge, exercises his expertise and produces golden jewels which will please even the most capricious of Goddesses. He himself is ugly, but his jewels are not. In the myth of Hephaestos and Aphrodite, the issue of money is an important one. When the cripple surprises Aphrodite in her infidelity with Ares, he demands the return of all the wedding gifts he had offered to obtain her, expressing all the while his resentment, his jealousy and his sense of injustice and breach of contract.

> Because I am lame, she never ceases to do me outrage and give her love to destructive Ares, since he is handsome and sound-footed and I am a cripple from my birth. But my cunning chains shall hold them both fast till her father Zeus has given me back all the betrothal gifts I bestowed on him for his wanton daughter; beauty she has, but no sense of shame.[4]

We may find it shocking, but there is a very frequent relationship between material wealth and feminine beauty. The very beautiful woman frequently rises in social status. A girl who is beautiful has a gift from Aphrodite, which can attract money in multiple ways. Certain careers, and many of the great marriages, demand as a prerequisite that the woman be beautiful, that is, that she correspond to the prevailing concept of eternal Aphrodite. This gift is no different from most natural gifts, which translate into influence, power, or profit. Exceptional beauty is one of the gifts that we may have from birth, a "fairy" gift, or more precisely, a gift from the "fairy" Aphrodite in the same manner as fortune or destiny may grant riches or nobility to an inheritor.

The gifts of fairies are always difficult to bear, in spite of the apparent ease with which one can be beautiful, rich, noble, or talented. The person who cannot succeed in integrating and honoring the gift or who uses it in a destructive fashion will be in a much worse position than those who have been less gifted by fairies, Goddesses, and Gods. I have often noted, from personal as well as professional experience, that the psychology of a very rich

man strangely resembles that of a beautiful woman; both are haunted by the same terrible and unanswerable doubt: "Am I loved for myself, or only for my beauty, or my money, or my family, or my celebrity?" The union of Hephaestos and Aphrodite expresses this archetypal situation in one of its manifestations. Aphrodite is beautiful and demanding; Hephaestos is ugly but generous; they make a deal: one has money, the other has beauty and charm.

Hephaestos is also the unloved one, personifying the drive for riches and power that avenges the lack of love. Rejected by his mother Hera (or in another version, by his father Zeus), because he is deformed and less handsome than the others, he labors without respite, and it is he who finally wins the most beautiful wife. But Hephaestos is a God, and as such his striving and struggling for love can be seen as a process of individuation. He achieves perfection in his art.

Let us return to jewelry and gold. The emanations of this perfect metal are indeed magical; that is, they exercise a beneficial power of attraction at a distance. Whether or not this is physically true, this definition describes precisely the effect produced by a lovely jewel as well as by beautiful women—to attract at a distance. In order to be Aphrodisiacal, gold must be visible and worn proudly for the pleasure of all. When gold is controlled and hoarded, when it serves as the basis for a "rational" monetary system, it is no longer in the domain of Aphrodite, but in that of Apollo or Zeus.

If I were to say "All women should wear gold jewelry," it would be alleged that gold is not within everyone's means. But I believe that the loss of creative audacity in the use of jewelry is not, in general, the result of either social difference or economic poverty. Remember that in our time almost the planet's entire store of gold is hoarded in subterranean vaults guarded by armed soldiers. This behavior, in regard to the precious metal, stems from the whole of our ideological and unconscious religious attitudes. It gives precedence to the masculine or Apollonian mode of thought, as opposed to the feminine modalities of Aphrodite, who would scarcely understand why, after extracting the gold from the earth with great difficulty, we should proceed to bury it again, in the name of economic rationality.

This Apollonian principle is so unquestioned and so charged

with multiple significance that it has become the psycho-
sociological equivalent of the cult of a jealous God who would like
to keep all the gold for himself. His cult requires that we sacrifice
our gold in molding it in the form of ingots, which the armed guar-
dians bear to the subterranean temple. This God is so demanding
that he consumes almost our entire production of gold, resulting in
its extreme rarity. It is very difficult, under these conditions, to
render unto Aphrodite what belongs to her. Every sudden increase
in the price of gold provokes the melting of gold jewelry into in-
gots, the metal's power thereby passing from the realm of
Aphrodite to that of Apollo. Even when they are not actually
melted down into ingots, jewels which stagnate in safe deposit
boxes belong to the economic power, and their Aphrodisiacal ra-
diance cannot exercise its influence. If gold were suddenly to lose
its function in our Apollonian economy, perhaps we would realize,
after the fact, that this hoarding was a pathology. That we pro-
duce it and then consign it to the military might appear to us as a
depressing perversion, symptomatic of spiritual degeneration.

Moreover, as if by a quasi-cynical effect of religious history,
those who still adorn themselves with clothing embroidered in
gold, with tiaras and precious stones are men, Catholic priests of
the Vatican. Although there was an epoch in which kissing the
hand of a woman was common, today only the hand and the ring
of the Bishop are kissed while one bows. Once women em-
broidered their own clothing and that of their families with gold
and purple or met together to fashion splendid garments for their
Goddesses. But male priests have made "servants of the Lord" of
all women. Whatever our efforts to embroider their chasubles,
stoles and altar cloths, to make lace for their surplices, to decorate
their churches with flowers and to contribute our gold pieces to
cover them with glory, the glory remains exclusively for the males.
Their demonstration of luxury and ostentation, which would ap-
pear to them so indecent, sinful, and terribly Aphrodisiacal in a
woman, does not seem to them at all inappropriate when the gold
is shining on their own persons. It is evident for them that the cult
of the Lord requires all this gold.

To liberate gold, to wear it, to render it visible, to allow the im-
agination of women to be re-invested with its Aphrodisiacal power
—when we let our imagination elaborate on this theme, we often
find ourselves borrowing from Oriental culture which, through its

fairy tales (and above all, the Persian fairy tales) has given us images of scintillating luxury and of princesses covered with gold and precious stones. But there is a way of remaining within the context of our culture and of our history, rather than borrowing from the Orient. I should like to quote an episode related by Titus Livius which well illustrates the question of apportioning gold according to its masculine and feminine uses. The pole of masculine or anti-Aphrodisiacal ideology is here represented by Cato, who in the Hellenistic period was the ablest orator representing the reactionary thought of Rome. This political faction, supporting a return to the traditional austerity of the Roman patriarchy, favored the Oppian law, one adopted twenty years earlier in the context of war efforts and restrictions. The law stipulated that: 1) it was forbidden for women to possess more than half an ounce of gold; 2) feminine attire should remain sober and avoid the use of multiple and exciting colors; 3) women, except when attending religious and public ceremonies, should not circulate freely in the city. To this end the use of a horse-drawn carriage was forbidden to them, as was the right to travel more than a mile. The arguments of Cato sound like a familiar refrain:

> Give a free rein to these undisciplined, untamed animals [i.e., women], and then expect them to set a limit to their own license! . . . What they are longing for is complete liberty, or rather, if we want to speak the truth, complete license. . . . "We want to gleam with purple and gold," says one of them, "and to drive our carriages on ordinary days as well as on festive days." . . . Indeed, if they carry this point, what will they not attempt? They will over-run all the laws relating to women whereby your ancestors curbed their license and brought them into subjection to their husbands. Even with all these bonds, you can scarcely restrain them. . . . The very moment they begin to be your equals, they will be your superiors.[5]

The Roman matrons, united as with a single voice and in a single body, opposed the continuation of this law, passed in wartime and now imposed in times of peace. They were supported by the more Hellenized of the magistrates (some being their fathers, husbands, sons, or brothers), who had the right to vote and who demanded the abrogation of Oppian law. These liberal men, rather than being scandalized by the liberty and audacity acquired

by the Roman women under the influence of Greece, were attracted by the sensuality and freedom to which the Greek Aphrodite and the Greek Dionysus had initiated them. The cultural influence of Greece and Asia ("regions full of all kinks of sexual allurements") which so disquieted Cato—"I am the most alarmed lest these things capture us, instead of our capturing them"—was just what attracted the others. These more liberal magistrates, who themselves enjoyed the luxuries resulting from the conquests, were rather embarrassed that their horses and chariots should be richly caparisoned but the attire of their wives should remain insipid: "And when you, as a man, are allowed to wear purple on your outer garments, are you going to refuse your wife a purple cloak, and are the trappings of your horses to be more splendid than the clothing of your wife?"[6]

To repress the feminine use of jewels and shimmering clothing, to seclude the gold and reserve it for military use, and to wish to contain, at any price, the dangerous sexuality of women—these are behaviors and attitudes that seem related through some unconscious association. Must we underline their common factor, that they are all designed to ignore or undermine the power of Aphrodite? And finally, would there be a link between our collective attitude towards gold and our attitude towards sexuality; that is to say, have we demythologized the use of gold by considering it to be a question of international economics, in the same way that we have reduced sex to a hygienic function? By this process, both one and the other lose their symbolic quality and their Aphrodisiacal power. It may seem far-fetched, but the myth of Golden Aphrodite clearly suggests such a link, and there are many other myths associating gold with sexuality. Paul Friedrich has remarked that in the Indo-European languages there is an extraordinarily old and persistent association among gold, sexual fluids, honey, and the spoken word.[7] This is why we find in many languages such expressions as "the gold of your sex," "the golden words," "the honey of your sex," and so on, all combinations of these four terms being meaningful.

Aphrodite alone does not exhaust all the mystic meanings of this perfect metal which, in all cultures and in all epochs, has been the bearer of multiple significance. The bow of Apollo, the helmet and shield of Athena, the caduceus of Hermes, the throne of Hera, the sceptre of Zeus. Everywhere gold reflects a quality which has at-

tained perfection. In a polytheistic religion, each archetype is one of the possible paths towards spirituality, and each has its own perfection. Thus, there are many ways to be initiated into the perfection of gold, and of these Aphrodite is but one. If, after a rupture, one tries to deny the lost happiness and to hide it away in the unconscious, these moments of perfection still remain as indestructible as gold: consciously or not, we seek to recover these moments of eternity, which gold symbolizes so well.

Those fortunate enough to have been initiated into love's ecstasy know how the beloved and oneself, the objects surrounding us, and all our inner thoughts seem to be bathed in a golden radiance; sometimes the particles of light appear visible, like a rain of small, golden flashes. These know who Golden Aphrodite is and know that she cannot be tarnished, in spite of the Christian scorn.

In insisting, as I have just done, on the spiritual significance of gold and of sexuality, it is important to bear in mind the warning that gold has many forms and that gold coins and money are, moreover, realities subject to the worst perversions of the instincts of power and domination. Both gold and Aphrodisiacal qualities are difficult to obtain, and when one possesses them they are just as difficult to use in a way that preserves their splendor. Aphrodite, who symbolizes both planes of sexuality—the pleasure of the senses and prostitution, as well as the innocence of sexual ecstasy—is situated similarly with respect to gold. The worst and the best are here commingled, and each person must discover for him or herself those flowers from which a sweet and golden honey may be made, and those from which only bitterness or poison are produced.

Gold is a pure, luminous, and incorruptible substance, and a false relation with this metal is perhaps the sign of a wrong connection with that which, within us, could be pure, luminous, and incorruptible. Our sexuality should be able to be symbolized once again by gold, and golden Aphrodite.

What has been said so far about beauty and its civilizing influence suggests, moreover, that beauty is essential to Aphrodisiacal ecstasy. But although it is true that the splendor of Aphrodite is not given to many women, it would be false to conclude that Aphrodite gives her blessings only to beautiful persons. There is certainly an esoteric side to the teachings of Aphrodite, and all men and women are not equally gifted in discerning the

Aphrodisiacal mysteries, but formal beauty is not the most important element! On the contrary, it seems that the fear of not being beautiful, which is today widespread and exaggerated among women, is painful evidence of the fact that we have lost our beautiful Goddess. The cult of Aphrodite has little to do with standards of beauty conceived in our image-conscious and consumer-oriented culture. Nor should the link between sexual desire and beauty be understood according to our habitual and rigid schemes of feminine beauty. The beauty which brings desire is closer to a "state of grace" and is composed more of audacity and charm than by conformity with an external norm.

The Aphrodisiacal sexuality cannot be revealed without beauty, that is, when there is disgust for oneself or for the partner. Seductive and amorous gestures only produce shame when there is no confidence in being desirable and beautiful. In such a psychological mood, sexuality sometimes takes on a diabolic quality and may correspond to a wish to give way to the "lower instincts" and to wallow in them. This attitude is the opposite of the Aphrodisiacal meditation.

The expressions "black magic" (that is, the use of magic for personal or perverse motives) and "white magic" (the use of magic through compassion or love) lead us to speak, by analogy, of black sex (sexual love experienced as a concession to the lower instincts and to ugliness) and of "pink" or "golden" sex, these being the colors of the Goddess and of a sexuality associated with beauty rather than abasement. As for the comparison between the terms "magic" and "sexuality," sexuality has always been related to religion, which itself, in a broader sense, also includes magic. One cannot avoid the religious aspect of the sexual function, but the cult of Aphrodite calls sexual attraction a state of grace, whereas Judaism and Christianism have made of it, in almost all of its non-procreative functions, a state of sin. But both grace and sin are religious notions.

All religions which exclude the feminine principle tend to associate sexuality with evil and "lower" functions. As Jung has often stated, a vital force which is not recognized and valued becomes negative. In this sense, one might say that the prelates of the Church—and very obviously the Inquisitors (in distrust of Christ's message of love)—were, by virtue of their ferocious antagonism to Aphrodite, the most diabolic, the most obsessive of sexual perverts

imaginable. The quantity of filth, misery, and sexual humiliation which they have engendered is immeasurable. This impressive deployment of negative forces has not, however, succeeded in vanquishing Golden Aphrodite, for her power, though weakened, can never be destroyed.

> This may seem irreverent, or just claiming too much, to those who are unwilling to feel it completely, refusing to see anything mystical or divine in the moment of life's origin. Yet it is just in treating this moment as a bestial convulsion that we reveal our vast separation from life. It is just at this extreme point that we must find the physical and the spiritual to be one, for otherwise our mysticism is sentimental or sterile-pure and our sexuality just vulgar. Without, in its true sense, the lustiness of sex, religion is joyless and abstract; without the self-abandonment of religion, sex is a mechanical masturbation.[8]

The association of the sexual function with "evil" also brings about relationships in which the pleasure of transgression becomes more important than the intimacy of the encounter between two human beings. We find this pathology even in the atheist or "liberal" mentality, wherein those who felt the need for the stimulation given by the sense of transgression (that is, "doing bad things") had to create bizarre situations and complicated fantasies to recover a similar excitement. The stories told about de Sade, Gilles de Rais, or Don Juan are examples of such a reversal of values. The violent and sadistic pornography of today presents the same cruelty, the same desire for transgression which alone succeeds in exciting perverse mentalities. For such mentalities, the last taboo to be broken is that of aggression against women. Gilles de Rais and the sadistic marquis have been replaced by expensive and closed circles of pornography where the spectator, from his chair, can observe—sometimes live, sometimes videotaped—scenes of mutilation and sexual humiliation which may go as far as the torture and murder of women who are non-consenting victims. What gives these videos their high price is that the suffering of the victim was not fictitious: the fun of transgression and of perverse excitement is therefore enhanced. These porno clubs are reserved for an international, rich, male, and decadent elite. These somber heroes whom transgression excites are still caught in a reaction against the

dominant religion, and their perversions are a consequence of the religious attitude which identifies sexual pleasure with evil. To the extent that the Judeo-Christian devaluation of sexuality still unconsciously persists, some people will find their fun in the degradation of the sexual function.

The widespread feeling today of a religious void implies that neither the moral obligation not to inflict suffering upon others nor the sacredness of sex are taken seriously. For those interested in neither perverse transgression nor obedience to all of the Judeo-Christian doctrine, the dominant color of sexuality is neither black nor pink, but rather the grey of sexual platitude, neither sin nor sacrament. Sexuality then loses all of its magic.

Perhaps one must see this religious void as a temporary necessity, as if, personally and collectively, we had to go through a period of laicization of sexuality in order to separate it from sin. Perhaps we must accept with patience a state of neutralized sex, wherein one sees no evil but wants the sacrament. It is possible that Aphrodite's path cannot be taken before we reach this neutral point in the process of identification and dis-identification with Judeo-Christianism. Perhaps this stage is necessary before we take the next step.

For sexuality to recover its color and its magic, it must regain its sacred character. This time it must be associated, not with sin and darkness, but with pink and golden beauty, and with Aphrodite's civilizing power.

A world from which Venus had withdrawn has been depicted by Apuleius. Eros, prostrate and suffering from a wound inflicted by Psyche, caused such concern to his mother Venus that a white seagull came to warn her that:

> "The result is," screamed the gull, "that Pleasure, Grace, and Wit have disappeared from the earth and everything has become ugly, dull and slovenly. Nobody bothers any longer about his wife, his friends or his children, and the whole system of human love is in such complete disorder that it is now considered disgusting for anyone to show even natural affection."[9]

Ugliness and Depression

We have seen how the feeling of ugliness—if not transformed into a motivation to excel, as in the case of Hephaestos—casts a shadow over the sexual experience. But what is the effect of the absence of beauty, and the ignorance of Aphrodite, in domains other than the sexual? For those who see a link between pleasure, beauty and spirituality, I believe it is also easy to see the sequence which leads from ugliness to depression. To my knowledge, modern psychology does not seem to have given much recognition to the pathogenic character of an "ugly" environment, that is, of an environment in which Aphrodite is not honored in any form. As a psychologist, I have often seen how certain depressive states could be interpreted as the trauma of a sudden "loss of beauty." When depression follows the loss of places, objects or persons who have been loved for their beauty, one may see the return of vital energy when the afflicted person is encouraged to reconstruct the harmony and charm of his or her environment. Obviously, the degree of this sensitivity is not the same for everyone: not everyone reacts to an environment perceived as ugly, and even the perception of someone or something as "ugly" comprises an interplay of subjectivities.

My intent is, not to study individual differences (or the differences between men and women) in the perception of beauty and ugliness, but to emphasize the depressing effect that ignorance of Aphrodite, in her non-sexual aspect, may have on certain persons. For example, to explain the difficulty with which country people adapt to the city, one can invoke a thousand reasons, all of them valid: stress, social isolation, insecurity of employment, the anguish of a new mode of life, and so on. But must we not add to this list the fact that the city is only beautiful for those who have the means of replacing the harmony of nature, which is lost in most cities, by a certain luxury of space and comfort, which money can buy? Poverty only becomes sordid when accompanied by ugliness. Although it is true that in the country the sun shines for everyone equally, it is not so in the city, where in crowded districts and in some ill-conceived buildings, sun, light, and beauty seem inaccessible.

For those who love beautiful landscapes and flowers, it is traumatic to lose the sight of the mountain, or the sea, or the clematis climbing on the wall of the house, or the pleasures of a small patch of flowers. I know a very introverted man for whom the contemplation of the sunset represented a veritable cult, albeit unconscious. No longer to watch the setting sun, no longer to meditate in front of the "rosy-fingered Dawn" as Homer calls her, was for him the loss of his pathway to Aphrodite. And even though he does not express it in these terms, he is very conscious of missing terribly these moments of peaceful contemplation. He relates his depression to his feeling of seeing everything as "grey" and "tasteless" since he went into town. The rosy and golden splendor of Aphrodite, here in the form of dawn, has been taken from him.

When depression takes root, only those gestures indispensable to survival persist. The depressed person no longer devotes any of his or her energy to Aphrodite. The attractiveness of the home and of the personal appearance deteriorate, the baby is no longer dressed up, the table is not elaborately set, and no effort is made to be charming to others. Activities become strictly functional, and the person is no longer interested in the ephemeral beauties which require constant renewal through care and desire for them. I have often had the impression, when visiting deteriorated human settings, that real cultural poverty is expressed by the total absence of Aphrodite. In such environments, one cannot find a single splendid object, and everything that is nice, gracious, or fragile is sooner or later broken, tarnished, or ridiculed.

There is a certain threshold beyond which ugliness and desolation threaten psychic survival. Lack of Aphrodite brings frigidity in all interpersonal relationships. In the eyes of the depressed, life has lost not only its bountiful quality (Demeter has abandoned them) but also its charm. Since we give treatments in order that the depressed person may recover appetite or sleep, we may ask ourselves why hospitals do not care to include an Aphrodisiacal element. As far back as the ninth and tenth centuries, the Arabs understood that flower gardens, poets, musicians, and an attractive table were essential to a hospital. In such a culture as ours, which gives precedence to the civilizing quality of Apollo, most of the hospitals, and too often the habitations, in spite of their functional sophistication completely lack an Aphrodisiacal quality.

Laughter, Joy, and Little Children

> Rare as such gaiety may be in cultures where there
> is a tie between sex and guilt, the release from self
> brings laughter in love-making as much as in
> mysticism, for we must remember that it was
> Dante who described the song of the angels in
> Heaven as "the laughter of the universe".... The
> grasping approach to sexuality destroys its gaiety
> before anything else, blocking up its deepest and
> most secret fountain. For there is really no other
> reason for creation than pure joy.
>
> Alan Watts, *Nature, Man, and Woman*

Little children and babies like laughter, caresses, honey, sweet
fruits; all of these are elements of the myth of Aphrodite: "And
from the first day, the babbling of baby girls, their smiles and their
fetching ways, are her privilege, her lot just as with the immor-
tals—gentle pleasure, tenderness and sweetness."[10] Babies like to
play and laugh. Every mother, even those who have never heard of
"polymorphous perverts," knows this instinctively. That Freud in-
troduced the notion of "perversity" to designate this Aphrodisiacal
energy reveals as much about his period, perhaps, as about his
own unconscious, and as much of his opinion of Aphrodite as of
the sexuality of children. More specifically, in his work "The Wit
and its Relationship to the Unconscious" (1912), Freud analyzed
how laughter triumphs over repression. But the myths of Hermes
and of Aphrodite propose a different fashion of grasping the link
between the comic and the sexual, showing how laughter, as well
as sexual desire, both are escapes from repression and domination
by "innocence," or by "stealing through."

In fact, laughter leads as assuredly to the seduction of women as
to that of children. What do we do spontaneously to be friendly
with a child? We try to make him or her laugh. And who remains
insensitive to seduction through laughter? Moreover, laughter and
desire have this in common: neither can be forced.

Wherever Aphrodite is honored, there is room for laughter and
games, for sweetness and for peace. Inversely, it is sufficient to

observe the more anti-Aphrodisiacal aspects of modern life to realize that places unfavorable to the Goddess are no more favorable for rearing little children. Children thrive in a climate of intimacy; their link with nature, with their bodies, with people, and with food resembles that which is propitious for lovers.

Still in an Aphrodisiacal mode, young children are not insensitive to "civilized" pleasures; they appreciate shimmering and silky materials as much as does Aphrodite, as well as bright jewels, fantastic clothing, perfumes and celebrations. Perhaps they mostly differ from adults here in being less snobbish, for a child may find authentic pleasure in an imitation pearl, whereas an adult may find a false pleasure in contemplating a true pearl, if it is valued as a symbol of money or power rather than for its beauty.

Maybe there is something other than a domineering and stupid infantilism in the many popular expressions in which the man addresses a woman by calling her "baby." Would there not be, perhaps, a half-conscious analogy between the desire of a man for a woman and the sensual pleasure of a woman with a baby? In certain ways, is not the woman, to the man, what the baby is to the woman—a being whose skin is softer to caress, who calls forth tenderness and laughter, who smells good, who is more beautiful and physically smaller than himself, and whose confident abandon brings about his own release from constraint?

Rather than interpret this symbolic association under its aspect of dominance, perhaps we should follow another reasoning. If it is true that the beloved woman may become the "beautiful baby" of her lover, without necessarily establishing an adult–child type of domination, we could argue that a baby does not need a dominant father, but a tender and sensuous mother. In this case, we should conclude that it is right for a man to develop his masculine "maternal" qualities and for the loved woman to let herself be cared for, without in any way losing her autonomy in other aspects of the relationship. If at times we play at being cuddled like a "baby" by a lover, it is usually a game of physical tenderness, since it is at this level that the mothering of babies takes place. If it is kept physical, the dependence–dominance relationship might be prevented from invading the whole psychological and social association.

Perhaps the mythic association between Aphrodite and little children means to suggest that identification with the body of the other is just as fundamental in sexual love as in maternal love. If

the baby smiles, I smile; if the baby is well, I am well; the happiness of my baby is my own happiness. Are not the best of our ice-creams those we see being eaten by our delighted children, and does not a gift given to a child bring as much pleasure to the one who has given it? There is this same communion of enjoyment between the body of lovers, and many men are moved by the body and the pleasure of their mistress in the same way as a mother by the body and pleasure of her child. Maternal love and sexual love are the only kinds to have invented such variety of caresses, ticklings, kisses, tender games and little surprises. According to the myth, to make a baby laugh and to delight one's partner in sex both draw upon the same Aphrodisiacal intimacy.

Other qualities of Aphrodite, such as candor and ingenuousness, relate her to children. Every spring, Aphrodite purifies herself and renews her innocence and virginity in a sacred bath. As regards to sexuality, her purity is that of a child who has never learned that the senses are evil. Aphrodite's bath and her innocence originate in a psychic virginity which permits her to be the guardian of a psychic prodigy: every true amorous encounter, even if the gestures are always the same, is "for the first time"! We make love thousands of times in our lives, yet not one encounter has the same psychological quality as another. By the grace of Aphrodite, our innocence and psychological virginity may be renewed: ". . . she restores the distinctiveness of The First Time. She is the opposite of a Don Juan who wishes to reach the thousand-and-first time."[11]

But this quality has another side. An attitude of innocence, characteristic of certain immature seductresses, which is frankly infantile instead of "childlike" may have devastating social consequences. Such women do not easily recognize that good manners or marital, parental, ethical, or professional considerations should restrain their pleasures. This type of disequilibrium certainly contributes to the reputation for immorality so often attached to women who like the pleasures of love to the point of yielding to them wherever they may lead.

Despite its negative effects, this trouble-making innocence has positive value. The novelist Lawrence Durrell brilliantly describes such a character: "Justine" arouses terrible passions and does nothing but breed trouble.[12] Nevertheless, the kind of void which develops around her is characterized by a great quality: an inabil-

ity to attach any meaning to whatever may belittle her joy. This
quality Durrell sees as no other than the inner moral sense of a soul
that has discovered a royal road to happiness, in which nudity
finds no shame. Perhaps, he suggests, we should study these per-
sonalities, because it is possible that they promote creativity de-
spite the visible confusion and corruption they seek, and find.
Lawrence Durrell, for his part, contributed to this study by writing
his *Alexandria Quartet.*

CHAPTER THREE

The Teachings of Aphrodite and Sappho

To rediscover the teachings of Aphrodite, we shall follow the way opened to us by Sappho. But before looking at what this extraordinary woman brought to humanity, we should understand to what extremes her influence was opposed. Judeo-Christianism is so structured that it has set the love of God against the love of women. The Christian saint who wishes to approach God must keep away from women, whereas, in the cult of Aphrodite, woman was a vehicle of divinity. Insofar as Christian mythology is still a basis of our unconscious fantasies, the pleasure of lovemaking and man's fall are symbolically linked. The Christian imagination distinguished two kinds of spiritual beings—heavenly angels, who have no sexuality at all, and demoniacal spirits whose sex life is perverted, sex and damnation being once more associated. As for those pagan spirits which inhabited forests, brooks, trees, animals, or the bodies of women, these have all become evil spirits through the Christian influence. Mary Daly,[1] in *Gyn/Ecology* as well as in *Pure Lust,* and Carolyn Merchant[2] in her book *The Death of Nature* have strongly stressed the negative consequences, for women and ecology, of the elemental, hating Christian theology. Hunting evil spirits has had a greater place in Church history than the quest for spiritual life itself. Christ's attitude of tolerance and compassion has been forgotten.

In her work on the eroticism of fairies, Maureen Duffy, quoting Gregory the Great, sees in the following quotation a summary of the Christian attitude towards sexual desire: "The sirens have the faces of women, because nothing estranges men from God as much as the love of women."[3] A curious religion in which it is sane for a priest to welcome death, because through death one may approach God, while one is not allowed to desire women, because the love of women estranges man from God! Thus, "orgies of flagellation" (an expression of Duffy's), self-mutilation, and the throes of the exalted martyrs would please God, whereas the joys of love between men and women would be an offense.

The pagan priests and priestesses were forbidden to shed blood, but love relationships and sexuality were not usually forbidden to them. The Catholic priests may favor the shedding of blood, as in the Crusades, or the raising of armies to defend the Papacy. Soldiers are sent forth to the slaughter with the blessing of the clergy, but these priests are forbidden to love women. And these sexless old men who constantly confused woman with mother, and sex with evil, presumed that they had the right to control the sexual life of others and even went so far as to doubt whether procreation should be pleasurable. The good Christian, according to Christian doctrine, should remain open to all suffering, because it comes from God, but should remain as closed as possible to the joys of sexual love, because it could be the devil's work. To await death, to avoid women, and to disdain the body would make saints, whereas sexual pleasure and the enjoyment of life would lead to damnation. Those saints, such as Francis of Assisi, who could not completely adopt this worldview, had to keep themselves apart from ecclesiastical institutions—drop-outs, in a way, from their own church. These attitudes epitomize the combat of Judeo-Christianism against eternal Aphrodite.

The rediscovery of Sappho, a real woman and guide to Aphrodite, can give us some cues to the teachings of the Goddess. Sappho was attacked by the Church, not only because the content of her teachings concerned Aphrodisiacal matters, but also because a woman of such authority shocked the Christian conception of feminine self-effacement: "Let the woman learn in silence with all subjection. But I suffer not a woman to teach, nor to usurp authority over the man, but to be in silence."[4]

Who Was Sappho?

Officially the dean of a semi-religious school or "university" which prepared young women for adult life, she taught them the art of expressing themselves in poetry, dance and music—and the art of loving, which was considered fundamental to the quality of life. A teacher beloved of all her students, celebrated and respected in all of Greece, she was a kind of Socrates for young women. Although the dates of her birth and death are not precisely known, she is believed to have lived between 620 and 570 B.C. Since she was the most widely known person in Lesbos—as well as a celebrity throughout Greece—she was often called the Lesbian.

Moreover, on the island of Lesbos, where Sappho's influence was established, there was a military school for boys in honor of Ares, the God of hand-to-hand combat and of war. This sexual specialization, which conforms to one of the most persistent sexist stereotypes, should be examined more closely. For in our times, the mythological link which makes of Ares the lover of Aphrodite is missing, and his destructiveness is no longer balanced by the power of Aphrodite. The soldier boys still have their war games in which to release their energies, but the brutal force of Ares is no longer balanced by Aphrodite and the Sapphic schools, resulting in a social disruption just as serious as the disruption of personality types into sexist stereotypes. We still have military schools, where one is taught destruction, while schools in which one would learn to live and love would certainly be the object of distrust and scandal. It is no surprise that the military are, in general, brutal, for they have the spirit of Ares without much chance to learn of Aphrodite.

Reciprocally, many young women have become quite dull upon leaving what our culture has imagined as a substitute for the Sapphic school. These colleges and institutes of domestic sciences, the only schools reserved for young women for the past two thousand years, were still teaching yesterday that modesty consists of keeping silent, whereas Sappho taught the art of speech; that good manners require the repression of movement, whereas Sappho taught dancing and music; that "home economics" made one the humble servant of her husband, whereas Sappho taught the art of

being for one's lover Aphrodite's priestess and the guide of love's
rituals.

To introduce Sappho, one must speak of her Lesbianism since
the word itself designates love such as it was lived on the island of
Lesbos, in Sappho's school. Understood as an opening to women
rather than an exclusion of men, Sapphic lesbianism does not con-
tradict Aphrodite's myth. Sappho, indeed, taught women and did
not turn aside from them when her influence and celebrity reached
the masculine world.

With Judeo-Christianism, in which all forms of intellectual
authority became exclusively masculine, it seemed quite natural to
speak of "university" or "college" without ever grasping that this
"universalism" or this "collegiality" excluded half of the human
species and that there was thereby just as much affective and in-
tellectual homosexuality in these institutions as there was in Sap-
pho's school. Even today, we consider a women's college, or a
feminine university, or women's courses as some sort of specializa-
tion or reduction. Any feminine grouping is specifically designated
by its gender, as if all the male institutions were not men's groups
and their teachings not "men's studies"! To rediscover the Sap-
phos, we should have to reverse a norm which has infiltrated our
thinking more profoundly than we would believe and which is well
epitomized in the prescription of St. Paul spread throughout our
institutions: "And if they will learn anything, let them ask their
husbands at home: for it is a shame for women to speak in the
church."[5]

Those who continue to classify the poems of Sappho as "Les-
bian" should logically classify Socrates as a "pederastic" philo-
sopher and Plato's *Symposium* as an essay on homosexual love.
One would see, at the same time, that the philosophy of Socrates
and the dialogue of Plato are truly homosexual works, while
Sappho's poetry is only peripherally Lesbian. Socrates and Plato
seem to love only those of their own sex, and their philosophy is
quite completely masculine, whereas the work of Sappho has an
undeniably universal quality. She, in fact, was the first to use the
same words to designate: 1) love between two women; 2) love be-
tween men and women; and 3) love between mother and child.
Whereas Eros (the Eros who inspired the philosophers) patronized
only the homosexual male, Aphrodite and Sappho extended their
influence as much to men as to women. Thus the Aphrodisiacal

myth and the pedagogy of Sappho included and unified the masculine and the feminine, whereas the eroticism and the homosexuality of the classical philosophers included only the relationship between men and separated men from the world of women.

The historic bias which reduced Sappho to her lesbian overtones is the same which prevents us from seeing the homosexuality of Socrates and Plato and leads us to say that a work such as the *Symposium* presents a "universal" form of love, friendship, and pedagogical rapport, while Sappho would be a "lesbian poetess."

Platonic philosophy marked the end of Aphrodite's predominance; it gave the myth of Eros precedence over that of Aphrodite, dissociated love from its corporeal aspect, and valued mostly the all-male relationships. Disequilibrium between soul and body was there from the moment the classical philosophers suggested going 'beyond' the body to attain ecstasy. Plato introduced a hierarchical relationship between the purely spiritual path and the corporeal one. More and more, Apollo controlled Dionysus, and the Eros of the philosophers became a form of love superior to Aphrodite's, which was relegated to the commonplace. From the moment that the myth of Eros supplanted that of Aphrodite, the hierarchy of relationships between men and women began to assume the form it has today. Woman's body stopped being one of the paths to the sacred, and the love of a woman was considered an obstacle to spirituality.

Each period takes from the heritage of Greece what is convenient to it, and this is possible because of the fabulous complexity of Greek culture. We have retained from the Greeks, above all, *the heritage of the classical philosophers,* who are the ones who rejected the ancient myths and the Sapphic influence.

> Socrates, in turning his back on poetic myths, was really turning his back on the Moon-Goddess who inspired them and who demanded that man should pay woman spiritual and sexual homage: what is called Platonic love, the philosopher's escape from the power of the Goddess into intellectual homosexuality, was really Socratic love. He could not plead ignorance; Diotima Mantinice, the Arcadian prophetess who magically arrested the plague at Athens, had reminded him once that Callone (Death, Birth and Beauty) formed a triad of goddesses who presided over all acts of generation whatsoever: physical, spiritual or intellectual.[6]

One can find many examples of this "Platonic" bias in modern Hellenists who argue that Aphrodite does not personify love at a truly human level, because there is this animal component (that is, sexual desire) symbolized by the wild beasts which sometimes accompanied the Goddess.

One can further pursue this comparison between the exclusive and permanent homosexuality of the philosophers and the various forms of "transitory" homosexuality that were associated with Lesbos. During adolescence, Greek boys and girls were strictly separated. Since the whole of their days was spent exclusively among their own sex, sexual initiation and the sexual play which accompanies it occurred between friends. Nevertheless, they usually reached a maturity which was heterosexual.

Furthermore, the philosophers did not represent the norm. It is useful to look at homosexuality among the Greeks in the light of Euripides' *Lysistrata*, for how could wives have kept their husbands from war, by depriving them of sexual relations for as long as they fought, if the men were indifferent to this pleasure? How could these wives have held such power, if their husbands had not experienced sexual denial as punitive?

Many women today, although married to men who call themselves heterosexual, could not exercise such an influence over their husbands. The average career-oriented man, forced to choose between the requirements of his work and those of love, often chooses first to make gains in the hierarchical struggle, and only secondarily fight for his love. Many a wife has discovered, to her surprise, that her husband, when faced with a choice between the office and her, has less fear of giving himself completely to his career and even of allowing himself to be devoured by ambition (first the heart, then sex, then the mind) than of yielding to the powers of Aphrodite. Psychic homosexuality today is perhaps as widespread as was physical homosexuality in Greece, for many men derive their feelings of virility uniquely from competition and recognition among men. The necessity of work—even ambition and love of one's work—does not in itself exclude Aphrodite, but when the time given to work exhausts all the vital energies, then Aphrodite is offended. It is as if the soldier came no longer to the temple and Ares had become indifferent to her charms.

To return to Sappho, evidently she was married to a rich merchant, but we have no information about this union. No extant

poem is dedicated to her husband; none refers to him. However, nothing leads us to believe that she was hostile to heterosexuality. In several poems, Sappho expresses her regret that a young man has taken away her favorite young women (poems which a mother could take to heart on the occasion of her daughter's wedding); but on the other hand, many of her poems seem to be marriage hymns. Sappho's lesbianism does not appear to be a refusal of men, but rather a way of refusing to suppress any sexual preference. The values which are opposed to Sappho and Aphrodite are not those of heterosexual love, but rather those of sexual abstinence. Sappho's young women love one another rather than suffer deprivation when it is inappropriate, for whatever reasons, to have relationships with the opposite sex.

We must stop considering Sappho only from the point of view of her lesbianism and ask ourselves what other qualities have made her a poetess whose influence became so widespread. Why does such a great Hellenist as Werner Jaeger believe that Sappho was, of all poets, the one who sang best of love? And why this astonishing statement: "Among the Greeks, no male poet approaches the spiritual depth of Sappho"?[7] Why does Friedrich call her "a religious seeress who invented love"?[8] And finally, how can one explain the truly special ferocity with which the Fathers of the Church destroyed her works?[9]

The Competence of the Body and the Pleasures of Love

> She climbed into bed, flung one leg over me as I lay on my back, and crouching down like a wrestler, assaulted me with rapid plungings of her thighs and passionate wrigglings of her supple hips.
>
> Apuleius, *The Golden Ass*

On perusing the curriculum of the Sapphic college, we find that the ideal of unity between body and spirit was more than wishful thinking.

The theories of Reich and the various psycho-sexual practices of

today (bio-energetics being, perhaps, the best example) insist once more on the body's importance. But we have few examples of a harmonious integration of body, soul, and mind. That this problem may be partly of a theological order has often been suggested, because our monotheist God is a spirit without body. It is true that his son lowered himself to our level and deigned to incarnate, but he is neither a lover nor a father, his mother is a virgin, and his terrestrial life has been presented to us in a way that could hardly be more disincarnate. The body of Christ only assumed importance at the moment when he had a crown of thorns on his head, nails in his hands and feet, wounds in his sides, and blood streaming from his heart. It is with reference to his agony and suffering that the Catholic priests have given the most detail on the corporeal life of Christ. One might say that it was poor old Joseph alone who bore the burden of the body, but he was never deified: he remains forever a human, a carpenter whose wife belonged first to God the Father and God the Son, but never to him. She allowed herself to be penetrated exclusively by the Holy Spirit and subsequently devoted herself entirely to the divine son. Maybe Joseph is an appropriate model for all men who follow too closely the Catholic conjugal ethic.

Aphrodite is divine, pure and spiritual; but, distinct from the Christian Trinity, she leaves no doubt about her approbation of corporeal realities. Geoffrey Grigson lists several adjectives qualifying her: there is Aphrodite of the "lovely backside," Aphrodite of "copulation," and Aphrodite, "lover of genitals."[10] As to the "honeyed kisses," they are a specialty which the Goddess has not disdained to teach humanity.

The Englishman Weyland Young, studying the decadence of occidental eroticism, insists on the importance of not separating the gross (which he calls "fucking") from the sublime (that is, the religious), for to do so would lead inevitably to a disdain for corporeal realities: "How can religion and fucking be kept apart? By bloodshed, yes; and we have had the bloodshed. But by other means, and now that we have decided against the bloodshed in this field, they are coming together again."[11]

Aphrodite reunites these two levels of reality: she is simultaneously the Goddess of the "beautiful backside" and the sublime "Golden Aphrodite."

Modesty has its place—Aphrodite's attraction for veils which

both cover and reveal—but there is also a place for the body's
vigorous expression:

> "Look darling," I said, "We didn't remember to invoke the gods of
> Wine, did we? But he always aids and abets the goddess of Love, so
> he's come on his own accord. Let's put the whole of this jar aside for
> tonight. It will rid us of all embarrassment and supply us with the
> energy we need for our work. In provisioning the ship of love for a
> night's cruise, one needs to make certain of two things only: that
> there's enough oil for the lamp and wine for the cup."[12]

In this quotation we notice that the lamp remains lighted which
gives full consciousness of what one is doing and with whom one is
doing it. The puritanical reflex of turning off the lights seems to
confirm the relegation of sexuality to the level of animal realities,
semi-conscious and dark.

Insisting on the beauty of Aphrodite, as one inevitably does, we
risk forgetting that her mysteries are concerned with the whole
body and not only with the eye. The woman who has the qualities
of Aphrodite knows how to move, breathe, and vibrate, and is
capable of generating as well as receiving high-intensity sexual
energy.

Some beautiful women give the impression that they are in-
habited by Aphrodite's qualities. Their seductive appearance
which promises of pleasure, however, leads to deception each time
this promise is not kept by the body.

But when competence at bodily love prevails over good looks,
certain women, even though unsightly, may exert upon their lovers
an extraordinary attraction.

Several years ago, while traveling in Morocco, I went to see two
performances of belly dancing in the same evening. The first took
place in an American hotel, where I had gone to meet some
friends. The publicity insisted upon the splendid figure of the
dancer: she wore a light veil embroidered with pearls and was in-
deed beautiful. She moved little, but with grace. Her gestures were
those of the belly-dance, but perhaps because of the air condition-
ing, or her bleached blond hair, the whole thing appeared to be
insipid and deceptive. Later in the evening, in the public square of
the old town, I watched a young Berber woman dancing. She was
certainly very poor and had no chance of penetrating show-

business; her figure was too heavy, and her features hard and im-
perfect. Although dressed to the neck in a poor cotton dress, and
without any artifice of scenery, she kept the public under the spell
of her dance with the brusque movements of her hips, her
rhythmic cries, her vigor, and her delighted eyes. All her muscles,
all her gestures expressed what is most sexual within us. Each
movement proceeded from her belly as if from the center of
herself. I have never since then seen a more erotic dance. The first
dancer, although beautiful and graceful, seemed to imitate the
movements of love, but she could not radiate with Aphrodite's
energy. It was only upon seeing the 'real' belly dancing that I knew
the first was only a pastiche.

Aphrodite or Tantra

Tantrism and Aphrodite's sexual mystique are quite different in
their attitudes towards both the body and women. Indeed, in Tan-
trism, the attitude towards the body and the attitude towards
women seem to be linked. The world of sensations, substance, and
the body (Shakti) are a part of the gross or lower universe and are
represented by the feminine. Shiva (the male counterpart) unites
with Shakti as the soul to the body, but only to subsequently
detach himself from her, for the ultimate goal is disengagement
from the gross world and union with a masculine God. In the
original Tantrism, the spiritual development of the woman is not
mentioned, and her personality has little importance, for she is
primarily the mirror in which Shiva becomes conscious of himself.

That the body is considered by Tantrism as part of the gross
world may seem rather paradoxical, for the practice of Tantric
meditation requires sexual engagement and an acute physical con-
sciousness of it. But the value granted to sexual love is not the
same in Tantrism and in Aphrodisiacal initiation.

The recent craze for Tantrism, or rather Neo-Tantrism, in
which the role of the woman is seen in a different and more posi-
tive way, reveals the need for the spiritualization of sexuality. This
fad reintroduces an extreme spiritualization of the sexual ex-
perience, since the original goal of Tantric sexual meditation was

neither pleasure, nor emotion, nor psychological knowledge of the partner. As opposed to that, in Aphrodite's myth great importance is given to bodily pleasure and to the partner's personality, and there is not the ideal of control and detachment which Tantrism upholds. Aphrodite's cult valued the initiation of women from a physical, psychological, and religious point of view, while Tantrism, at least in its original version, was primarily a means of spiritual development *for the man.* In this regard, awakening Aphrodite might be more suitable to occidental women than borrowing Tantrism from the Orient.

The Sapphic "I" and Psychological Skill

Sappho's poems were written in the first person, describing subjective rather than objective reality. She has none of the objectivity of one who observes and deduces from a "scientific" or external point of view. Of all Greek literature, her work is the most subjective. Like Aphrodite, who herself feels what she inspires in others, Sappho speaks from her own experience. Her poetry is a turning point in the history of consciousness, because she explores and describes realms of the subjective previously unknown. One of her poems was so celebrated that most Greeks knew every word of it:

> He seems to be a god, the man
> facing you, who leans to be close,
> smiles, and alert and glad, listens
> to your mellow voice.
> And quickens in love at your laughter
> that stings my breasts, jolts my heart
> if I dare the shock of a glance.
> I cannot speak,
> My tongue sticks to my dry mouth
> thin fire spreads beneath my skin,
> my eyes cannot see and my aching ears
> roar in their labyrinths.
> Chill sweat slides down my body,
> I shake, I turn greener than grass.

I am neither living nor dead and cry
from the narrow between.
But endure, even this grief of love.[13]

Friedrich gives credit to Sappho for the creation of subjective poetry. Today it seems self-evident that we may express personal feelings through poetry, literature, and song. But in an epoch when poetry was primarily a means of transmitting historical facts and collective myths, Sappho's description of her personal feelings seemed an audacity without precedent. Sappho was, in a way, one of the first to describe in poetic form a deeply felt emotion. This is extremely rare in the literature of antiquity, if one bears in mind that she wrote some two hundred years before the "I" of the philosophers. The Sapphic "I" is complex, for it is at the same time both personal and universal. Sappho spoke of herself, but because her subjectivity was inspired, she named the nuances of love which had been ignored up to her time. In doing so she gave new depths to human consciousness, for to name something helps to become aware of it.

> She is the seeress who reveals to us the personification of growth and beauty and all the rest of Aphrodite's characteristics. Above all she incarnates the goddess' most fundamental trait: her subjectivity working through the heart, the synthesis of wild emotion and sophistication.[14]

In Aphrodite's realm, it is not contradictory for an emotion to be both strong and very nuanced, as it is in love. Sappho's poetry described and clarified the strength and complexity of love feelings.

Over the past fifteen years, the artistic productions of women have grown fantastically. It is no accident that the proliferation of feminine and feminist literature has occurred through, and coincidentally with, the liberty women have taken in writing in the first person. Nor is it accidental that this conquest has implied also the power and necessity of sexual liberation: Sappho and Aphrodite, the woman and the Goddess whose femininity has not been castrated, re-emerge together.

Germaine Greer has examined with great intelligence the process of female castration: "In fact, the principal factor in the

misdirection and perversion of feminine energy is the substitution of the concept of femininity, or of the absence of sexuality, for feminine sexuality."[15] The teachings of Aphrodite, as those of Sappho, are an antidote to the psychological castration described by Greer. Sexuality is a form of knowledge, and it is sometimes the most fundamental way for the Aphroditic woman. When such a woman finds her sexuality constantly repressed, for social, moral, or political reasons, her capacity for knowledge and creative audacity are also impaired. Her faculties are impeded because the path of Aphrodite, the one natural to her, has been closed. The risks of love and the need for sexual discovery are not really different from other forms of knowledge and adventure. Aphrodite has, in common with Hermes, the God of communication, a taste for adventurous relationships and new challenges. The words of Hermes seduce and convince by the same "subjective" qualities that give the word of Aphrodite its force of attraction and enchantment. Hermes, the messenger and diplomat, assures the bond between opposing parties in the same fashion as Aphrodite links man and woman.

Wife, Prostitute, and Courtesan

> I believe in you! I believe in you! Divine mother,
> Aphrodite of the sea!—Oh! the way is bitter
> Since the other God harnessed us to his cross;
> Flesh, marble, flower, Venus, I believe in you!
> —Yes, man is sad and ugly, sad under the vast sky.
> He has clothes because he is no longer chaste,
> Because he has defiled his proud head of a god,
> And bent down, like an idol in the fire,
> His Olympian body to base serfdom!
> Yes, even after death, in pale skeletons
> He wishes to live, insulting the original beauty!
> —And the Idol in whom you placed such virginity,
> In whom you placed such virginity,
> In whom you made our clay divine, Woman,
> So that Man might illumine his poor soul
> And slowly rise, its boundless love,
> From the prison of earth to the beauty of day,

Woman no longer knows even how to be a courtesan!
—It's a good joke! and the world jeers
At the sweet and sacred name of great Venus!
 Rimbaud, *Soleil et Chair*

If we were to be rigorous in talking about Greek women, we should have to study their sexual life according to social class, town, period, and so on. The sum of these variations in time and space, as well as the individual accommodations—including the twists of disobedience, the lies and tricks of all kinds which in all times have inspired lovers whenever the law constrained them—ranges from everything to nothing as concerns the woman's liberty to enjoy Aphrodite's gifts. It was not, perhaps, so different from the present situation in the Occident, where there are probably just as many frustrated women confined within their homes as there were in the Greek gynaeceum, except that the constraint today is interiorized rather than a physical barrier. It might be an even worse confinement to be kept at home by economic, moral, and domestic restrictions, for then the woman is herself her own gaoler, unaware of what she does to herself.

But just as life in modern suburban households is not uniformly dull, neither was it so in the Greek gynaeceum. In both contexts we may suspect that many women enjoyed a good life and honored Aphrodite, either with their husbands or by ruse and infidelity if these were not servants of Aphrodite in the conjugal bed. One need only read the comedies of Aristophanes to be convinced that, although his characters' licentious ways were obviously exaggerated and caricatured, there must have been a core of truth in them, for otherwise his farces wouldn't be funny. In his play *Women in Power,* Aristophanes has his character Praxigora say, while disguised as a man: "Women, seated, fry their meat; as in the past; they bake their cakes; as in the past; they annoy their husbands; as in the past; they have lovers in the house, as in the past; they make sweets; they like the game of love, as in the past."[16]

Beyond all social differences, Aphrodite reigned over them all, the respectably married woman and the courtesan or prostitute slave, the Spartan woman, athletic and austere, as well as the Athenian citizen confined to the invisibility and the cloistered protection of the gynaeceum. From the sophisticated Corinthian to

the Boeotian peasant, all women knew Aphrodite and rendered homage to her. Though the courtesan was physically and sociologically separated from the married woman and much freer, the sexual life of both was under the auspices of the same Goddess.

In our culture, because of contempt for Aphrodite, the prostitutes are in a double-bind situation. No patriarchal culture seems able to do without them, but guilt and shame have fallen upon the shoulders of women, and they bear more than their share of the collective conflict as regards sexual pleasure.

As do all professions, the one of giver of pleasure, said to be the oldest in the world, has its art and its rules, its stars and its failures, its good and bad moments. The lovemaking may be banal, quickly and badly indulged, and may, just as does bad food, provoke disgust and cause psychological poisoning. But, it may also be a great art, and she who is the artisan is then truly a priestess of Aphrodite.

> Cynics and moralists agree in placing the delights of love among the grosser pleasures, between the pleasures of drinking and those of eating, and moreover declare them, since they assure themselves that they can do without these pleasures, less indispensable than these. . . . I shall believe in this supposed assimilation of love to the purely physical joys (supposing that there are any such) the day I see a gourmet sob with joy over his favorite dishes, as a lover on the shoulder of a young woman.[17]

Masculine cultures, with their endless and almost obsessive enhancing of hierarchical subtleties among men (the lieutenant, the sub-lieutenant, the apprentice first and second class, the "upper middle class" or the "lower middle class," etc.), astonishingly lack discernment as regards the most obvious feminine hierarchies, past or present. For example, historians have often grouped, under the same word "prostitution," realities which should be differentiated. I do not want to summarize here the history of prostitution which, in the archaic period of the Greeks, presents highly differentiated aspects and significations; but we may nevertheless clarify the terms and give a few examples, since all forms of prostitution originate in the same Goddess.

The Prostitute

The ordinary prostitute, who had no special training and who surrendered herself to prostitution as a last resort, or in an occasional manner, may have been a stranger, a widow, or an orphan. In any case, she was not a citizen and could not enjoy the security that the state offered its citizens and their mothers, wives, daughters, and sisters. Outside of prostitution, the professions open to non-citizeness women were few and paid little. The prostitute could also have been a slave, bought and exploited by a brothel owner.

In Corinth, prostitutes gathered around the port and recruited their clients from among the sailors, the foreigners, freed men, and even slaves. A part of the lower town, they had, like the unfortunate of all periods, the reputation of being greedy (because they were often hungry); dirty (because they lived in the most insalubrious quarters); vulgar (because without education); and mendacious (because they did not have the means to live according to their real feelings). They honored Aphrodite, their patron, for without sexual desire there would be no clients. They offered a percentage of their revenues in sacrifices and gifts to Aphrodite's temple: "Cyprian," she said, "you will have ten percent of everything I earn. Only find me work, and you shall have your share."[18]

At the age of retirement, when her charms had faded, the prostitute brought to the temple and consecrated to Aphrodite the symbols of her specialty—the mirror, the tresses of false hair, the fancy sandals (some sandals were made to imprint, while walking in the sand, "follow me"), and other trinkets—to signify that she was leaving the trade. She did this in the same spirit in which, for example, the aged fisherman offered his fishing nets to Hermes and Poseidon.

In the sixth century B.C., the legislator Solon instituted state-controlled brothels in Athens, which were served by slaves bought for this purpose. These prostitutes were, in a sense, the "civil servants of sex," and the laws protecting them resembled those that protected and regulated the lives of all the state's slaves. Free enterprise, in the matter of bordellos, remained legal, so that besides the slaves who prostituted themselves for the benefit of the state, there

were also independent prostitutes (freed women, foreigners) working for their own profit. But, in principle, all prostitution outside of the state bordellos was subject to a special tax, the *pornikon,* which fed the town's coffers.

On the other hand, prostitution was forbidden by this same Solon to any wife, daughter or mother of a citizen. Anyway, one might ask what would prompt a woman as protected as the Athenian citizeness to turn to prostitution, for although her personal liberty was very restricted, she enjoyed an extraordinary security. Widowed, orphaned, or abandoned, without dowry or suitor, she could always claim support from her closest male relative, and the latter was obliged to provide for her needs and treat her with all the respect due a citizeness of free birth. In the absence of an inheritance or male protector, the state took charge of her, and she retained all her rights as a citizeness.

We know little of the motivations which prompted Solon to institute these laws, which concern not only prostitution but also numerous other aspects of the life of women, girls, and couples. It seems, however, that Solon only wrote, codified, and made public the common law already in use. One may certainly raise many questions of interest to the historian of women: was Solon, who was homosexual, a misogynist and anti-feminist? Were his laws designed to protect the family and citizenship or to restrain women even more severely in their roles as wives and citizens? Would it be important to insist on the shadow of this celebrated Athenian society: the submission of married women and a prostitution which deprives wives of their husbands and prostitutes of their honor? Many questions are presented to historians and feminists of today, for it is difficult and challenging to look at another epoch with the criteria of our own. But what matters here is that, despite this obvious distinction between prostitute and citizen, both honored the same Goddess of love. Aphrodite could grant her grace, or refuse it, as much to a sailor who wanted to "enjoy Aphrodite" by paying a prostitute in the port as to a married couple who loved each other.

Prostitution has its heroines and its victims, its champions and its losers, and we have today, as in other times, miserable ones, temporary prostitutes, young groupies who are more or less conscious of their function as prostitutes, and great courtesans who are exacting mistresses, demanding in exchange for a more or less

contractual affection conditions of life and work that are truly impressive.

The Greeks denoted the difference between these two types of prostitutes by different words. The hetaera was a prostitute of the "superior" category, which we translate in general as "courtesan," and who corresponds today to the kept mistress.

The Hetaera

The hetaera's formation may have begun when she was very young. Perhaps she had been bought as a slave by a "madam" who was herself a retired hetaera, with an eye for young girls who possessed the appropriate qualities. Or she was a child who had been exposed at birth, then taken in to be brought up as a hetaera. Or, again, the function of hetaera may have been hereditary, the mother teaching the profession to her daughter and leaving her clientele to her. At first glance, this hereditary prostitution may seem shocking. But if one today researched the conditions of prostitution, one would perhaps conclude that, if it can no longer be foreseen by heredity, it is nevertheless sociologically predictable, environmental influence replacing that which in Greece was linked to the mother. In fact, selling little girls and women, and the whole organization of prostitution among the Greeks, makes us feel hostile to them. The works of Sarah Pomeroy[19] and Catherine Salles[20] document a somber view of the lot of women in the Greek world. Their detailed studies are an excellent antidote against a too idealistic view of Greek antiquity. They present the hetaera, like other prostitutes and all the slaves, as an object which could be rented, bought, sold, shared, resold or exchanged.

But we could be as scandalized by modern prostitution and the different forms of sexual contracts in our society. Let us first clearly note that the definition many Hellenists have given Greek prostitution has been extremely wide and all-encompassing, whereas our modern definition is extremely narrow—a frequent mechanism for salving the conscience. At the United Nations or the World Organization of Health, one still speaks of "female circumcision" and "local customs" to avoid seeing that these practices are, in some places, indicative of sexual slavery and mutilations. In many Islamic countries, one calls by the name of marriage a reality

which gives the man the right of life, death, imprisonment, and castration of his wives, not to mention the unlimited exploitation which he may and does not fail to make of their labor. Many Moslem women are, legally and humanly speaking, similar to slaves, whereas Greek slaves could at least purchase their liberty or hope, based on a particular competence or on loyal service, to be set free. In an absolute patriarchy, women have no means of gaining their freedom, no *peculum* (the nest-egg that a slave could put aside to redeem himself), no temple for refuge in time of flight, no chance of being promoted to the level of a free person. The prevailing opinion in many countries today is still that it is "normal" for a man to brutalize his wife. That certain property contracts for women are called "marriage" rather than "slavery" does not change the reality but avoids scandal and collective guilt. One should study some of the engagement contracts of the ancient hetaera and compare them to many of the actual concubinages of our time. The conditions of today are no less harsh (among other things, the fact that children born to these unions lack the protection of a father), the major difference being, probably, that the hetaera's contractual terms were more clear.

Today many "rented" women have an additional handicap: they recognize their actual status only at the moment of divorce when they receive their financial allotment. "Rent-a-wife" or "rent-a-womb" exists, in fact, wherever only the man possesses the economic power. Although there are probably many men who would not have involved themselves in a marriage which ended in costing them so much money, there are as many women who would have preferred another occupation to that of being fulltime devotee and benevolent associate in a failed marriage. One must not project all the cynicism upon the ancient hetaeras while projecting all the innocence upon the modern mistress or wife, for the attachment which hetaeras felt for their partners may have been tender, friendly, and durable.

Even if we regard the hetaera as a luxurious sexual object, this kind of object was neither easy to acquire nor to keep, for the more competence she acquired, the more costly an object she became. Her owner had perhaps paid a fantastic sum for her, which inclined him to treat her as he would any object of great price. If the modern pimp obtains for nothing use of the women who prostitute themselves for his benefit, manipulating them through their fear,

their need for affection, and their lack of self-confidence, does this not aggravate the violence, the small esteem these women hold for themselves, and the dependency which follows?

A hetaera could not be content to be a beautiful doll. She had to develop her talents as a musician and dancer, and above all, she cultivated a certain "Aphrodisiacal" quality of spirit and intelligence. If he or she was mindful of the benefits, the owner of a hetaera did not treat this talented professional like a slave of low degree, because poor living conditions could diminish her value. It is well-known that, in all creative professions, caprice must be tolerated, and any artist's boss must keep a difficult equilibrium between exploitation and control of the activities of his or her "artist" and the freedom and security that promote creativity. The hetaera, although indeed a slave, was an artist of an extremely delicate kind! It was to the proprietor's advantage to give her every opportunity to develop an interesting personality and even to allow her to participate in the benefits. In this manner many great courtesans purchased their liberty, as did Neera who got the money from several lovers.

The fabulous destiny of some courtesans, although not common, is sufficient to cause us to reflect upon the cliché of the woman-as-object. Many of them were rich enough to patronize the arts, and works of great artists offered by hetaeras have been found in temples. Some of these women were very powerful, at least in that power conferred by money and influence over important men; some had great dignity in their manners.

Phryne, born in Boeotia, lived in Athens and became so rich that she subsidized reconstruction of the wall of Thebes after Alexander destroyed it, but on the condition that the following words be inscribed upon it: "Destroyed by Alexander, rebuilt by Phryne, hetaera." Apelle made a portrait of her which was, perhaps, for the Greek world the equivalent of our Mona Lisa, and it was she who posed for the celebrated Aphrodite Nude at the temple of Cnide, a work by the sculptor Praxiteles, famous both as artist and as her lover. Her beauty and Aphrodisiacal qualities gave rise to a respect akin to piety. On one occasion, when she was accused either of blasphemy or of murder, her lawyer, seeing that she was about to lose her case, suggested that she strip before the jury. By this gesture, she is said to have obtained her acquittal, for the judges believed that such beauty proved that the Goddess in-

habited her body and that, consequently, Aphrodite would be offended if one of her priestesses were condemned. At Phryne's death, a statue representing her was placed in the temple precincts at Delphi.

Another great courtesan of fabulous destiny, Rhodopis, started life as the slave of the Samian Iadmon. For some time, she was the companion in slavery of the fabulist Aesop (whose fables later inspired La Fontaine), but legend has it that Sappho's brother, a rich merchant and in love with Rhodopis, gave a huge sum of money to buy her liberty. Together with Lais and Aspasia, she was certainly one of the most celebrated courtesans of Greece. Her riches alone were legendary; for even if it is only a legend, the construction of an Egyptian pyramid was attributed to her.

As for Aspasia, she was the famous and influential mistress of Pericles. Mistress, friend, counselor, she had an enormous influence over him. He even dared to say that she inspired a great number of his ideas. She held a salon where important citizens came to discuss politics and philosophy, and, it is said, even brought their wives. Pericles had such need of her and held her in such esteem that public rumor noted his habit of very openly showing his affection for Aspasia, kissing her each time they parted and each time they met.

In the feminist reaction against the woman-object, there are perhaps two different sorts of anger: the first, more easily understood because more evident, is that at being treated as object instead of person. Simone de Beauvoir and the more recent feminist philosophers have well described the alienation which derives from being "the other sex" and the difficulty women still have in participating in the human ideal of equality between two free people, neither being the "object" of the other. But there is a second kind of anger, connected with, but almost the opposite of the first: that of the devaluation of the woman-object. In work relationships, in the responsibilities of daily life, and in most human relationships in general, numerous circumstances subject one, at any age, and with any sex or class, to the rapport of object to object. At such times, one perceives oneself as money-maker, sexual object, object of decorum, domestic robot, or a disposable item in the affective world of the other.

Was woman as object considered more precious in previous times than she is today? And could religion have had something to

do with this devaluation of women? Has the loss of our Goddesses changed our status from that of a sacred object to that of a domestic convenience? Many young men are more excited by their first car than on the day they first make love; others are truly proud and moved when they receive a promotion or experience a new gadget, but are tense, distraught, ambivalent as soon as they engage in a love relationship, witness the birth of a child, or participate in the events of family life.

That some hetaeras could obtain a price unimaginable to the modern prostitute perhaps indicates that the pleasure of their company was held in high esteem. Moreover, if rich Greeks or Kings of Persia spent fabulous sums to obtain the favors of celebrated Greek prostitutes, it was because these women possessed the art of inducing an unforgettable amorous ecstasy. Their reputations were built on the satisfaction of their lovers. Perhaps it is difficult for us to imagine their competence, for we no longer think that an Aphrodisiacal talent may be educable. The brothel holder, or sometimes the mothers or priestesses of the temples, guided and developed this talent in their protégés, provided they had the aptitude, for not every woman is equally gifted. Aphrodisiacal qualities, like an ear for music, mathematical genius, or a flair for business, are distributed without thought for egalitarianism. And as with all natural talents, these gifts may remain hidden by lack of recognition and practice.

The Priestesses of Aphrodite

The loss of our Goddess of love, of her temples, her priestesses, makes the art of loving a manifestation so private that we usually forget that this art, as all others, is perfectible. The pilgrim to the temple of Aphrodite at Corinth probably aspired to such perfection when he celebrated the mysteries of the Goddess with one of the numerous priestesses officiating there.

For many reasons, we know very little about these priestesses. Many scholars specializing in ancient Greece have been offended that the Greeks, whom they admired so much, had "sacred prostitutes." In the little spoken of it, they have insisted above all on the "Oriental" origin of these cults, as if to imply they were not "truly"

Greek. A strange point of view; it is generally recognized that just this admixture of influences from many cultures and religions gave Greek culture its specificity, richness, and power.

More significant is the fact that many scholars have spoken of "prostitutes" rather than of "priestesses"—which would have been much more exact—but these priestesses did not at all correspond to their idea of a priesthood. Rather than modify their prejudices, they preferred to translate "priestess" as "prostitute." For the rest, Christian fanatics displayed a special ardor in destroying the temples, the statues, and the texts that would have enabled us to understand and appreciate this kind of priesthood:

> Eusebios says in his Life of Constantine that his master's destructive method was to have pagan temples decanted of their wealth and their mystery. Doors were pulled down, tiles were taken off the roof, and the temples left open to the weather, their statues having been dragged out with ropes. This temple near Aphaka, in its out-of-the-way situation, Eusebios called a "hidden and fatal snare of souls" dedicated to the "foul demon known by the name of Aphrodite."[21]

We know the celebrated Epistle to the Corinthians and the fear that ancient Babylon inspired in the Jews. In this interplay of influences and cultural adoption which enriched the Greeks, it seems indeed that Aphrodite was the Greek version of the Goddess Ishtar of the Babylonians or of the Goddess Innana of the Sumerians, or the Astarte of the Phoenicians. They all had in common the preservation of the central and divine principle of life: the union of male and female through desire. Coupling remains the most powerful analogy of this fundamental unity, without which there is only death, desolation, and hostility between men and women. This unity was at the heart of these cults and was symbolized in the temples of Innana, Ishtar, or Astarte by the embrace of a King and a High Priestess or, as in the temples of Aphrodite, of a priestess and a devotee. Exactly what happened in these cults in which the priestesses of Aphrodite officiated? We may think of it as does Grigson: "Piecing the clues together, it seems there were holy professionals and holy amateurs."

Evidently, not all the temples of Aphrodite were served by priestesses such as were to be found at Corinth, her principal

center. But even when the temple was a very simple expression, it was situated in a place of natural beauty. We know little of the relations between the temple priestesses and the women of the cities. However, through their common worship of Aphrodite, one suspects that the men as well as the women profited from the knowledge dispensed by these priestesses. After the repression of Aphrodite's cult by the Christians, their art was no longer transmitted either from one woman to another, or from priestess to pilgrim, or from a Sappho to her disciples.

For most of us today, sexuality is certainly one of the more important pleasures of life, but not necessarily a form of spiritual experience. Yet for the Aphroditic woman, her spiritual life, or, as Jung would say, her "individuation," might be linked to her sexual life. For this type of woman, sexual encounter is the most profound of human experiences, a revelation of her own depths. It is therefore not only a source of joy but also a path of inner knowledge. All women are not "priestesses" of Aphrodite, but for the one whose way this is, the Christian religion (or what remains of it in our psyche) becomes a formidable obstacle on the path of self-realization, for it confounds marriage, maternity and femininity and leaves them undifferentiated. For such women, Christian discourse has no meaning, for they see the world upside down. Thus, they feel pure, not in sexual abstinence, but in profound union; they believe that it takes courage to yield to sexual desire, and their longing for a child arises out of sensual love.

The Wife

Olympian Aphrodite, daughter of Zeus and Dione, was married to Hephaestos. The evolution of the myths which led Aphrodite to marry may have many meanings. It must be remembered that Aphrodite bore the title of "virgin," before the Catholic Church gave it a less pleasant significance. This term signified, not "she who has not known a man," but, as Esther Harding has remarked, "she who belongs to herself" (one in herself). One may understand her marriage as a loss of liberty, as in some feminist interpretations which point out that the change of status corresponded to the patriarchal spirit of the classical period. I believe it so, but it must be added that Aphrodite acquired a lover, Ares, at the same time.

This turn of events is quite in the Aphrodisiacal spirit of resistance to marriage, above all when the husband has been imposed and is, as was Hephaestos, a cripple.

Aphrodite's marriage may also be interpreted as a prescription for honoring sexuality and Aphrodisiacal pleasure within marriage, rather than as an oppressive patriarchal tendency. Young married women, or mature matrons who wanted to revive their husbands' ardor, all went to Aphrodite's temple. Perhaps we must give some nuance to our image of the Greek husband of the classical period, whom we have conceived as being a homosexual, attracted primarily to young boys, who married out of duty. In this regard, it is useful to read the description of another symposium and its Aphrodisiacal effect on the husbands. The mime invited for the banquet enacted the love of Ariadne and Dionysus:

> The two actors represented two lovers impatient to consume the love which had possessed them for a long time. Seeing them in close embrace, the single guests swore to get married soon, and those who were already married mounted their horses and galloped away to their wives, in order to enjoy them. . . . And thus the Banquet came to an end.[22]

Although Greek marriage may have been primarily a duty of citizenship for some, it was not such a sad reality for all couples. In all periods there are men and women who make love because of external pressure: the Greek could do so through civic duty, the Christian through conjugal duty, we today for hygienic reasons or to affirm our psychological normality.

Aphrodite is not a Goddess of marriage: that is Hera's domain. But the Goddesses may associate and cooperate in polytheism, just as the values which they personify may associate in a given personality. Aphrodite assures the reciprocal pleasure of spouses that keeps them together, and without her the marriage remains cold and sterile. Thus Aphrodite comes to the aid of the loving wife in a way that perfectly complements Hera (and Demeter): "Such a positive image of the physically passionate wife is totally absent from the majority of present world religions and normative systems."[23]

To have both a passionate relationship and a stable marriage is never easy. The frequent tensions between Hera and Aphrodite represent a conflict inherent in all marriages that last. A passionate

wife is, for the ancient Greeks as for modern men, a gift which provokes ambivalence, for Aphrodite is not easily contained, and the husband may well fear that such a wife may escape the conjugal bed, as a horse throws its rider. The reassuring wife who has the qualities of an industrious bee, nourishing, chaste, and humble, is an image that has nothing to do with Aphrodite. The men of Greece expressed, in many texts, their fear of associating Aphrodisiacal love with marriage. But on the feminine side, the cult of Aphrodite within marriage always had an important place. If Aphrodite gave rise to fear in husbands, this only signals the insistence of their wives in honoring the Goddess in the conjugal bed. Many myths relate the vengeance and anger of Aphrodite when her contribution to the conjugal union was ignored.

Christians, for their part, have resolved this problem between Aphrodite and Hera by choosing once and for all in favor of domestic and maternal virtues.

Infidelity and Lying

We may note how the Greek Gods and Goddesses differ from the Christian God in that they are not perfect; their divinity does not exclude the worst and most universal faults. Thus Hermes and Aphrodite have a moral attitude so different from our own that one would believe that lying, theft, and infidelity are excusable when inspired by Hermes or Aphrodite. In Christian morality, lying is a sin, whereas in the spirit of Hermes, the "fault" appears to be on the part of the one naive enough not to see that the other is lying. It is the same with theft; one must avoid being the person from whom something is stolen. Hermes, the divine thief, is the patron of robbers as well as of merchants, for sometimes robbery is justice, and sometimes the profit of a businessman is robbery. He is also the patron of diplomats, liars, and sophists, as if all three were in the same corporation; all are adept in arranging, keeping silent, or embellishing the truth, in order to preserve a relationship and to keep open the possibility of negotiations. One has to learn that the "whole truth" is not always to be revealed. And in this matter, Hermes, Aphrodite's friend, is an expert.

Lying bothers neither Aphrodite nor Hermes, for the truth which takes into account only objective facts or logical sequences, without allowing for subjectivity and the emotions, is never, at least in their world, more than a half-truth. It is difficult, for example, to get a "true" answer to the question: "Have you been faithful?" And so on. Hermes or Aphrodite will whisper that there are so many nuances to fidelity, so many complexities that a straight answer would not take into account. Finally their "yes" or "no" is always an interpretation of how you should feel and rarely a matter of fact.

Aphrodite is to fidelity and feminine deceit what Hermes is to commerce and masculine diplomacy. These divinities beloved of the people used ruses, lies, and seduction to contest and get around a dominant power, while avoiding a direct confrontation which would be to their disadvantage. Direct confrontations usually take place when weapons and partners are equal. Unless one is inhabited by a sense of honor greater than one's sense of survival, there is a certain good sense in utilizing the techniques of dissimulation and flight when faced with an adversary more powerful than oneself. Lying is a mode of flight, one of the ruses said to be "feminine" because it averts an unequal fight.

Honesty and respect for the truth are qualities which have full value in a context of equality. Without equality, the obligation to tell "the whole truth" fosters dominance and control, rather than justice and integrity. It is difficult for me to write such thoughts, for I was trained in the school of humanistic psychology and have appreciated the values of authenticity, coherence, and congruence. Though I continue to value these qualities, the myths of Hermes and Aphrodite seem to specify the psychological states in which these qualities may flourish and perhaps may help us avoid, in some relationships, too high an ideal, which may do more psychological harm than good. It is prudent, in the moral domain as in the economic, to avoid living psychologically "above one's means." For example, conjugal honesty, when it expresses confidence and esteem, is a state of "psychological transparency" that we all wish for ourselves. This confidence is an important part of love and intimacy with another person. We may even conceive of conjugal truth as being the "supreme luxury" or as a kind of "nobility" in a love relationship which is both equal and free. On the other hand, when the obligation to "tell all" is experienced by

one or the other of the partners as a kind of control, a psychological teleguide strictly determining a narrow territory of avowable behavior, the effect is the inverse: rather than deepening the relationship, it accentuates dependence and reciprocal constraint. At this point, Aphrodite or Hermes steals away or, as Friedrich says, "slip[s] through the interstices between the structures."[24]

The energies which flow from Aphrodite are as fluid as the water from which she was born. It is equally difficult to restrain water as it is to restrain Aphrodisiacal energy, for they both find their way through the least fissure, always seeking to flow freely, evading every obstacle, by every means.

When fidelity is a result of fear and restraint, it has no virtue and is all weakness. Inasmuch as sexual conduct is still judged by a "double standard" of sexual morality, the most absolute frankness is not necessarily an expression of self-respect but may reinforce, at least psychologically, the slave dependency of some women. Wherever it is more of a calamity for a woman than for a man to follow the inclinations of her own desire, Aphrodite seems to suggest that lying might be an escape from domination.

It is quite possible that, as long as women do not feel they have the right to both sexual liberty and respect, to marriage and economic independence, they will resort to lies and half-truths. If it must be so while we await better times, it is useful for them to feel Aphrodite's absolution and thus escape the Christian guilt which burdens sexual freedom so excessively. Women have remained, statistically and morally speaking, closer to the Christian ethic than have men. This is all to their honor, insofar as truth and honesty are among the highest of human qualities. But these virtues, like love, require reciprocity, without which they conspire in the victimization of the one who is honest.

One could speak at length on the subject of women and the sense of honor, following the train of thought so brilliantly initiated by Adrienne Rich.[25] If we define honor from the standpoint of masculine morality, however, it is easily concluded that women have no honor, for they must steal, lie, and cheat about liberties which are freely granted to men. Moreover, the sense of honor engenders a willingness to fight in its defense when threatened. Whatever the epoch or context, in any combat between two men of honor in which "fair play" is invoked, a preliminary phase in-

volves the choice of time, place, weapons, and the protocol of the fight so as to equalize the chances of the opponents. There are always a "neutral ground," witnesses, and a code to be respected. But it is Athena and not Aphrodite who goes to battle according to the masculine code and feels at home in it. Aphrodite does not wish an engagement in a territory where she has no advantage.

How many men break rank when confronted with the battle of love or the emotional joust? In these they would have to face a cunning woman, whom they must confront on her territory, in emotional arguments in which she is at ease, in matters where she can use her alliances with the children, the family, or friends. Aphrodite has a feminine code of honor which is proper to her, but this code of honor does not include telling the whole truth as it is generally understood. For Aphrodite and Hermes do not see a fault in the same way as we do: the shimmering multivalent levels of reality prevent them from expressing anything truly monovalent. All great lovers of women have ended by saying their affairs were all a lie or a mirage. Anyone who catches a glimpse of Aphrodite soon learns that she holds no promise of eternal love. Love gives itself as eternal and departs; that is part of Aphrodite's myth.

The "seven veils of women" and the dynamic of hysteria have always had to do with this problem of truth: how be faithful to the instincts, to the here and now, and yet remain predictable? How tell the truth about myself, when I am so submerged that I cannot say what is happening to me? Hermes and Aphrodite cannot accommodate themselves to a definition of truth which is in the realm of Apollo (logical truth) and of Zeus (ethics, social code, or justice).

Certain people lie as a psychological shelter from the scrutiny of others. As is well-known, lying gives rise to a kind of solitude and estrangement vis-à-vis those to whom one has lied, and it is just this solitude such persons seek. I am not speaking here of those for whom lying is a way of being, a permanent and pathological state which alienates one forever from any profound human relationship, but of a temporary lie, or of partial lies, which deflect attention from oneself for a time, in order to procure a respite and to find shelter before taking flight, engaging in a confrontation, or initiating a change.

Courage is often defined as the strength to speak the truth, as

one sees in Athene's courage in competition or in Hestia's rectitude
in notarial matters. But in the domain of sexuality, as in those of
diplomacy, oratory, or business, one may have to consider other
points of view.

Between a man and a woman, the necessity of "telling all," if it is
compulsive, may sometimes serve the infantile need to be dis-
charged from responsibility, to be pardoned for everything by a
partner seen as "mother" or "father." In this case, it is not the
lover's transparency which prompts the confession but the need to
kill within the egg any illegitimate desire which would afterwards
have to be confessed. At that point Aphrodite whispers lies, so that
sexual attraction, although illegitimate, may continue to filter be-
tween man and woman, despite the dominant moral organization.
Lies in this case have the same role as disobedience in fairy tales.
M.-L. von Franz has wisely observed how the fairy-tale heroine
often transgresses a "taboo" through disobedience, bringing about
terrible consequences; but her disobedience is also the act which
opens for her a higher level of consciousness after many trials and
sufferings.[26]

Let us add that it is the most natural thing in the world for
satisfied lovers to be faithful to one another, and without resent-
ment. True fidelity is not promised, it exists. It is often the ex-
cessive control that one would wish to exercise over Aphrodite
that fogs the transparency of the relationship. One must be pre-
pared to do without the benediction of papa, mama, and the Pope
when on the voyage of Aphrodisiacal discovery.

Lying is also at times a last resort in averting tragedy, and
Aphrodite, as much as Hermes, has more affinity with laughter
and frivolity than with the truth, if this truth must be somber and
tragic. We shall quote Homer,[27] who relates the adulterous love of
Aphrodite and Ares, to show how Hermes, through laughter,
comes to her rescue and saves a situation from tragedy. Notice
how he suggests that to sleep in the arms of golden Aphrodite is
well worth suffering the revenge of a wrathful husband. And as
one may expect, the Sun plays the role of informer. As to the ruse
of Hephaestos, who only pretends to be leaving for the
"weekend," this must be placed to account for his jealousy and, as
the husband, his right to exclusivity.

Demodocus struck his lyre and began a beguiling song about the loves of Ares and Aphrodite, how first they lay together secretly in the dwelling of Hephaestus. Ares had offered many gifts to the garlanded divinity and covered with shame the marriage bed of Lord Hephaestus. But the sun-god had seen them in their dalliance and hastened away to tell Hephaestus; to him the news was bitter as gall, and he made his way towards his smithy, brooding revenge. He laid the great anvil on its base and set himself to forge chains that could not be broken or torn asunder, being fashioned to bind the lovers fast. Such was the device that he made in his indignation against Ares, and having made it he went to the room where his bed lay; all round the bed-posts he dropped the chains, while others in plenty hung from the roof-beam, gossamer-light and invisible to the blessed gods themselves, so cunning had been the workmanship. When the snare round the bed was all complete, he made as if to depart to Lemnos, the pleasant-sited town, which he loved more than any place on earth. Ares, god of the golden reins, was no blind watcher. Once he had seen Hephaestus go, he himself approached the great craftsman's dwelling, pining for love of Cytherea. As for her, she had just returned from the palace of mighty Zeus her father, and was sitting down in the house as Ares entered it. He took her hand and spoke thus to her: "Come, my darling; let us go to bed and take our delight together. Hephaestus is no longer here; by now I think, he has made his way to Lemnos, to visit the uncouth-spoken Sintians." So he spoke, and sleep with him was a welcome thought to her. So they went to the bed and there lay down, but the cunning chains of crafty Hephaestus enveloped them, and they could neither raise their limbs nor shift them at all.

When all the Gods (but not the Goddesses who, "with the modesty of their sex, remained home") hasten in to witness the scandal and to render justice to the deceived husband, it is Hermes who saves the adulterous couple, through laughter:

Apollo: "Hermes, giver of blessings, messenger, son of Zeus, would you be content to be chained as fast, if then you could lie abed with golden Aphrodite?"
Hermes, the radiant messenger, replied: "O Lord Apollo of darting arrows, would that it might be so! Though desperate chains in thrice

that number were to enclose me round, though all you gods were to have full sight of me, and all the goddesses too, I would even then choose to lie with golden Aphrodite."

Neither Aphrodite nor Hermes can long support tragedy: flight, whispers, lying, and skill in dissimulating their fault with humor are all common ways of avoiding painful drama.

The association between love and lying has many facets. We know how deceptive is the voluptuousness of Aphrodite when she leads one to believe that she will remain forever. We suspect that the idealized image that lovers have of one another is close to being fraudulent. It is difficult, however, to accuse only the liars if the emotional message they are receiving is "Lie to me, for I cannot bear not being your only and greatest love."

Aphrodite, as Hermes, leaves the responsibility of truth to the one who listens. It is our responsibility to perceive that we are being flattered, or manipulated, or feared, or that the other is trying to escape. If we don't accurately perceive, we are guilty of a defective intuition.

CHAPTER FOUR

Should Aphrodite Be Disrobed?

Aphrodite possesses a magic garment which is often described either as a ribbon, a girdle, or a bodice; it is a band of fabric wound around her body, "a curiously embroidered girdle in which all her magic resides, Love and Desire and the sweet bewitching words that turn a wise man into a fool."

She will lend her magic garment, but the woman who borrows it must be well prepared to wear it. In the long quotation that follows, we can appreciate how Hera, preparing to seduce her husband, clothes and adorns herself before asking Aphrodite for the final touch, the magic garment which transmits to any personal quality an irresistible charm.

> Hera went in (her bedroom) and closed the polished doors behind her. She began by removing every stain from her comely body with ambrosia, and anointing herself with the delicious and imperishable olive-oil she uses. It was perfumed and had only to be stirred in the Palace of the Bronze Floor for its scent to spread through heaven and earth. With this she rubbed her lovely skin; then she combed her hair, and with her own hands plaited her shining locks and let them fall in their divine beauty from her immortal head. Next she put on a fragrant robe of delicate material that Athene with her skillful hands had made for her and lavishly embroidered. She fastened it over her breast with golden clasps and, at her waist, with a girdle from which a hundred tassels hung. In the pierced lobes of her ears she fixed two

ear-drops. She covered her head with a beautiful new headdress, which was as bright as the sun; and last of all, the Lady goddess bound a fine pair of sandals on her shimmering feet. Her toilet perfected, she left her room, beckoned Aphrodite away from the other gods and had a word with her in private:

"I wonder, dear child," she said, "whether you will do me a favor, or will refuse because you are annoyed with me for helping the Danaans while you are on the Trojans' side."

To this, Aphrodite, daughter of Zeus, replied:

"Here, Queen of Heaven and Daughter of mighty Cronos; tell me what is in your mind, and I shall gladly do what you ask of me, if I can and if it is not impossible". . . .

"Give me Love and Desire," she said, "the powers by which you yourself subdue mankind and gods alike."[1]

In this myth, it is important to notice how the wife who wishes to seduce her husband clothes herself, rather than undressing. Further, sovereign as she is, the powerful Hera knows she needs Aphrodite's touch, for without this, beautiful clothing is only beautiful clothing.

In Aphrodite we again find the dualism of nature and culture. Her allure preserves a superb equilibrium between the beauty of nature, manifest in her nudity, and that of culture, expressed by her talent in using all the resources of art to create still greater splendors. But this equilibrium is a constant dialectic between two poles, each as anti-Aphrodisiacal as the other. The one extreme is the craze for dresses, jewelry, perfumes, makeup, and so on, beneath which the personality disappears; the natural and the instinctual are eclipsed; there is no one but a mannequin behind the clothes. The real woman isn't there because her physical and emotional spontaneity have been fettered and supplanted by an aestheticism. At the other pole is the negation of aesthetic preparation, the crude nudity which aims at (and succeeds in) demythologizing sexuality. For example, when the young women of Sparta did their gymnastics in the nude, such display expressed, not a liberation with respect to prudish attitudes towards sex, but rather a tendency towards the militarization of women. De-feminized, de-eroticized, this Spartan nudity is closer to the athleticism of Artemis, the swift Goddess with the short tunic and the large, strong feet.

In Greek history, one finds indications of a debate: "Should Aphrodite be disrobed?" Up to the classical period, she was never represented in the nude, but was draped in a moist or clinging garment, so that no aspect of her form escaped the eye. At that time, she was designated as Aphrodite "of the beautiful eyes," whereas later, with her representation as nude, she was qualified as Aphrodite "of the beautiful backside" (Aphrodite *callipyge*). Have beautiful eyes more erotic power than beautiful buttocks? Only women of perfect proportions (and young girls) appear to advantage when displayed in the nude. On the beach, the nymphs first catch the eye, whereas in the intimate encounters of lovers, all the resources of the personality contribute their charm.

When the beautiful courtesan Phryne posed for her lover Praxiteles, who was sculpting the first nude statue of Aphrodite for the temple of Cnide, the event seems to have provoked a controversy: should one represent the Goddess naked? Aphrodite embodied all modes of feminine seduction, as much the married woman who wished to kindle her husband's desire as the courtesan of perfect lineaments, but only a courtesan could pose for a nude statue of the Goddess. From that time Aphrodite would appeal more and more to the eye. Certainly, when the genius of a Praxiteles is conjoined with the perfection of a Phryne, the power of seduction of the Goddess remained manifest. But perhaps the controversy in itself expressed a collective sense of danger, that of reducing the magic of Aphrodite to the perfection of body measurements.

Pornography or the Tchador

Since this controversy, we seem to have floundered endlessly between 'showing' and 'hiding'—at one extreme, pornography, which brutally commands the attention, and at the other, the tchador, the long black garment which conceals the Moslem woman from head to foot. As soon as the woman herself no longer controls what she will reveal and what conceal, the playful Aphrodisiacal creativity is no longer possible. Here, as elsewhere, playfulness and creativity are intimate.

She snatched away the plates and dishes, pulled off every stitch of clothing, untied her hair and tossed it into happy disorder with a shake of her head. There she stood, transformed into a living statue: the Love-goddess rising from the sea. The flushed hand with which she pretended to screen her mount of Venus showed that she was well aware of the resemblance; certainly it was not held there for modesty.[2]

When male power is no longer associated with its female counterpart and when only men legislate what is permitted and what is not, we have the tchador, or the high collar of the bigots, and pornographic display. These two poles express the two sides of the same repressive reality: the tchador leads as surely to pornography, when external censorship is relaxed, as pornographic decadence leads to a puritanical reaction when the client has tasted the despair hidden within it. Both belong to the same continuum, the same refusal of Aphrodite: the tchador, by withholding, and pornography by violent exhibitionism, as if to convince oneself that "there is nothing in it."

Through the tchador, the patriarch obviously seeks to confirm his status as exclusive master, mostly out of fear before the multiple powers of feminine seduction. The artfulness of women in seduction has always been and still is the stumbling-block of all patriarchy. By means of repression, the uneasy master seeks to neutralize the precious gem of Aphrodisiacal desire, the bearer of anarchy. But Aphrodite is astute, and even behind a veil or a sorry convent uniform, there still remains the gait, the odor, the bracelets, and above all, the eyes, which even from behind a tchador may flash forth their lightning. With all logic, one must proceed even to mutilation to end amorous disorder; from the tchador to clitoral excision, it is the same choice, the same male fear of Aphrodisiacal anarchy.

If the tchador is obviously repressive, the form that anti-Aphroditism takes in our own culture is more difficult to see. How, for example, does the picture of a woman, legs spread apart in a stupid position, convey a demythifying message: "all women are interchangeable, femininity is not so mysterious, and we give it to you to see and buy." This femininity reassures because it is so banal and so docilely submissive to the power of money. The bun-

nies must look young, empty, and uniform in appearance. The tactics of the multinationals of sex seem to render sexuality totally insignificant—whereas the tchador seeks to render it impracticable for any other than the husband—and in this they have been most successful.

Behind the tchador, one does not see the woman, nor does one see her in a display of buttocks, breasts, and sex which belongs to no one. This anti-Aphroditism might even be worse than the other, for there is no more ignorant man than the one who thinks he knows all about seduction, women, and pleasure. Such men, unconscious of their ignorance, confound Aphrodite with the Barbies, the Bunnies, the pin-ups, etc., with which the image-makers amass their money.

It is quite significant, in this regard, that the businessmen of sex, when they wanted to make one of the most expensive 'erotic' films in the history of cinema, should have chosen *Caligula*. The action takes place in the most decadent period of Western history, and this type of eroticism is in fact a decadent pornography. When the script treats politics, money, or power, we see real characters, each with an individuality, and only these parts of the script were assigned to talented writers. But as soon as it is a question of sex, one sees only de-personalized bodies, without real personalities. This movie is concerned, above all, with power-madness and with the kind of sexuality which inevitably accompanies such power-craving. The character of Caligula precisely illustrates the habitual contents of pornography: the sadism and scorn, misogyny and violence that form the framework of each sexual scene. If the money-makers have invested their millions in the myth of Caligula, it is to inspire the "playboy" who "possesses" his sportscar, penthouse, girls, and gadgets. Aphrodite is certainly absent from all of this, for her art is contrary to that of serialized love.

All eroticism which nourishes itself on pornography (whether of the expensive or cheap variety) already is decadent. If an alternative does not soon emerge, we shall see the other face of this scorn of Aphrodite: puritanism and repression, which will be all the more inevitable because the Mafia of sex is succeeding in dissimulating the real need for Aphrodite. The "new age" of sexuality should re-integrate all her aspects: her bodily qualities (one might say her "bio-energetic aspect") and her spiritual aspect. Aph-

rodite's myth expresses, without doubt, the corporeal and genital qualities exploited by pornography. Aphrodite does not disdain pleasing everyone and being popular.

But this insistence on the physical aspect of sexy Aphrodite should not cause us to forget that she is also the dove and the pearl; these attributes should not be separated from her more genital qualities. The white dove is a symbol of purity and a bearer of peace. The Greeks associated it with Aphrodite, and it symbolized, as did the many winged animals, the presence of the spirit, the "pure" spirit of Aphrodite. In removing the Holy Spirit (symbolized by the dove) from its link with woman and with the body, Christianity confirmed the de-sanctification of sexual pleasure. The dove, associated with the meeting of soul and body in joy and orgasmic ecstasy (the Aphrodisiacal connection), was associated by the Christians with the hour of death when the soul leaves the body. The dove, like Aphrodite, seeks companionship and social contact; this cooing and loving bird symbolizes both the social and the pacific aspects of the Goddess.

As for the pearl, it evokes something exclusive, hidden, and difficult to find, something precious, feminine, and perfect. Like the diamond, the pearl often symbolizes matter's spiritualization, a good image for the mystique of Aphrodite and her link with corporeal reality. For one who knows how to find pearls, their purity and whiteness are not tarnished by their enclosures in the coarse shell buried in sub-oceanic slime. To be sure, the pearl is hidden, and, as with all spiritual knowledge, its acquisition implies a deep plunge inwards and a disciplined attention. The apostle Matthew said, "Cast not thy pearls before swine." This goes too for Aphrodite's mystique; decadent orgy and sexual promiscuity have nothing to do with pure Aphrodisiacal mysteries.

Returning to our original question—"Should Aphrodite be disrobed?"—we find an answer in an increased personalization of art as well as of relationships. Insofar as clothing, jewelry, modes, and fads express the personality and are in consequence a means of deepening relationships, they act as a "charm" in the original sense of the word, and they are allied to Aphrodite. The myth of her girdle, and the fact that she is willing to lend it to Hera, for example, signifies that any woman may, if Aphrodite indwells her, wear clothing and jewels that will serve as an Aphroditic spell. But as soon as style and fashion serve primarily to communicate one's

position in a hierarchy, they are no longer effective in Aphrodite's realm. A flower, a ribbon in the hair, and a white mink coat may all have equal Aphrodisiacal power. But the mink coat more often expresses as well the husband's social importance, whereas the inexpensive flower and frivolous ribbon are related, not to the power of Zeus, but to that of Aphrodite.

In traditional cultures, codes of dress are extremely stable and precise. The regional costume, the headgear, the dress of mourning, of communion, marriage, and travel, and that for young girls and for married women—these communicate something precise with reference to the social order. Such traditions and the innumerable variations of costume which represented them have been replaced by an increasing uniformity of clothing. Throughout the civilized world, men wear suits and ties, and feminine fashion is more and more an international and standardized affair. In contrast with former times, most secular dress aims precisely at giving a minimum of information about the person wearing it; styles are conceived to be functional rather than significant and are, most of the time, work uniforms. That is all very well for work; one may wish that, at the office, clothes become even more simple, durable, and comfortable (which excludes neither harmony nor elegance), for work is not the field of Aphrodite but that of Athena (who wears a helmet and buckler). Moreover, if it is Aphrodite whom one wishes to honor, fantasy and voluptuousness should be added to, and go beyond, the exigencies of functionality.

> She was clothed in a robe more brilliant than gleaming fire
> and wore spiral bracelets and shining earrings,
> while round her tender neck there were beautiful necklaces,
> lovely, golden and of intricate design. Like the moon's
> was the radiance round her soft breasts, a wonder to the eye.[3]

The counterculture, in its most shining days, before it denied Aphrodite and returned to the conformity of blue jeans, expressed by clothing a joyous and playful charm. It was well in the spirit of the three Graces, followers and companions of Aphrodite: Joyous (Euphrosyne), Flowering (Thalia), and Brilliance (Aglea). On the one hand, they are responsible for weaving the Goddess's garments and of bathing, perfuming, and adorning her; on the other, by these means they bring grace, joy, and good humor to human

beings. By their gracious manners, they bring a certain sweetness
of life and attractiveness of speech, and prepare the advent of
Aphrodite.

I knew a woman, a peasant, who had never had means enough
to follow fashion or to purchase elegant clothing. Her figure, after
eight pregnancies, was not that of a young girl. But for what she
called the "special occasions," she brought out a fabulous mauve-
colored silk dress. Her sparkling eyes, gentle voice, expressive ges-
tures—the magic which made this woman so moving and so
beautiful was indeed Aphroditic. Her children, as do all children,
intuitively understood the nature of this transformation and spon-
taneously became for their mother what the Graces are to
Aphrodite. One could say that it was enough to announce that she
was going to wear *the mauve dress* for the whole ritual of house-
cleaning, lace tablecloth, bouquets, and so on to take place;
beauty seemed to unfold all through the house, as if Aphrodite her-
self were coming. This luxury has nothing to do with social class;
it is more a matter of opening oneself to the rituals of the Goddess.
To obey the "codes" of fashion and their hidden hierarchies is to
play the games of Zeus and Hera, not those of Aphrodite. This
pair is preoccupied with hierarchy and social order, while
Aphrodite wants to play, to dazzle and to seduce. To be with her,
we must have the audacity to emerge from the ordinary, to go be-
yond the norms of what are called standards of beauty.

Yielding to the tyranny of fashion often implies the acceptance
of another tyranny: that of norms of beauty for the feminine body.
These norms invert Aphrodite's spirit and diminish the number of
persons who perceive and feel themselves as beautiful. Many
thereby never discover their own loveliness. Rigid norms of beauty
require each woman to conform to models dictated by an anti-
Aphrodisiacal culture. Since fear of women is so widespread, the
models imposed are most often those of young, slender girls whose
femininity is less distilled. The way of Aphrodite proceeds in-
versely, tending to express beauty in a unique and audacious man-
ner, in a different way by each personality. Feminists in the past
ten years have considerably shaken the oppressive clichés, de-
nouncing the destruction of the personality that takes place when
girls and women conceive themselves as stereotypes rather than as
individuals, as if trying to correspond to what is 'selling best' on

the market of sexual objects. Constantly seeking, in men's reactions, confirmation of their beauty and therefore of their own value, they lose the feeling of their own identity.

This insecurity is a direct consequence of the loss of Aphrodite, who gives inner assurance of feminine beauty. As soon as feminine beauty loses its spiritual representation, when the Goddess who teaches beauty is excluded from divinity, women are enclosed within an infernal circle. Constantly proving that femininity is not unsightly, but no longer having the means of truly participating in beauty, they practice only absurd rites, which are doomed to failure in the same way as the spiritual life of one who mutters empty prayers or repeats meaningless gestures. Preoccupation with appearances becomes the equivalent of religious bigotry.

In the early days of feminism, opposition to alienating standards of fashion and beauty may have seemed a refusal of feminine beauty. To be a beautiful woman sometimes was a fulltime occupation, with the annoying characteristics of not only bringing no remuneration, but also of being fundamentally deceptive; it was a trap for women. To fight sexist stereotypes (women are beautiful but weak, men are strong and brutal), it is often necessary to adopt a posture radically opposed to these clichés, and, when one is a woman, to develop one's own aggressiveness, without asking if it is going to "look nice." Inversely, men had to re-discover gracefulness and emotional vulnerability. But the refusal of beauty, whether as a part of the Puritan credo or as a rigid reaction of the feminist movement, leads nowhere. I have met women who affect an almost studied ungracefulness to signify their distaste for female preoccupation with beauty. These attitudes show courage (and were probably necessary and useful), but one cannot be against beauty, nor against virile strength. One would have to deny the beauty of flowers, of babies, and of children, birds and landscapes. Grace and charm exercise an enormous influence when they are freely exercised.

The alienated woman, the luxurious doll denounced by feminism, drowns in her mirror, whereas the Aphroditic woman is mistress of one of the most potent magical powers of the universe, that of desire, pleasure, and seduction. The former seeks to please, whereas the latter induces others to please her, for her power is great:

[Artemis, Athena, and Hestia] These are the three
minds that she is unable to persuade, that
is, to seduce. But nobody else, none of the
blessed gods, no mortal man, no one else can
ever escape Aphrodite. She even leads astray
the mind of Zeus himself, the lover of lightning,
the greatest of all, the one who receives the
greatest honor.[4]

And truly, Zeus does not defend himself very much.

CHAPTER FIVE

Hyper-Masculinity and Hyper-Femininity

Aphrodite has many lovers, and each of these unions represents a different type of relationship. We shall see later how, with the couple Aphrodite–Adonis, the attraction of similarity is greater than that of difference, while the couple Aphrodite–Ares is a union of inverse polarities: war and peace, desire and aggression, fire and water, hyper-masculinity and hyper-femininity. The myth of Aphrodite, which opens a peaceful and perfumed world, pink and gold, brings in its train another mythological figure: the brutal Ares, God of combat, the hand-to-hand warrior of "bloody rage and carnage." We must ask why this encounter between Aphrodite and Ares should give birth to Harmony, daughter of War and Love.

This daughter should not be negatively defined as the "absence of war" nor positively as the "victory of love," but rather as the issue of a paradoxical equilibrium between the hyper-femininity of Aphrodite and the hyper-masculinity of Ares. In this paradoxical sense the Romans understood the *Pax Romana*, conceived mythically as relating to Venus and to Mars. More precisely, the Romans claimed to be descendants of Venus through Aeneus (her son by Anchises) who, after leaving the Trojan War, became the progenitor of the Roman people in Italy. They thought of themselves as sons of Ares, Romulus and Remus being his children. Their military training was tough, Ares-style, and their admiration for hand-to-hand combat, as well as for the "martial" arts (from

the word "Mars"), is well-known. The Roman peace, *Pax Romana,* which is not without resemblance to the *Pax Americana,* was the result of an imposed power: the smaller nations did not fight among themselves because a more powerful nation imposed peace upon them.

Caesar, the greatest Roman, expressed by his personality the courage of Ares. He also claimed to descend from Venus, and he had a very exceptional, seductive personality. His Roman Peace, a civilizing peace, was a sophisticated mixture of aggression and construction, conquest and influence, military deployment and cultural fusion with Greece. This peace was to be ruptured in the time of Roman decadence, when the cult of Ares, as well as that of Aphrodite, was pushed to extremes, to the neglect of other divinities. For example, bloody gladiatorial combats satisfied those who liked Ares, whereas debauchery and prostitution invaded the political scene. Aphrodite (Venus) was invoked where it would have been more suitable to call upon Athena (Minerva), and the virginity of Artemis (Diana) and Hestia (Vesta) no longer received the respect that was its due.

To the extent that we are Christians, it is difficult for us to conceive of this essential bond between Aphrodite and Ares: Greek wisdom, unlike Christian, implied that the one did not come without the other. In replacing the myth of Ares–Aphrodite with that of the perpetual peace of Christ, we have made taboo the belief that peace does not exclude aggression. The Christian utopia is so attractive that we cannot admit without anxiety that one cannot have Aphrodite without Ares, peace without combat, pleasure without suffering. Reality, however, constantly contradicts this ideal of Christian peace. The historian Sue Mansfield remarks how the Christian culture is simultaneously the most pacifist in its ideals and intentions, and among the most violent in its deeds. The first Christians, it is true, were averse to combat and were interested, above all, in the inner life and spiritual realm. But very soon one saw the evolution of this pacifist mentality. The "soldiers of Christ" quickly appeared as heroes avenging the sins of the world, and the righteous Christian battle against the forces of Evil justified all aggressions.

Must we see here a relationship of cause and effect? The suppression of the aggressive pole in the Christian myth, represented by the myth of Ares, occurred at the same time as the suppression

of the Aphrodisiacal-sexual pole. All schools of psychology seem to point out that repression of rage and anger (Ares) drives out also the pleasure, tenderness, and laughter of Aphrodite. Bio-energetics informs us that the same muscular complexes rule both laughter and orgasm, both hatred and love, both Ares and Aphrodite. In gestalt therapy, there are as many exercises for the expression of violence and aggressiveness (one might say, "to arouse Ares"), as there are for the liberation of sexual energy, perhaps because the same repressions apply to both. Bio-energetics and gestalt therapy recognize the bond between Aphrodite and Ares; working on the release of repressed aggression, one postulates that the ban on desire and sexuality will also be removed.

The warrior God to whom our generals now give homage is no longer the primitive Ares but the sophisticated Apollo. Whereas Arian violence is physical, aggressive proximity, Apollo's is cold and distant, a war game of money, science, and computers. This abstract violence is, in many circumstances, more cruel than the other, for it exceeds the field of battle and afflicts civilians also. Our real men of war are men of science and technology; it is Apollo, "who slays from afar," who dominates the military scene today and who does the killing.

Moreover, the number of rapes and delinquent aggressions is growing in all the world's large cities. This appears to be a symptom, not of the return of Ares, but of his negation. Repression of the physical expression of aggressive energies leads to a disordered explosion of violence. Ares is not Aphrodite's rapist but her lover. Neither with women nor with the elderly does Ares want to fight, but with real adversaries. Delinquent violence is absurd; it is not situated in any ritualized context. This violence is not abstract but anonymous. The delinquent strikes for the sake of striking; he rapes a woman because he does not know what love is. This violence is a revolt against a world in which the physical, aggressive energy has no outlet, a world which has been deserted as much by Ares as by Aphrodite. The violent delinquent usually has the opportunity neither to fight with male adversaries nor to know a loving woman. Absurd and impersonal, his violence is a sign of anomie, and neither Ares nor Apollo inhabits it.

Let us return to the association between Ares and Aphrodite. If Aphrodite does not come without Ares, then logically the more sensuous society will be at the same time the more physically ag-

gressive. Sue Mansfield adapted the principles of gestalt psychology to the realities of war in her interpretation of military history. She agrees with Fritz Perls that the central repression of our epoch is that of aggression, rather than that of sexuality, and she underlines the danger of an eruption of collective rage and helplessness which urges war, a fantasy of "ultimate therapy," where destructive energy would have, at last, an outlet. For our own security, we must be more conscious of our myths of war and should utilize the forces of destruction before they give rise to what Mansfield calls a "military mega-tantrum":

> It is strange, but nations that pride themselves on their secular rationality, objective efficiency and progress have nonetheless been incapable of thinking in a reasoned fashion when it came to warfare. We are as ritualistic as the primitives, but we don't have our rituals passed down. Primitives allowed the world and the tribe to continue. Whereas we have lost all of the rules of constraint. Since we haven't been willing to look at the irrational element in our myth of war, it has gotten out of hand.[1]

Ares and Courage

Ares is not an engaging personality; even Zeus is repelled by his bellicose character. If he manages to seduce Aphrodite, it is because he possesses courage, a quality that has been associated with virility for as long as beauty has been connected with femininity. As the feminist should recognize the strength of women without depriving them of beauty, it is important, with the figure of Ares, not to eliminate courage from the list of positive virile qualities. Ares, even with his brutality and his typically masculine strength, remains a divine figure. To forget his courage and retain only his brutality represents the same decadence that has made of the divine Aphrodite a "beautiful but dumb" personification of beauty.

Aphrodite, Dionysus and Ares are 'hot-tempered' divinities. Self-control, that same control which Apollo and Athena exercise, contrasts with the impetuosity of Ares who very quickly boils over and explodes in fury. These three passionate divinities intervene by

directing us from within and provoking an emotion. The rage of Ares, the desire of Aphrodite, and the madness of Dionysus have in common taking possession of the heart and body at a high point of intensity. In the *Iliad* (1.10), Homer describes a possession by Ares: ". . . a somber fury boiled in his breast, his eyes were like flashing fire, with sparks. . . ." If, in this description, we replace "somber fury" with its opposite, "flashing desire," we should see that the text thus modified could describe a possession by Aphrodite. As to the phrase describing the fury of Ares, "whose soul was filled to drowning with darkness," one could invert it to its Aphrodisiacal opposite—"The desire which fills the soul bathed in light"—thus describing the contraries that unite Aphrodite and Ares.

One who is possessed by Ares uses the trembling of fear to find the courage to fight. This "fire from heaven" is a going beyond oneself which leads to the capacity to endure pain or even not to feel it. A dose of this energy is necessary so that physical pain, taken in its larger sense (cold, heat, rain, wounds, etc.), does not prevent us from taking risks of all kinds. Those who are too soft can know neither the fire from Ares nor that of Aphrodite. Endurance aids us in not declaring ourselves vanquished too soon. When one reads the ancient texts and the abundance of details concerning the capacity of the combatants to support pain, one understands at the same time to what extent the grace of Ares is today a rare blessing. Pain being inevitable, one might as well learn to endure it with courage, that is, to learn to know Ares.

Courage, like the sense of beauty and eroticism, is a human quality. There are acts of courage seen in humans of which animals would be incapable. If, through concern for the equilibrium between masculine and feminine personalities, feminism has tried to teach girls to refrain from tears, this should not hinder us from appreciating Ares' qualities in men and boys. Otherwise, a reversal of stereotypes would give us a society of matrons and "Mignons," and the polarity between men and women would be emptied of sexual attraction.

Love and Fight

> "Now fight," she challenged me. "And you must
> fight hard, because I shall not retreat one inch,
> nor turn my back on you. Come on face to face if
> you're a man, strike home, do your very worst!
> Take me by storm, kill me, and die in the breach.
> No quarter given or accepted."
>
> Apuleius, *The Golden Ass*

This exhortation is not that of one warrior to another; it is that of a young girl to her lover, before getting into bed to take the pleasures of Aphrodite. No great experience of life is necessary to recognize that love is a battlefield; the wounds from it are cruel and injuries many, and happy are the survivors who have preserved intact their capacity to love. The illegitimate love between Ares and Aphrodite gave birth not only to sweet Harmony but also to two boys: Fear (Phobos) and Terror (Deimos). They are currently associated with their father and the emotions felt on the battlefield, but these emotions resemble some sent us by Aphrodite, since the fear of loving is as widespread as that of fighting. One who has never felt fear and terror when in love does not know the whole range of Aphrodite's power nor what it is to risk one's affective life. If we consider the sexual encounter as a fight, it seems more "normal" to feel fear in love. And to recognize this fear without guilt is at the same time the first hint to find the courage of love. The actual widespread attitude of keeping "cool" and detached as regards sexuality is, most of the time, a way of denying fear, as if the whole matter were banal and without risk.

The God of combat and the Goddess of love thus come together in the most physical aspects of courage: Ares and Aphrodite both have this generosity of the body, without which there would be neither sexual fusion nor aggressive physical opposition. It is this vigor which the young Photis wished to arouse in her lover by calling him to "amorous combat."

The fire of Ares and the glory of Aphrodite are both beyond fear, but contain it.

Men, War, and Women

Aphrodite, who never fights directly, is nevertheless at the origin of the Trojan War. Even if she does not fight her own battles, she quickly involves the men around her in combat.

The marriage of the Goddess Thetis with the mortal Peleus was a celebration to which all the Goddesses were invited except one: Eris, whose name signifies Discord and Strife. Shocked by this affront, she came just the same and cast before the guests a golden apple, whence the expression "apple of discord." On it were inscribed the words "For the Fairest." Immediately, discord arose among Hera, Athena, and Aphrodite. Zeus, in his role of judge, decided to appeal to the judgment of a mortal and chose for this the handsome Paris, a young shepherd of Mount Ida. Hermes went to find him and brought him to the wedding ceremonies. Hera tempted him, offering him power; Athena offered him glory from victory in all his battles; and Aphrodite offered him the hand of Helen of Sparta, so beautiful that she was said to be a reminder of the divinity herself. Seduced by the opportunity of having the love of Helen, rather than by those of power or glory, Paris awarded the golden apple to Aphrodite. Keeping her promise, the Goddess then helped him to conquer the heart of beautiful Helen and to take her from Menelaus, King of Sparta. Aphrodite's responsibility in unleashing the war of Troy is therefore central: it was by offering the pleasures of which she is mistress that she provoked the long series of conflicts, which are the same as the conflicts she provokes within each personality when love and pleasure compete with power and glory.

The bond between Aphrodite and Ares, among its many significations, expresses the belief, deeply rooted amongst the Greeks that, men fight for women and that the origin of war is fundamentally a rivalry for them. The most illustrious example is obviously the *Iliad*. This belief was so strong among Greeks that even Herodotus, the first historian who made an effort to be scientific, felt obliged to explain that 'perhaps' there was a rivalry for women in the origins of the Trojan War. He recounts many other stories of rapture (of Europa, for example, and Io) which were believed to

have brought about the greatest of the wars between Europe and Asia. Each rapture marks a progression in the hostilities which eventuate in war. Thucydides, who interprets war from a basis of economic and political causes, also reports the opinion that competition for Helen provoked the Trojan War.

One might argue that the rapture of women, in a society in which wives were scarce, had an economic and survival meaning that it no longer has today. Moreover, Helen was not only the most beautiful of women, she was also rich and powerful, and the man who wed her would become king and reign over her possessions, which were considerable:

> Representing the two sides, you will fight a duel, and we shall have Helen and all her possessions as forfeit in the combat. The victor will have the right to the spoils, and to patriate his wife with her property.[2]

Desirable Helen was the daughter of the King Tyndarus, who then reigned over Sparta. In this period, a woman preserved her right to her dowry all her life, and if the union was broken, the husband was obliged to return the dowry. In the case of a princess who, like Helen, inherited her father's lands, this law made of her marriage to Menelaus a matrilocal type of union. Therefore, when Menelaus lost Helen he also lost the right to reign over the lands that had come to him through his wife.

The historian Sarah Pomeroy leads us to believe that, for Menelaus, the desire to reign over Helen's holdings was more determinant than his passion for her.[3] Pomeroy reminds us that, in the context of archaic Greece, sovereignty could still be transmitted through women and that this social and economic power has nothing to do with Aphrodite. Nevertheless, to give exclusive privilege to the economic and political explanation would be to diminish the power of Aphrodite's own myth, which in the Homeric account is determinant. It seems to transform a love and power story into a tale exclusively about power. Had Helen been an ugly duckling, completely without Aphroditic charms, we may doubt if the Trojan War would have taken place.

In her work on the origins of World War I, Barbara Tuchman stresses the fact that, when the German soldiers left for the front, their songs, fantasies, and humor seemed to reveal as a principal

motivation the desire to reach Paris to "have a taste of the little French woman."[4] The French, at least in this period, still presented the image of a sensuous nation, giving much importance to good food, wine, and love affairs; in a word, they were fervent adherents of Aphrodite and Dionysus. The role of rape and prostitution in war is very great and counts among the most ancient and entrenched of gratifications granted to the soldiers. Among the Greeks, even the most noble heroes did not disdain this sort of "war trophy." In France during the occupation, despite the efforts of the Resistance, the Germans as winners took every opportunity to enjoy the French women.

But the archetypes of hyper-masculine Ares, the brutal and virile warrior, and hyper-feminine Aphrodite, the beautiful and feminine Goddess, should not give rise to an exclusive identification for, like all the archetypes, these two constitute only a part of psychic reality.

This limitation leads us to examine quite another configuration, which unites Aphrodite, no longer to the hyper-male warrior, but to the gentle Adonis, her young, delicate, and sensitive lover.

From Ares to Adonis

Passing from Ares to Adonis is a bit like passing from the virility of the cowboy to that of a gracious and emotional Valentino. If it is plausible that women are attracted (especially in the movies) by heroes and warriors who make love with their boots on, it is equally true that they tend to complement this somewhat aggressive virility with other, more tender male figures. The impressive procession of one-hundred thousand women who, at the death of the romantic actor Valentino in 1926, came to participate in the last rites provoked a shedding of feminine tears which strangely resembled the ancient rites of Adonis. This emergence of Adonis in a place and period where stereotypes of the virile warrior were very well-anchored suggests a persistent need to compensate the force and brutality of Ares by the sweetness of the romantic young lover. A young lover is to the mature woman somewhat as the pre-adolescent boy was to his protector in Greek times: one

who is seductive by reason of his youth and innocence and who behaves at times as a lover, and at times as a tender child who requires being protected and cajoled.

Plutarch considers Adonis to have none of the qualities of a husband and scarcely recognizes in him a quality of virility. He remarks upon the obvious: this cult of an effeminate God takes place only among women. In Athens, in the middle of the dog-days, the women sowed the seeds of flowers which germinated rapidly in a thin layer of soil placed in a shallow plate of terracotta. These tiny gardens, called the "gardens of Adonis," were then set out in full sunlight between earth and sky, that is, upon the roofs of the houses. The flowers grew quickly, and since there was much sun and little soil, they faded just as fast. In eight days, the whole cycle was over: the young sprouts had germinated, flowered, and withered. In such conditions there was no new generation to replace the wilted plants, and the culture was a sterile one. After the rituals of Adonis, the faded flowers were thrown into a fountain or into the sea, as if to signify that this ephemeral episode was over though the waters of life continued to flow.

In these small, sterile gardens we may easily see a symbol of all that is ephemeral, without roots and without consequence. These flowers, like Adonis who was carried away by death before reaching manhood, never attained maturity, as if the whole meaning of their existence was exhausted before they reached the age of reproduction.

As with young lovers, whom a woman should not dream of turning into responsible husbands and fathers, Adonis has nothing to do with marriage. His mythic territory is rather that of illicit loves and summer romances which cannot pass the test of time and the responsibilities of family life. The myth also suggests that the romantic lover, despite the sexual powers characteristic of his young vitality, does not have the psychological maturity to match such a lovely flowering of sensuality. This kind of relationship cannot grow in depth, it cannot "take root," and it is for that reason ephemeral. However flamboyant a romance may be, a real relationship cannot be tested in the sunshine days of summer vacations. Gardens in which the earth is reborn rich and fertile despite winter, as relationships in which love is reborn rich and fertile despite difficulties, are not the domain of Adonis–Aphrodite. Demeter, more than any other, knows the secrets of the dark,

nourishing earth, of the turn of the seasons, and of slow, protected growth. But to know of this archetype, one has to leave Adonis and Aphrodite.

Adonis dies while he is still very much a youth; he is killed by a furious wild boar or, according to one variant, by a bear. His death may be interpreted as the failure of gracious Adonis when confronted with forces which are brutal, savage, and powerful. The gentleness of young Adonis still does not make of him a competent hunter, and lacking the power to fight for himself, he is killed by a brutal beast. The Adonis-type of man survives as long as he is "protected" by stronger women, but in a male competitive world he is too vulnerable. Greek women associated beautiful Adonis with the charm of flowers and of scented plants (such as the myrrh). But in the masculine view he was associated with lettuce, a plant that for the Greeks symbolized impotence and insignificance. His graciousness is pleasing to women, but men consider it worthless.

As with all young men who seek a mistress who is at the same time a maternal figure, Adonis "dies young"; that is, this kind of relationship does not mature well. Adonis in many ways resembles the son-lover of the Mother Goddess; both are destined to be separated from the mother-lover or the mother-queen.

In the festival of Adonis, tears had as much place as joyful celebration. The fact that women celebrated Adonis mostly with tears should be set beside another reality: women have less fear of love than do men. Considering the myth of Aphrodite and Adonis, and considering that all love contains pain, just as presence contains absence, one could think that women fear love less because they have tears as a way of assuaging the sufferings of love. Without a sort of ritual to Adonis, we are alone with our frozen tears, fearful of taking new risks. The death of Adonis reminds us that, from the moment we fall in love, we fear losing the other, or at least losing his affection or his presence. The Adonis festival mingles the pain of love and the consolation of return and literally suggests that it is worthwhile to love, even if the lover will sooner or later leave. To let go, in tears, the hardened pain of love is important, for if Adonis has not been wept for and buried, how could he be re-born?

CHAPTER SIX

Who Shoots the Arrows: Eros or Aphrodite?

> Some humanism has carried its feeling deeper to
> the centrality of love, finding there the meeting
> point of man and soul. But what sort of love is
> meant? Here the archetypal psychologist tries to
> distinguish among love's many patterns. Eros,
> Jesus, Aphrodite, Magna Mater—just who has
> sent the Valentine? No doubt that love is divine,
> but just which divinity is governing its course?
> James Hillman, *Re-Visioning Psychology*

It would take long to summarize the numerous interpretations of
the myth of Eros. A critique of the use of the name "Eros"—and its
derivatives in Freudian psychology: eroticism, the erogenous
zones, the erotic qualities, etc.—would be a considerable task in
itself. In the context of this book, to do so would wrongly inscribe
Eros as a central theme. Our intention in this chapter is to ask the
following questions: why speak of Eros when Aphrodite is con-
cerned? Why have we masculinized the divine figure of Love? Why
did Freud ignore Aphrodite to Eros's benefit? Shall we relate his
preference for the myth of Eros over that of Aphrodite to his
declaration that the "libido is male"? And if the libido is male in a
psychology dominated by the myth of Eros, would the inverse
reasoning be correct? That is, in a psychology in which Aphrodite
regained her true role, would sexual energy become feminine
again? And finally, is it not a little outrageous that love relation-
ships, to which women devote so much of their skills—as if love

were, with motherhood, their only specialty—should remain under the patronage of a male God, and this even in the most contemporary of psychological theories?

In Greek literature, the myth of Eros is confusing, the figure of the God difficult to discern, while Aphrodite's myth is clear and her cult well-described. Since there are so many figures and significations of Eros, one may wonder why Freud retained him rather than Aphrodite. We do not know much about the primordial Eros, in contrast to the abundance of symbols and myths which give power to Aphrodite in the domain of "sweet desire." Moreover, we must not forget what "erotic love" meant to most philosophers and must ask ourselves if this is truly the heritage we wish to transmit. And finally, we shall look at the trio formed by Psyche, Eros, and Aphrodite. This overview will be partial and incomplete, because it is primarily a matter of asking the questions and arousing doubt concerning the preponderance of Eros over Aphrodite.

The Primordial Eros

The primordial Eros, to whom Freud refers when opposing him to Thanatos, personifies a principle of attraction. The primordial Eros does not appear in Homer, but Hesiod, in his *Theogony*, presents him as a God of the first generation of immortals. However, Hesiod does not make of Eros a divinity whose personality is well-defined: only Gaia is clearly identified as a primordial Goddess, and it is really she who appears as the great divinity of the primitive Greeks. Homer seems to confirm the predominance of Gaia when he presents her as the most ancient of the divinities: "I shall sing of well-formed Earth, Mother of all, who nourishes all things living on the land" (*Homeric Hymn* to Gaia). Let us return to Hesiod and his brief description of Eros. He presents him immediately after Chaos, in these words:

Chaos was first of all, but next appeared broad-bosomed Earth, sure standing-place for all the gods who live on snowy Olympus' peak

and misty Tartarus, in a recess of broad-pathed earth, and Love, most beautiful of all the deathless gods. He makes men weak, he overpowers the clever mind, and tames the spirit in the breasts of men and gods.[1]

That is all Hesiod says of Eros, and when he refers to him a second time, Eros is part of Aphrodite's cortege. Moreover, the first generation of Gods was produced without Eros's participation: Chaos gave birth to Night, who in turn gave birth to the Light of day and to Ether, while Earth "without the aid of the tender Eros" brought forth the Sky (Ouranos), the mountains, and the nymphs. Eros was responsible for one important mating: that of Earth and Sky, a mother–son couple, but this union was a most destructive embrace. The Sky covered the Earth so tightly and left so little room for distance that this bond, the work of Eros, had to be destroyed. The enormous Earth "suffocated and trembled within her depths" on being entirely covered by Sky, who did not allow the children to whom she gave birth to "rise up into the light."

Gaia succeeded in bringing one of her children, Cronos, into the light. With the help of his mother, Cronos severed his father's genitals, re-establishing a distance between Sky and Earth. Aphrodite, as we know, was born of this act, from the sperm cast into the sea when Ouranos's sexual organs were severed. Following upon this, all procreative acts were inspired by her.

The idea of primordial Eros is scarcely developed in Hesiod and gives way in the majority of Greek myths to the power of Aphrodite, who has command over her son. Eros is not, in most traditions, an ancient and primordial God but a young one, submissive to his mother's power. It is Eros who shoots the arrow, but it is Aphrodite who designates the target:

> Aphrodite, with a flash of your power you caress the hard minds of humans and gods as Desire in his bright imperial plumage overwhelms them with huge wings. On your radiant golden sorties, cruising inland or riding the loud salt sea, swift Eros, you inflict your crazy times on the pulsating hearts of us all. Queen of everything you alone hold absolute power.[2]

Moreover, whereas Aphrodite represented the universal principle of sexual attraction, the young Eros seemed to "specialize" in

two types of relationships: those uniting Gods and mortals, and love relationships between males.

The paternity of Eros has been most often attributed to Ares, but he has also been called the son of Hermes, of Hephaestos, or of Zeus. Sometimes he is simply called the "son of Aphrodite," without mention of a father.

The Eros of the Philosophers

The philosophers of classical Greece were an intellectual elite who honored principally Apollo and Eros and, preparing the way for monotheism, disdained more and more the popular Gods and Goddesses. Hermes, Dionysus, and Aphrodite were still favorites of slaves and women, while Eros, the darling of the philosophers, represented more and more the love which unites the pederast and the pre-adolescent boy. What we call "Greek love" was Eros's territory. The Platonic philosophers seemed to equate, on the one hand, bodily love, heterosexual love, the preference of Aphrodite to Eros, and being of low birth, and, on the other, homosexual love, lived within the head and heart rather than through the body, and being of a higher level of consciousness. They made a distinction between the celestial Aphrodite born of Ouranos—insisting on the fact that, having had no mother, she did not participate in the female as much and was, therefore, of a "higher" nature—and Aphrodite Pendemos (which means "popular," "she who is loved by those of little worth"), who was said to be born of a mother, Dione. Whereas Aphrodite personified the union of man and woman, linking spiritual love to its carnal reality, the erotic love of the philosophers became further and further removed from the body, its ultimate success being precisely in removing itself as far as possible from the senses, the body, and woman. This tendency prepared the way for the anti-Aphrodisiacal monotheism of the Christian theologians as much as for a Freudian psychology, which retained from our Greek heritage the myth of Eros rather than that of Aphrodite to designate the mysteries of attraction between men and women.

The questions of the two Erotes—the primordial Eros, principle

of love and attraction, and the juvenile Eros, son of Aphrodite—is far from being clear. Each of the guests of Plato's *Symposium* who eulogizes Eros presents of him a different image: for one, he is the most ancient of the Gods; for another, he is the youngest; for some guests, he is a God born of Aphrodite; and for others he is not a God but a beneficent daimon. And that is without all the variations given by the Orphic theology in which Eros receives other names, other origins, and other functions, including those of Aphrodite.

In the *Symposium*, besides the contrast between the primordial and juvenile Erotes, there are five different ways of conceiving him and one invariable feature: love between males is considered morally, philosophically, politically, and aesthetically superior to that which unites man and woman. The justification of this judgment would be that "erotic" love, reserved for young boys, produced noble ideas, military courage, political action, and happiness, while Aphrodisiacal love between men and women, apart from producing sons, was more of a duty. Lowest of all came love between women, of which one did not speak. In the eyes of the *Symposium* philosophers, this kind of love produced nothing—no geniture, no politics, and no philosophy—and was therefore insignificant. The spirits of Sappho and Aphrodite did not inspire this banquet nor these philosophers. This kind of misogyny is found unaltered in the Church or in any organization where "important" things seem to take place between men only. In the Greek classical period, intellectual ebullience took place in the realms of philosophy, politics, and war, wherein men felt their importance the most. If one considers their importance from the perspective of history, one must admit that this perception was quite right. However, no one can prove once and for all what part of the Greek miracle came from the rigorous mind of its most illustrious men and what part from its variegated culture, including its mixed pantheon, its matriarchal past, and its multiplicity of cross-cultural influences.

Philosophy today has lost its glory to the benefit of science and technology. As to the warriors, they fight in the fields of high finance and technology, but the spirit that rules is the same. The lance and shield have been replaced by the attaché case and the computer, and the armor by the suit and tie. In these sanctuaries, in which only men have "real" importance, it is easy to detect the

belief that the world of women is trivial. Many of these men, although not physically homosexual, are psychologically so, because for them the strong feelings of male companionship have replaced Aphrodite.

In fact, any professional in an organization whose activity is extremely intense will naturally tend to consider everything else, by comparison, as unimportant or marginal. Many of those who, right or wrong, have the impression of being at the core of action, of doing "really important" business, or of fashioning the destiny of peoples by their decisions develop a vision of the world in which anything that does not touch the great work is perceived as peripheral, banal. If, moreover, as was the case with the philosophers of classical Greece and as is now the case in the fields of politics, big business, and new technologies, the world of such a man is insulated against women, he readily thinks of them as insignificant because they do not participate in what he considers to be *the* most exciting thing. Devoting himself entirely to an organization where, as a rule, women are subordinate, he will emotionally, if not sexually, turn to male companions for affection between equals. Eros has then taken the place of Aphrodite.

A similar disequilibrium may be found in an exclusively feminine world: women who have never "gone out" of a traditionally feminine world have blinders just as thick. Nothing and no one has importance except home and children, and when a male intervenes in such an exclusively feminine territory, he risks being treated as a child, an incompetent adult, or an unavoidable commodity.

Such a competition between men and women to exclude the other sex from their own territory may take several forms. One may caricature the most current attitudes and classify them by four clichés:

1) Men do really important things, and women are the equivalent of a logistical battalion in an army (the soldiers whose functions are to nourish, lodge, obtain provisions for, and transport the combatants). Women are marginal to the real meaning of existence. This is the world of Apollo and the Greek Eros.

2) Women are the foremost sex, the most beautiful, the most perfect. Femininity is the Life, the Truth, and the Way, and all true values remain with femininity. This is the world of the Great Mother, matriarchal monotheism.

3) The masculine and feminine universes are in constant attraction and repulsion, interdependent and organically linked. We are here in the world of Aphrodite, Hermes, and, in general, of Greek polytheism: constant negotiations, many rivalries, but also great intensity of life.

4) The two universes are equally insignificant.

In these four attitudes, all equally caricatures, we recognize successively that of the Greek philosophers; that of the necessary reaction of "female is beautiful"; that of ecology; and, finally, the more contemporary attitude of leveling to the base, which one may interpret either cynically or in a humble and humorous way. For Aphrodite to be present, there must be as much strength at the feminine pole as at the masculine, and an attraction between the two. In fact, Aphrodite personifies this principle of attraction between the masculine and the feminine. If the separation of the feminine world from the masculine is so firm as no longer to promote the attraction of equal but opposite forces, Aphrodite can no longer intervene.

I give no further attention to the Eros of the philosophers, because he has already usurped a place that does not belong to him. But as a son of Aphrodite, his participation in the trio of Aphrodite, Eros and Psyche may enlighten us on the relationship between mother and son, mother-in-law and daughter-in-law.

Aphrodite, Eros, and Psyche

> She kissed him long and tenderly and then went to
> the nearby sea-shore.
> Apuleius, *The Golden Ass*

The destructiveness of incest in the myth of Oedipus is a great favorite of psychology. But the same myth is certainly less adequate to account for the whole scale of more or less incestuous flirtation between mother and son when the father is not a central figure.

The attachment of parent–child arouses, as is well-known, feelings whose intensity is as great and often greater than that of passionate love between adults. But as much variation obtains in the

parent–child couple as in conjugal couples. Many myths, many Goddesses, and many Gods typify the different aspects of the parent–child relationship. Thus Hermes is playful but irresponsible; Zeus is responsible but authoritative; and Demeter's relationship with Persephone has a different quality than that between Eros and Aphrodite. Let us look here at the relationship that a seductive woman (an "Aphrodite-woman") maintains with her son. As we have seen, Aphrodite is not primarily a maternal Goddess. Furthermore, since her myth concerns sexuality between men and women, the relationship with her son risks being far too much in terms of a male–female relationship, the mother remaining always a Goddess of femininity whom no other woman may dethrone. The challenge imposed upon the son is then considerable and dangerous.

The story of Eros and Psyche has been considered from many points of view. I particularly like the interpretations of M.-L. von Franz[3] and Neumann.[4] To avoid repetition, I shall look at this myth from another point of view: that of the possessive, seductive and controlling mother of a son, who is also a threatening and jealous mother-in-law.

Most summaries of the myth of Eros and Psyche skip over Aphrodite's role. Because it is just this point which interests us, I shall choose from Apuleius's tale[5] several elements illustrating her feelings and behavior: "So my excellent lad has already taken a mistress, has he? Here gull, you seem to be the only creature left with any true affection for me, tell me, do you know the name of the creature who has seduced my poor simple boy?"

This description of Eros as a naive and innocent boy astonishes, for this same boy is described elsewhere in completely different terms:

> She at once called her winged son Eros, alias Cupid, that very wicked boy, with neither manners nor respect for the decencies, who spends his time running from building to building all night long with his torch and his arrow, breaking up respectable homes.

But why does Aphrodite bear such malice towards Psyche? "Rivalry between women," one would say right away, because Psyche's exceptional beauty threatens Aphrodite's supremacy. This

interpretation, at once both true and self-evident, should not, however, prevent us from seeing that Psyche, from the moment she becomes Eros's lover, is no longer just any beautiful mortal but Aphrodite's daughter-in-law. Aphrodite's reaction then resembles the unconscious reactions of a seductive mother who sees her son prefer another to herself. When a woman has always been the most beautiful, the most important person for her son, it is plausible that she feels towards her daughter-in-law as Aphrodite did towards Psyche. And the more a woman experiences this event as a woman supplanted by another, rather than as mother of a son who wants to fly with his own wings, the more this myth describes the psychological conflict: "What! With her, of all women? With Psyche, the usurper of my beauty, the rival of my glory? This is worse and worse."

The component of seduction, in a relationship between mother and male child, is stronger for women who have preserved, along with their identity as mother, an Aphrodisiacal nature to which a sensitive son does not remain cold. The seduction of the son has been studied in psychology, generally from the aspect of the damage done to his psyche, in the implicit but justifiable belief that it is dangerous for a mother to be seductive towards her son. Some psychologists do not embarrass themselves with nuances and conclude squarely that it is dangerous to be seductive, as if they themselves could assume no other posture than that of the son threatened by an Aphrodisiacal maternal power.

But the myth of Aphrodite–Eros–Psyche throws light not so much on the life of the son as on that of the mother and the daughter-in-law. It suggests both the danger for the latter and a possible resolution of this triangular conflict, via the relationship of the two women, which becomes the way of initiation for Psyche.

Eros–Aphrodite–Psyche are a trio, two women and one man: the mother, the daughter-in-law and the son. Aphrodite's conduct with regard to her own son offends those who believe that a good mother should refrain from any seductiveness towards her son, should never threaten to withdraw her love, nor allow him to feel her sovereign femininity, as Aphrodite does:

> Please understand that I'm quite capable of having another son, if I please, and a far better one than you, and quite prepared to

disinherit you in his favor. However, to make you feel the disgrace still more keenly, I think I'll legally adopt the son of one of my slaves and hand over to him your wings, torch, bow and arrows, which you have been using in ways for which I never intended them.

There it is, completely in the open—the jealousy and the threat, the spite and the effort to regain control over this son who no longer obeys and who loves another, a rival.

At this point of the conflict, there is reason to be disquieted. If the mother indeed wins out, her son will remain a little angel with chubby cheeks all his life, doing errands for his mother. If, on the other hand, the son definitively breaks with his mother and leaves her to her bitterness, he risks developing a paralyzing fear of women, for the more they are Aphrodisiacal, the more dangerous they will seem to him. To protect himself, he will have to remain aloof, or choose the young and the inferior, or break off as soon as sexual tension begins to rise. This finale would resolve nothing because the youth would have learned nothing about love from his mother, and she would be defeated in teaching her son that in which she excels. How can this drama find a resolution?

The development that next takes place is not between mother and son, but between Aphrodite and Psyche. The Goddess, rather than being accommodating towards Psyche, hides none of her power nor her anger towards her and makes her undergo a series of difficulties. Psyche, before she becomes a "real woman" worthy of being the daughter-in-law of Aphrodite, is forced to develop and prove her own strength. Without the trials with which Aphrodite besets her, Psyche would have remained juvenile, not having been measured against any obstacle, and she would not be worth the name she bore, for of what use is a soul that has never known suffering?

The myth illustrates the danger of a relationship in which the mother is an Aphrodite, but it also proposes an outcome which demands neither the sacrifice of the woman's Aphrodisiacal qualities, nor the destruction of the son's virility and autonomy, nor the rival's elimination. The story has an incestuous flavor, but also the kind of "happy ending" that Aphrodite prefers: a banquet, a wedding, Eros and Psyche received into Olympus. All is well that ends well.

CHAPTER SEVEN

Leaving Aphrodite

> The power I possess is sex, passion, love, which
> you mortals, in honoring me, celebrate in your
> diverse ways. I'm not less the darling of heaven. I
> am the Goddess Aphrodite.
>
> Euripides, *Hippolytus*

We must now leave Aphrodite, but not without a few warnings.
As with all power, that of Aphrodite may be dangerous and
negative. Mistakes are cruelly punished by the Gods, and
Aphrodite, though more a good fairy than an evil sorceress, is no
less redoubtable when she avenges an affront: "My subjects live in
the Mediterranean sunlight from the Black Sea to the Atlantic
beaches, and those responsive to my sacred privileges, my whims,
my implacable caresses, I reward; I delight them; but I stir trouble
for any who ignore me, or belittle me, and who do it out of stub-
born pride."[1]

Myths which tell of her anger and vengeance point to these un-
pardonable mistakes. Aphrodite, when angry, strikes her victims
with impotence, frigidity, disgust, nymphomania, or madness. But
lovesickness, even when terribly painful, is not an expression of
her anger; when the trials of love are surmounted, if we have not
been psychologically destroyed, both our strength and our con-
sciousness have been raised. The trials that Aphrodite caused
Psyche to undergo transformed the ignorant and naive girl into a
woman who was aware of what love costs and who knew at last
the true face of her husband.

What the ancient Greeks called an insult to a divinity brought upon mortals divine wrath, a tragic spell. As in neurosis and psychosis, this sort of suffering led nowhere and produced nothing. An ancient Greek whose destiny was going badly would ask which divinity he or she had offended. This questioning was part of what we would call therapy. If we understand the Gods and Goddesses as personifications of psychological qualities, then to offend a divinity is to mistreat a part of our personality, and our psychological troubles are the divinities' punishment. Thus, Atalanta, who proudly refused to yield to Aphrodite, was transformed into a frigid lioness. Having denied sexuality (that is, having refused to honor Aphrodite), Atalanta lost not only her sexual function by becoming frigid, but also her humanity, by being transformed into a lioness.

One knows Hippolytus's tragic destiny: he offended Aphrodite by his exclusive love for Artemis. Further, his refusal of sexuality had something haughty about it, as if he judged Aphrodisiacal love to be less "pure" than his feelings for the virgin Artemis. Phaedra was for Aphrodite an instrument of vengeance, and Phaedra's passion, from which Hippolytus obtained no enjoyment, was none the less the cause of his tragic destiny. Aphrodite seems much more indulgent towards guilty lovers, whom she is always ready to absolve or protect, than towards such disdainful refusals as those of Hippolytus or Atalanta.

In traveling to several communities in Canada and the United States, where groups seek a renewal of spirituality outside traditional religions, I at times encountered these pure Hippolytuses and these strong Atalantas, who all hastened to tell me that for them sexuality "is no longer a problem," that they had "gone beyond the sexual chakra," or that as compared to "spiritual love," the satisfactions of sex were very slight, not to say base. Some others had eliminated Aphrodite by returning to a concept of sexuality exclusively linked to procreation. Still others had a concept of the "Great Mother" that was completely anti-Aphrodisiacal, and only the maternal element was venerated (an idea that leads some young women to believe they should bear all the babies that mother nature sows within their wombs). I had the clear impression that the ancient official religion was still there, but with a new name. For example, the spirituality associated with maternity and femininity was that of "Madonna and Child," as if it were the only

alternative to sexual decadence and the sole possible content of feminine spirituality.

In some but not all of these communities, where the goal is a non-dogmatic and universal spirituality, I have nonetheless seen silent disapproval at the sight of a young visitor whose nails were painted and whose makeup and clothing were quite seductive. I have seen many of the so-called new-age "spiritual men" prefer a shy femininity (that is, non-Aphrodisiacal), as if they feared that hysteria might seize their holy places if women laughed too loudly or too often. Some of them distinctly seem to fear "the folly that Aphrodite arouses in our hearts." When selecting a wife, these men tend to take their model of feminine behavior from the old Protestant stereotype of the pastor's wife, as if it were sufficient for the renewal of feminine spirituality to refresh the old models.

In some esoteric circles, although everyone seemed intellectually very sophisticated, I encountered a persistent but subtle reaction to Aphrodite, expressed by a distrust of seduction and a fear to appear to be "still entangled" in sexuality. Many spoke more freely of alchemical marriage, in which the interior poles of masculinity and femininity are united in the same person, than of a union mediated by Aphrodite. In default of being themselves truly "beyond" these passions, some of them were preoccupied with appearing so, for the group pressure was in this direction. This psychological set-up kills the Aphrodisiacal mood, and it is painful for individuals as much as for the group, since it is Aphrodite who has the power to heal the wounds of separation between men and women. Furthermore, just such an attitude leads to amorous complications, and I have seen more than one community destroyed by what could be called a "vengeance of Aphrodite." The jealousies and intrigues may be all the more destructive when Aphrodite has been neglected, and the group may be undone by just that which they have so carefully denied.

We must not conclude that Aphrodite avenges herself upon everyone who lacks a flamboyant sexuality. If this were so, chastity would be impossible, and we would have a monotheism of Aphrodite. We must not forget that Aphrodite has no power over the virgins Athena, Hestia, and Artemis: there are ways of finding one's path other than through Aphrodite and sexuality. But the Goddess will tolerate neither pride (an infatuation with one's own beauty, as if one owns the Aphrodisiacal qualities) nor haughty

refusal (as if one could be immune to her power). To those, Aphrodite reserves a few surprises, as she did for Apuleius:

> Of one thing I'm quite certain: that though I have always shied away from love affairs even with ladies of the highest rank, I'm now a complete slave to your sparkling eyes, your rosy cheeks, your shining hair, your fragrant breasts and those kisses you give me with your parted lips. It is a willing slavery too. I have no notion of leaving you and no regret that I'm so far from home, and I'd give the whole world not to forfeit the joy in store for me tonight.[2]

As for those whose pride leads them to think themselves the Goddess's equal and to appropriate for their own a power of which one can only be the servant, Aphrodite undertakes to remind them of their human limits. Jung calls this kind of inflation of the personality an "identification with the archetype" and shows its disastrous consequences. There have always been women so absorbed in their own beauty, in their seductive capacity, that they demand a devotion which should be granted only to a Goddess; they confuse the archetype and their own interpretation of it. The beauty of Helen and that of Psyche have been made the occasions of repeated warnings: she who forgets that Aphrodite's gifts have only been loaned risks being baffled, humiliated, and finally destroyed. The cult of Aphrodite is not the cult of oneself and of one's own beauty; it is the artful giving of oneself. It is not a bag of tricks to capture another.

Esther Harding sees the myth of the Sirens as symbolic of sexuality when it is used as a means of domination.[3] According to Harding, the frigidity which goes with excessive concern for mirrors, appearances, and clothes does not hinder a woman from "taking men in her nets," because, having no autonomous passions and no profound instincts, she may marvelously reflect the desires, humors, and passions of a man who has become enchanted by her songs.

The siren, who is only half woman, well symbolizes the feminine personality in which Aphroditic gifts are both exceptionally strong and unrealized. Since we have long ignored individuation by way of Aphrodite, instead of grasping and rejecting the incompleteness of the "siren syndrome" we deny Aphrodite herself. The woman thus finds herself a prisoner of a double bind,

for if she rejects within herself Aphrodite's qualities, confusing them with those of the siren, she mutilates her personality in such a way that she no longer feels she is a woman. She has lost her chance of finding Aphrodite's path. If she preserves these qualities but remains enclosed in egocentric contemplation of herself, her destiny will be tragic and destructive, like that of the sirens.

It is therefore most important that the human person not appropriate a power which is that of an archetype. In other words, a woman with Aphrodisiacal qualities has to learn how to be a priestess of Aphrodite, using her power to give love and pleasure instead of keeping it to herself, since it does not come from her but from love itself.

Obviously, it is not easy to regain contact with Aphrodite after two thousand years of rejection. Weyland Young, analyzing the erotic literature of the Occident and the language of love since the Middle Ages, concludes that our literature—the depository of our values and the reflection of our manners throughout the ages—expresses two major tendencies with respect to sexuality: suppression and corruption. He asks: in what works do we find a sexuality that is wholesome and joyous? In order to have any idea of it, he says, we must go back to Grecian Aphrodite.[4]

It is difficult to encounter Aphrodite. In general, men fear to relax their control and give a woman, Aphrodite's vehicle, the power to transform them. Women who are gifted with her spirit have, for their part, difficulty in accepting that men are not all-knowing in love and that a woman may teach them, and this without taking a maternal, manipulative, or superior attitude.

As it is difficult to receive Aphrodite's gifts, it is just as difficult to leave them. When she has filled us with her grace, there remains another trial: to accept, when the situation requires it, the loss of the "secret loves, the gifts of honey, the bed." When the enchantment of love ceases, everything seems so desolate. When sexuality has assumed an inordinate place in our life, a certain length of time is needed to taste anew the beneficent solitude of Artemis, or the satisfaction from work and friendships inspired by Athena, or the maternal happiness of which Demeter has charge.

Christine Downing speaks with accuracy of this difficulty of Aphroditic women in leaving their play of seduction, when it becomes a question, not of flowing with the energy of another, but of opposing, of rupturing a union, of keeping distant in order to

find solitude, do an absorbing piece of work, raise children, or fight in a competition.[5] The intricacies of love are not the only ones that we must learn, and all the other divinities claim their share of attention. The ancient psychology, implicit in pagan polytheism, recognized the dangers of identification with a single archetype and warned us not to try being equal to divinities through a search for an absolute, which is not human. Polytheism means that one sacrifices at many altars and lives more than one myth.

It is, however, a consolation to know that even when desire has gone, flowers have faded, gardens frozen, Aphrodite, like gold, is eternal; she renews herself every spring. We can recognize her return when she makes our eyes shine with peculiar brilliance, our voice drop to soft tones, and our gestures reach for the other.

PART TWO

Artemis

CHAPTER EIGHT

Artemis and Ecology

> Her faithful and the poets call her the Savage or the Queen
> of the Wild Beasts.
> Her pleasure is to travel the woods and the high crags
> battered by the winds.
> She loves those animals which have not been subjugated by man.
> The games of childhood and the chaste thoughts of
> adolescents belong to her.
> She is the Invincible Virgin, fierce and beautiful.
> She is pure and cold, like the light of the moon that guides
> the hunter through the forest.
> Her arrow is cruel, sure, and swift.
> She is the Goddess of untouched Nature, of intact bodies, of
> hearts free from passion.
> Andre Bonnard, *Les Dieux de la Grece*

The Virgin Artemis, archetype of a femininity that is pure and primitive, is becoming important once more. For a long time, we have had no representation of absolute femininity, that is, one defined neither by relationship to a lover (Aphrodite), nor to a child (Demeter or Mary, Mother of Jesus), nor with a father (Athena), nor to a husband (Hera).

In fact, femininity is rarely represented in the absolute, but rather in relation to some other reality of the masculine world. Usually, when a woman withdraws into a territory closed to the male, she is perceived as a pariah, a sorceress, or a crazy woman. When depicted in literature, cinema, or television, feminine virginity occurs generally in a tale about a male introducing himself into this realm and transforming the virgin into a "real woman," as if

femininity could never be complete in itself. As for the woman who dares persist in retreating, one is left with the understanding that she is too ugly, bad-tempered, or otherwise defective. She is more distrusted than esteemed. In contrast, we admire figures of male hermits, sages, illuminati, or simply solitary men; they are not presented as being incomplete because they keep their distance from the opposite sex or remain chaste.

Artemis, who is very beautiful, some say as beautiful as Aphrodite, thus comes to sanctify solitude, natural and primitive living to which we may all return whenever we find it necessary to belong only to ourselves. An Amazon and infallible archer, Artemis guarantees our resistance to a domestication that would be too complete.

Moreover, as protectress of flora and fauna, she is the figure most directly concerned with the contemporary ecological debate and its related social choices. With the topic of ecology, it is difficult to avoid well-trodden ground, for those who have sensitive ears have already heard the alarm, which is repeated louder and louder for those who won't listen. Thus, I have few facts and data to propose to our reflection, but familiar themes of ecological meditation instead. For meditation, like prayer, benefits from the repetition of the known. Let us begin with a meditation on water, then go on to trees and childbirth.

Living Sources of Pure Water

> I know a ledge where water springs from the
> rocks, where the River tunneling down from
> his birthplace slashes and sparkles.
> Euripides, *Hippolytus*

We have seen the white and foamy sensuality that relates Aphrodite to the sea, to the rhythm of the waves, and the moisture of love. To these profound and salty waters, Artemis prefers clear streams which spring from the mountainsides and run their course through the undergrowth where she herself likes to roam.

In ancient times, great importance was attached to water's purity. Even in large cities, one could drink spring-water brought from the mountains, and it would never have occurred to any legislator to pass laws to preserve the sacred purity of Artemis's waters.

Though our technological civilization has attained impressive heights, no city or modern town seems capable of conveniently providing itself with spring-water. And who, among those responsible, concerns himself with the fact that we no longer have pure water to drink? Scientific debates bear on the choice of chemical products to be emptied into the water and not on a way of enabling us to drink pure water. Should the luxury of running water be at the price of never drinking virginal water? The water we drink passes through the sewer, then filtration and chemical purification. There is no distinction between water for domestic use and drinking water. The sometimes criminal irresponsibility with which factories dump their tons of poison into our waters persists despite evidence of the damage. (The factory owners surely drink only bottled water, because that which flows from our taps is only good enough to wash their cars.) I know a very rich woman who gives Evian water to her cats and dogs because she is persuaded that it is better for their teeth. It is regrettable that this woman did not become a sanitary inspector or pediatrician: such intuition should not evaporate in a dog's dish.

In degrading the quality of the water in our towns, villages, and homes, we have lost something more fundamental than sanitary values. We no longer see water; we no longer hear water; we no longer taste water. What we have is dead water, a commodity, and it will never assuage the thirst of those who really love water's taste, sound, and appearance. Until I lived near a spring in the country for several years, I did not know that water could have a taste. Only upon returning to the city did I perceive the insufferable difference.

I invite those who believe that water is odorless, colorless, and tasteless to inspect a glassful of city water carefully, then compare it with a glassful of spring water. Then they should taste both with eyes closed and try to grasp the difference. It is with water as with wines: there are the great vintages, the honest little wines and the unpalatable poor wines. It is interesting that most animals will not

drink from polluted waters, while human beings, who no longer know water's taste, do not even perceive the difference.

Besides becoming undrinkable, water has become more and more invisible. Happily, in Europe, there are small towns which have restored their waterways, de-polluted them, and returned the land at the water's edge to the population. But the habit of treating streams as sewers is still dominant in the industrialized world, with the result that we no longer see or hear running water. One may meditate in the presence of water, but hardly in front of a tap!

I know a man who had the good fortune to have a small stream on his land. Often he did not hear me coming when I went to visit him, because the song of a stream can be so absorbing that one hears nothing else. Several times I observed him before he perceived me. He had taken the rocks out of the stream, removed the debris, and brought the stream back into its stony bed. He had done this work with a shovel, a crowbar to disengage the largest rocks, and his bare hands. In two years, he had transformed in this way, piece by piece, a swamp of murky water, producing a stream of pure, drinkable water which flowed in musical cascades and sprouted a border of ferns and luxuriant green mosses. But when this work was completed, I found him one day placing and re-placing the same little, flat rock in a precise spot in one of the small waterfalls. Not understanding the meaning of this activity, I asked what result he was trying to obtain. A little shy about having been surprised while obviously enjoying himself "playing in water," he allowed me to listen to all the possible variations in the water's song that resulted from changing the position of his little rock.

He also told me in a humorous way how working with the stream had been a kind of therapy for him. Whenever he felt that a situation or an interior state had become metaphorically "stagnant," he liked to come and clean out the stream, removing the obstacles that impeded the water from following its course, until he felt a renewed movement within himself as the stream of his feelings began flowing again. In speaking of his clearing out the stream, he was giving a quite accurate description of the therapeutic process proper to Artemis. When he achieved a profound identification with nature, the repetition of certain gestures, such as clearing out the mud and restoring the stream's natural flow, had the power of healing psychological suffering; at this point of

identification he "became" the stream. Each shovelful of mud, as thick and black as his own negative emotions, was subjected to the workings of the water, which bore it away, filtered it, and deposited it elsewhere. Some stones were as heavy and obstructive as his own complexes and had to be displaced through strenuous effort. At other times, he went to sit tranquilly beside the stream and watch it flow for a while, until the magic moment when the accumulated suffering and tension seemed to "fall into the water" and were borne away by the current, enabling him to let go of his emotions.

There are obviously many ways of entering into therapeutic contact with nature, but solitude and identification with nature through falling water, trees, or animals are cues that our contact is with Artemis rather than Dionysus, Demeter, or Aphrodite.

If we wish to honor Artemis once more, we shall have to stop neglecting and poisoning the water of the mountains and streams, perhaps even allowing this water to enter our villages, towns, and cities, no longer confounding these waters with the water of drains and ditches. Perhaps, afterwards, the nymphs, naiads, and nereids would return to inhabit our imagination and teach us the necessary respect for the waters of Artemis.

Why Do We Say That a Forest Is Virgin?

Towards the end of the pagan world, the Romans needed lumber to construct their ships and cut down the trees in the sacred groves of Artemis. Since that time, the attitude behind this behavior has become more and more widespread. Today, that almost all forests have been sacrificed to commerce and industry and that an important part of all the planet's resources are used for armed forces scandalize few people.

It is true that, to the extent that organizations and associations succeed in protecting the flora and fauna from the more outragous violations, we begin to hear once more the voices of the priests and priestesses of Artemis. But the funds and importance accorded these organizations are ridiculous when compared to the sums in-

vested without hesitation in military gadgetry. When we know how one small cell still reveals unknown universes to us and that each species has an inestimable value, we may imagine what the daily disappearance of numerous vegetal or animal species signifies in terms of arrogance and scorn for Artemis. Our error consists in believing that science can atone for all the spoilage, as if, one day, we should be able to synthesize the wild orchid or the elephant that disappeared today. And what if the remedy for a disease which may kill us were to be found precisely in these vegetal substances which are today disappearing? And if it is true that certain bizarre species have properties that fascinate even the scientific eye, how is it that we hesitate so little to destroy the places favorable to their growth?

What we call today a "virgin" forest was in former times called a forest "of the Virgin." By both of these expressions is designated a nature (as a woman) that has not known man. It appeared most important to the ancients that men learn to venerate a nature that is not there for their profit, but solely for their devotion. In contrast to this attitude, the most widespread opinion today is that an area that has not been exploited or is not eventually exploitable is quite simply useless.

It is true that Artemis's beauty is not for the benefit of any reproductive union. The myth even makes her a Goddess whose beauty should not be exposed to human sight, as if to signify that this beauty exists for itself. The myths associated with Artemis suggest that one may hear her or sense her presence, but that it is dangerous to violate her, even with the eyes. It is to Artemis that the virgin forest belongs, or the wild prairie "where no shepherd has the right to lead his flock, and no Scythe has ever passed."[1]

I am inclined to explain the oblivion to which the Artemis archetype has been consigned by the fact that, in our culture, femininity is usually judged as a function of its value relative to man, child, or to society and that it is rarely honored in itself. One finds this tendency even in Jungian psychology, where one would least suspect it; Jung's best texts concerning the "anima" and the feminine principle seem to want to convince us of the utility of the development of the "anima" for men.

The femininity of Artemis is sealed by an inviolable and un-negotiable virginity. This absolute virginity ("essential," one would say in philosophy) is not fashionable, so that it is difficult

for girls and women to know, within themselves, that aspect of femininity which is not in relation to some other reality. Not so long ago, the Artemisian virginity appeared in those who remained chaste all their lives by entering a convent, becoming a saint or a rebel. It is re-appearing today in the form of a radical feminism that also defends a femininity beyond all association with men. And I believe that we must preserve this non-associative femininity at all costs and reserve psychological and physical spaces for it.

Mary Daly, whose eco-feminism seems to me both original and radical, makes an analogy with the Hindu caste of Untouchables and speaks of women as the international caste of "touchables."[2] I believe indeed that the loss of a Goddess so fiercely opposed to all contact with the opposite sex, but nevertheless adored and respected by all, has meant a loss for all women of their power to defend a sacred territory, interior or exterior, physical or psychic. Nature, flora and fauna, is universally exploitable and commercializable, and since women are associated with nature, they have also become touchable, violable, and utilizable. Wherever the fierce independence of Artemis is unknown, those who exploit us perceive "being-in-oneself" as an absence rather than a presence to oneself. Those who understand no longer the need for Artemis also do not understand the need for sacred groves and virgin forests. To them we must ask: of what use is a human being?

The male who wishes to honor Artemis must understand that he may neither see nor possess her: there is a core in the mysteries of untouched nature and of femininity that must remain virgin. The woman herself, while providing favorable conditions for the development of this part of her nature, should not pollute it with words, nor implicate it in the process of seduction, nor exploit it in the world of relationships. It is essential to the ecology of human and spiritual values that we re-discover the meaning of an intact femininity and that we multiply, at the same time, the natural reserves of prairies, virgin forests, and spring-waters. Let those wild women also be multiplied who know the art of preserving within themselves a force that is intact, inviolable, and radically feminine. There are a few, and they are precious for humanity because they guard and protect an endangered species: the girl, the virgin, the Amazon, the archer—untameable and undomesticable primitive femininity.

Childbirth: A Major, Uncivilized Occasion

Leto, mother of Artemis, suffered the pangs of childbirth for nine days and nine nights before delivering her twins, Artemis and Apollo. This torture was inflicted upon her by the jealousy of Hera, to whom it was insupportable that Leto should birth children whose father was Zeus, her unfaithful husband. According to Callimachus's version of the myth, Leto suffered while giving birth to Apollo but not to Artemis.[3] Though daughter of a Goddess who suffered the worst labors of maternity, Artemis was born without causing her mother to suffer. Being born first, she was a help to Leto in her painful delivery of Apollo. Therefore the guardians of destiny made Artemis the patroness of childbirth, and women implored her for a rapid delivery.

However this may be, we understand that Artemis, as would any young woman who had witnessed such a terrible confinement as Leto's, would keep away from men and the risk of bearing children. We also understand how, although remaining a virgin, Artemis, knowing how her mother had suffered, dedicated herself to relieve women in labor.

An aged midwife, with an extraordinary reputation for competence, once told me that our idea of former midwives as women who themselves had given birth to many children was not realistic. Those who devoted their lives to helping women in labor and to caring for the children were very often women who were sterile or celibate. While aiding women in labor, Artemis was herself very far from maternity. Further, her myths constantly intertwine the realities of life and death: Artemis is not only the protectress of women, but also the Goddess who kills them.

We know that in ancient Greece girls were married very young, a circumstance which may explain their high rate of mortality during their first childbirth. The clothing of women who thus died was brought to the temple of Artemis at Brauron, because their deaths were attributed to her. Was this an expression of the Goddess's anger at the undue haste in bringing young girls to childbirth? Is this a warning to young virgins that contact with a man may lead to a new life, but also to death?

Today we think that medicine has changed things dramatically and that few women now die in parturition. But the power of the myth remains, as well as the intensity of childbirth. In spite of the fact that giving birth is a joyous and positive event, many pregnant women experience great anxiety, as if the event could obliterate them, go beyond them, or carry them off. Medical optimism and scientific statistics do not change this fear, for one may fear the psychic destruction of the personality as much as one fears physical obliteration. Have we not clearly seen, especially as young girls, how numerous are those women who, after the birth of their first child, no longer survive except as somebody's mother? The "self," the virginal identity, the autonomous person may die. Most pregnant women have a forewarning of this danger; in these anguished moments, one understands that the myth of Artemis confounds the giving of life with the giving of death.

Giving birth demands a total opening out of the whole being, and many women at the moment of maximum uterine opening tremble with all their being. This is the most difficult and most intense moment, just before beginning to "push" so that the child may come into the world. At this moment Artemis intervenes, bringing the deliverance either of a new life or a rapid death. As for the contractions, it is useful to recall other Artemisian images: many women refer to this sensation as a "savage pain," saying that at certain moments one may have the impression of combatting a wild beast that is tearing out one's belly. Joy and hope make all the difference, for it is a struggle for life rather than a deadly competition; but the pain reflects the two poles of untamed nature: the generosity which makes life and the bitterness that devastates the body.

Elsewhere, I have written of how a Dionysian man can truly participate in the feminine mysteries, because at the moment of delivery the paroxysm taking place in the woman's body may be emotionally experienced by such a man. For the child's father and also for those present who are part of the clan into which the child is born, this opening to Dionysiac intensity gives a truly primitive and spontaneous joy in the marvel of childbirth. Dionysus presides over celebrations that conjoin joy with sorrow, blood with life, suffering with celebration. Artemis and Dionysus have a common affinity for the primitive and the natural, but when Artemis pre-

sides at a birthing, it is mostly in the faces of the mother and child that her presence may be felt, whereas Dionysus may be seen in the expressions of all those who have given themselves to the event. The mother and child have been alone in an experience where the wild animal nature, the human emotions, and the spiritual realms are equally strong.

In the gynecological functions of Artemis, other mythologists have seen a reminiscence of an older myth—pre-Hellenic, Cretan, or Asiatic—in which Artemis was one of the forms of the Mother-Goddess. But if the myth's ultimate evolution was such that Artemis did not remain as a mother-figure, yet was still invoked by women at the moment of giving birth, it might be because an association other than the Mother archetype was possible between the queen of the wild beasts and the woman in childbed. Indeed, I believe that if the function of Artemis is to preserve our contact with animality, it is necessary that she be present at childbirth. At this moment, more than at any other, Artemis must teach one to submit to the powerful working of nature and to forget fancy up-bringing.

In most myths, it is Artemis who assists the female animals when they are in labor; this knowledge, acquired through the females of the forest, enables her to be a midwife. Artemis, attracted neither to towns nor to civilization, nevertheless agrees to come out of her forest to help women in childbirth. Here, once more, the frontier between the two worlds disappears. The woman in labor forgets her culture and her good manners and is completely possessed by the animal force that inhabits her with all the fury and, at times, with all the bloody cruelty of which nature is capable. The woman who has not learned to receive Artemis, or who does not learn at this moment to do so, is devastated. Without her teachings, how can we let our female body in labor do its work? Artificiality, civilized restraints, and hesitations have no place here, nor emotional hysterias, nor useless complaints that perturb all possibility of real concentration. It seems to me that the psychic concentration necessary to follow the rising waves of contraction resembles a dangerous gallop to the last gasp, during which one does not stumble because, come what may, the rhythm must be followed, or one falls and breaks one's neck. Or, one may have images of struggle between the mother's body and the child's push and pull, and one understands Medea when she says: "I would rather enter a

thousand battles than bring one child into the world." But Artemis, who rides wild horses and can battle the animals, can teach a woman how to follow her instincts.

> We must live with the helpless misery of childbirth, all the foolish despondency leading to it. Once I felt such chaos in my womb. I cried out for Artemis in heaven, who loves the hunt and whose care relieves those giving birth. She came to me then and eased me. She's the one goddess in heaven I will always admire.[4]

I have attended several 'natural' deliveries and have brought forth two babies myself, and each time there was a precise moment, that of the passage through the neck of the uterus, when the woman's voice changed completely and her cry seemed to come from elsewhere, from her animal past. This savage cry from afar announces the advent of Artemis—that is, nature proceeds with an impressive force—and no woman has the power to restrain her breath and her strength in opening herself to delivery when her time has come.

As soon as this effort has been made, Artemis returns to her forest, the woman regains her human speech and her acquired manners, and only then can she receive her child with human emotion.

CHAPTER NINE

Sacrifice

Artemis has nothing in common with bucolic sentiment and kindly nature. If bread and mother's milk are what one seeks, it is to Demeter, to the tilled fields, and to maternal solicitude that one must pay attention, and not to the dangerous idealism of Artemis.

The Goddess who slays the beasts, whose patron she is, has a liking for bloody holocausts.[1] It is not only animal sacrifice that is attributed to Artemis. In the most distant times of Greek religious history, she was associated with the practice of human sacrifice.

The Jews like to believe that it was Jehovah who withheld the arm of Abraham and prevented Isaac's immolation, thus putting an end to this terrible "pagan" practice. But, without denying Artemis, the religious evolution of the Greeks had already brought them to reject the idea of human sacrifice, at least in its most obvious forms. Towards the end of the fifth century B.C., when Euripides wrote his dual versions of the sacrifice of Iphigenia, the practice had long ago become taboo. Animal sacrifices were offered to the divinities, and the memory of human sacrifice was that of a past epoch or a fact of barbarian custom with which the Greeks of the late archaic and classical periods no longer identified.

The Phoenicians continued to practice human sacrifice up to the Christian period. Euripides, as if he wished somehow to absolve Artemis from her past characterization as a bloody Goddess, and shocked by the idea of human sacrifice, presents his *Iphigenia in*

Aulis as the story of the last sacrifice of the heroic epoch (that is, about 1190 B.C.). Further, he makes her sacrifice a turning-point in the change of mentality. In another interpretation of the same myth, *Iphigenia in Taurus*, Euripides attenuates the moral shock to the conscience of his time by situating the action, not far away in time, but faraway in space—in Taurus where, according to Herodotus, the inhabitants had continued the custom of offering human sacrifices to a virgin Goddess called Iphigenia, who was identified with Artemis.

Besides presenting the sacrifice of Iphigenia in Aulis as some very primitive ritual, Euripides wrote a happy ending that resembles the sacrificial scene of Isaac and permitted the Greeks to consider Artemis in a less cruel light:

> The priest took up the knife, praying, and looked for the place to plunge it. Pain welled up in me at that, and I dropped my eyes. And the miracle happened. Everyone distinctly heard the sound of the knife sinking but no one could see the girl. She had vanished. The priest cried out, and the whole army echoed him, seeing what some god had sent, a thing nobody could have prophesied. There it was, we could see it, but we could scarcely believe it: a deer lay there gasping, a large beautiful animal, and its blood ran streaming over the altar of the goddess . . . Then Kalchas, with such joy as you can imagine, shouted "Commanders of the assembled armies of Greece, look: the goddess has placed this victim on her altar, a deer from the mountains, and she accepts this instead of the girl, rather than stain her altar with noble blood."[2]

But the entire question of Artemis and sacrifice still remains, for while we may easily understand the desire for a change of mentality, it becomes more difficult to grasp the meaning of the more ancient human sacrifices attributed to her. Who were these sacrifices? And why were they? What significance can be given these acts?

For those who imagine an ancient and pre-patriarchal matriarchy that was as cozy as the home of grandma, it is shocking to have to recognize the dark and cruel side of Artemis. Inasmuch as she was a lunar Goddess, represented by the lunar crescent, she was related to another lunar Goddess, the terrible Hecate who personified the dark of the moon and the death-giving powers of

women-sorceresses. The Goddess Selene completes the trio, representing the full moon, benevolent and reassuring.

The cruelty of Artemis and the negative powers of Hecate are typically associated with the ancient matriarchies, where the power of giving life, in women, was understood to occur with its opposite, the power of bringing death. We shall not discuss here the need to re-discover the energy of Hecate, despite its terror, and the anguish we feel in not knowing the true face of femininity at its darkest. Hecate is sufficiently distinct from Artemis to be treated separately. Nevertheless, one must recognize that the continuum—from the sweet full moon (Selene), to the crescent moon (Artemis), to the terrifying black of the moon (Hecate) in which black magic was believed to be performed—associated Artemis and Hecate more intimately than Artemis and Selene. The queen of the wild beasts and the dark sorceress share an affinity for bloody sacrifice, and the accusation of cruelty does not disturb them.

It is therefore necessary to correct a too-tender interpretation of predominantly matriarchal religions by remembering that the full range of feminine powers includes their terrible, mortal, and bloody aspects. I know that one may interpret the sacrifice of Iphigenia as the propitiation of a father's political, social, or economic ambition and as the downfall of the matriarchy, the mother no longer able to oppose the decisions of her master and spouse concerning their child. Iphigenia was Clytemnestra's preferred daughter, the tender young girl whom the patriarch snatched from her mother's arms to serve his plans. But this interpretation, which I share, does not exhaust the myth's significance. Many interpretations may be true at the same time—the clash of wills between the mother and the father, the helplessness of Clytemnestra in a patriarchal marriage—but all this does not account for the meaning of human sacrifice in honor of Artemis. In fact, the evolution of patriarchy opposed this ancient form of sacrifice as a "human waste" or, more accurately, opposed a certain manner of human sacrifice, for it is dangerous to believe that Greek humanism and patriarchal justice have ended immolation. But their influence, just as that of the patriarch Abraham, certainly helped eliminate the superstitious excesses of a paganism that had become frenzied—to the honor of the patriarchal spirit in its finest aspect.

But maybe the causes, the values, and the ideas to which human beings were sacrificed have changed. There is still human sacrifice, but the forms, meaning, and executioners are no longer the same. Here, we must immediately distinguish between the sacrifice of a non-consenting victim (the destruction or torture of persons in the name of political or religious ideas) and that to which the victim consents and presents himself or herself for immolation.

In matriarchy, the person was sacrificed without apparent rationality, in the name of a divinity which claimed a victim. The most elaborate rituals surrounded the moment of death. In comparison, patriarchal mores elaborately rationalize destruction or torture of persons in the name of political or religious ideas—the System, the Party, Progress, or the Faith—and the most sophisticated rituals surround the process of condemnation (interrogations, court actions, suits) rather than the moment of death.

But the subject of our present reflections is the willing sacrifice, one in which the victim goes to the altar and offers him or herself to the God or Goddess. The sacrifice of Iphigenia will be the point of departure for our exploration of Artemisian sacrifices: why does Artemis require that Iphigenia be her heroine and her martyr?

Sacrificial heroism seems such a part of history that we may ask if it is not part of the human being. Whether it be the Japanese Kamikaze; the Buddhist monk who, emptying a liter of gasoline over himself, transforms himself into a living torch; the youth who starves himself to death for a political cause; or, above all, the Christian martyr, all are manifestly voluntary sacrifices that aim to recall those collective values that seem to merit the sacrifice of life.

If the Christian martyr has been given such a good press that the spiritual values he defends are highly praised, in what category should we rank, for example, the contestant in an automobile race, whose death is only a question of time? Neither hero of a cause nor defender of collective values like the martyr, the racer is nevertheless a sacrificial hero whose death satisfies and absolves the need for violence and the instinct for death of those who make him their model. The more this kind of hero really offers himself to death (that is, takes risks), the more he is applauded. Obviously, one speaks of "accident" rather than of sacrifice. But would the public continue to appreciate these shows if it did not receive quite regularly its ration of death? For cultural reasons, and because we

ourselves no longer slay the animals which we consume as meat, death resulting from a large knife used in the evisceration of a human being shocks us more than death as the outcome of the collision of two automobiles. These rituals called "sporting," like the gladiatorial combats, leave a chance of survival and kill only some of their heroes. One may then speak of "accidents" rather than of "sacrifice."

In general, we convince ourselves that suicidal heroism, martyrdom, and self-sacrifice are not really human sacrifice—since they are voluntary—and that death or its risk is assumed in all liberty. The little we know of ancient sacrifices makes it quite possible that they were partly voluntary. Euripides' ambivalence concerning the sacrifice of Iphigenia is revealing: on the one hand, he imagines her as a victim and expresses his revolt in the most profound accents, but on the other he sees her as a heroine. Thus she says:

> Now Mother, listen to the conclusion that I have reached. I have made up my mind to die. I want to come to it with glory, I want to have thrown off all weak and base thoughts. Mother, look at it with my eyes, and see how right I am. All the people, all the strength of Greece have turned to me. All those ships whether they sail, whether Troy falls, depend on me. I will be the one to protect our women, in the future, if ever the Barbarians dare to come near. . . . Because of me Greece will be free, and my name will be blessed there. I must not cling to life too dearly.[3]

Were there a feminine word for "savior," this expression would describe Iphigenia, the savior of Greece. Analogous to Christ's, her death assures the wealth of all Greece, redeeming the sins of Agamemnon and of Helen. As did Christ, who asked his Father not to spare him, but to allow him to "drink the chalice to the dregs," Iphigenia holds to her sacrifice: "Now there must be no tears. And you young women, join me in my hymn to Artemis the virgin, and celebrate my fate."[4] Again as Christ did, she honors the divinity who claims her sacrifice. Like Christ in the Garden of Olives, she goes through and beyond her tears before receiving the crown of the sacrificed. Though a Goddess rather than a God claims the sacrifice, though her mother rather than her father receives confession of her suffering at the thought of death, though

her crown is an emblem of glory rather than of derision, the honor which results and the spirit of willing sacrifice strangely resemble those of Christian martyrdom.

When pagan religion had to be abandoned because it had become fixated and corrupted, one may imagine how human sacrifice was portrayed in all its horror. The image of Iphigenia, an innocent child brought to the altar to be butchered and sacrificed to a cruel divinity, is indeed a revolting thought.

The interpretation of Iphigenia as victim rather than redemptress was very much part of its epoch, which just then was casting a horrified glance upon the practices of the ancient religions and was on the point of bringing about a change. For Euripides, as for us, sacrifice of a non-consenting victim is not a sacrifice but a murder. Aeschylus also judged the act of Agamemnon as a crime to the extent that Iphigenia sought to avoid it, and the words he places in the mouths of the aged Mycenaeans express his horror at the sight of a non-consenting victim: Iphigenia appears "with her beautiful face gagged to prevent her from cursing her people." This scene clearly suggests the replacement of human by animal sacrifice. Moreover, the fact that the ancients were scandalized by a victim who did not consent may confirm the necessity of a sacrifice's being voluntary if one were to please the divinity. And just as an animal that struggles to escape the knife is a bad omen and should be spared, the human sacrifice should probably have presented himself or herself to the altar in a state of religious ecstasy, similar to that described at the martyrdom of the Christians.

When the sacrifice is voluntary, it is no longer murder, but rather martyrdom (religious, political, or ideological). Obviously, all cultures condition or manipulate those who offer themselves in sacrifice, and one may guess the powerful influence that all sects, those of the first Christians or others, must have exercised on their members to convince them that their creed was worth more than life itself and that death was preferable to abandoning one's faith, one's cause, or one's honor.

The intransigent and suicidal heroism of Hippolytus, the only Greek hero whom the Christians have dignified as a saint, and the martyrdom of Iphigenia are two examples where the spirituality of Artemis joins that of Christianity. Purity, asceticism, moral intransigence, eternal virginity, glorified suffering, and giving one's life in

the name of an ideal and in the spirit of sacrifice are characteristics common to heroes of Artemis and Christianity. It was very difficult for me to see the positive pole in these matters, inasmuch as the emphasis on the glorified martyr has greatly contributed to my estrangement from Christianity. I have never personally enjoyed meditation before the bleeding Sacred Heart, the body of Christ pierced through the ribs, nailed on a cross, not to mention the abundance of details described by Christian literature, art, and mythology concerning the tortures undergone by the martyrs of the faith.

The debonair qualities of the Gods and Goddesses of Greece, on the other hand, appeared to me much healthier, until the sacrifices associated with Artemis obliged me to reconsider the whole question. I then applied myself to developing a point of view more favorable to the Christians, based on what we know of them at the time of the first martyrs.

Let's imagine the Christian martyr who refused to deny his faith and entered the lions' pit: for spectators there was a crowd of cynical Romans, most of them cut off from their own spiritual resources. The pleasure they took in seeing other human beings devoured by lions or killing one another in gladiatorial combat appears to indicate unrestrained brutality and violence. The Christian attitude was, therefore, the extreme opposite: passive resistance, refusal to oppose brutal violence with violence of the same order, songs of love, and ecstatic faces—all at the moment of going to death!

One may guess the impact of such an attitude on the Roman to whom neither bloody gladiatorial fighting nor decadent sexual orgies could bring happiness. The Christians offered the spectacle of human beings ready to die in defense of their spiritual life, and this in an ecstatic trance such as the Romans could not experience for themselves. The values of more than one Roman were challenged, to the point where many Roman soldiers joined the Christian camp and were suddenly ready to jump into the arena and give their lives for this new faith. All the uncompromising purity that characterized Artemis dominated these sacrifices, and one cannot deny that this spirit gave Christianity an incredible force, capable of conquering the Romans' aggressive brutality. This attitude, to be sure, also opened the door to the most pathological masochism, and Christianity has not failed to attract some of the most aberrant

personalities. No religion is immune to the folly of fools. But Artemis dislikes the "feast of the eagle," who is rapacious and cruel, and the offering of a life which one no longer holds dear. Her appeal to sacrifice or asceticism is not a hidden death-wish, but a desire to defend the life and values that one considers to be the highest.

CHAPTER TEN

Asceticism, Chastity, Solitude

The sacrifice of life is such an extreme situation that it risks losing its significance if one does not examine how the Artemisian archetype may be expressed in other and much less radical ways. We are then speaking of Artemisian asceticism rather than of sacrifice, but one may see the element of sacrifice within all asceticisms. Is not fasting the sacrifice of pleasures associated with nourishment, and is not chastity the sacrifice of pleasures associated with the instinct of reproduction?

But just as one must distinguish heroic sacrifice from pathological masochism, one must not confound fasting with anorexia, nor chastity with frigidity. It is not in order to experience stomach cramps that one undertakes fasting. Whoever has already fasted knows how it may lead to the most delicious imaginings, and how the first bite of food breaking the fast may be an unforgettable gastronomic event. Fasting does not find its meaning through the fact of not eating, but the psycho-physiological state which fasting produces is a prerequisite to an experience of another order.

Chastity, which resembles very much the asceticism of fasting, is distinct in that it may be chosen for a long period or even for a lifetime. But if chastity is the result of fear of sex or the consequence of frigidity, it generates only frustration. We must distinguish, as does Erich Neumann, between suppression, as in asceticism and discipline, and repression, which is neither volun-

tary nor conscious: "The effects of the confusion and obscurity engendered by repression are much more dangerous than the effects of conscious suppression and asceticism."[1]

Although asceticism has always been highly valued in the Christian tradition, we unfortunately have most often tasted "repression" rather than voluntary "suppression," which may lead to spiritual experience. Asceticism is now returning to us, almost as a fashion, by way of the Oriental religions, because what our own priests still propose to us has lost its meaning. But lack of Christian leadership should not hinder our recognition of this path of spirituality, wherever it may be found. Neither Artemis nor the Christian mystics of our own religious history lack interest. For example, the words of Thérèse d'Avila reveal a strange universe in which pain announces an ineffable joy. Here, the golden arrow of Artemis is in the hand of the Christian angel:

> An angel pierced my heart many times with a fiery golden arrow. The pain was so great that I cried aloud, but at the same time I experienced an infinite sweetness that made me wish it would last forever. God then softly caressed my soul.[2]

Contrary to the values symbolized by Aphrodite, who relates and unites creatures through sexuality, Artemis personifies a force which urges us to withdraw from human relationships and to seek elsewhere, in solitude, another kind of self-realization. One cannot, at the same moment, remain faithful to Artemis and to Aphrodite. These two Goddesses are antithetical and their cults mutually exclusive. If one is a polytheist and wishes to know both, one must alternate between these two archetypes because the spirituality of Artemis excludes Aphrodisiacal man–woman mingling.

Artemisian spirituality is familiar to the priests and nuns of the Catholic faith. Like Hippolytus, they believe that spirituality cannot be attained without chastity. And they are right, if one holds to the spirituality of the virgin (be it the Virgin Mary or the Virgin Artemis), for this form of surpassing requires a solitude incompatible with the requirements of relationships.

What is detestable is the pretension, on the part of Christianity, that there is no voice other than its own and that there is no spirituality without chastity. But we must not, therefore, produce the inverse dogmatism in believing that the chaste are simply

frustrated and that a complete personality cannot exist without the full expression of sexuality. Artemis would be offended if we spoke with enthusiasm *only* of Aphrodisiacal ecstasy, since she herself is not the less divine and necessary. Greek religion gave an important place to Aphrodite and sexuality, but the polytheistic attitude also valued the virgin. Whether we speak of a Buddhist monk, a Christian monk, or a Thérèse d'Avila, it is clear that there exists a form of spirituality related to chastity and asceticism, and the Virgin Artemis is but an expression of that archetype.

The tension between Artemis and Aphrodite is extreme, and the drama of Hippolytus-the-Pure illustrates the conflict between the two Goddesses: it is an echo of our own inner conflict. One may project this same conflict at the historical and collective level and interpret the movement which goes from debauchery to puritanism, and from puritanism to debauchery, as a battle between the values personified by Aphrodite and Artemis. Thus, certain periods seem to want to eliminate Aphrodite to the benefit of Artemis, and vice versa, as if the disequilibrium in one of the polarities could be compensated by the inverse disequilibrium, rather than by seeking a balance. For example, in the Greek Hellenistic period which followed the classical, there was an exaggerated disequilibrium in favor of Aphrodite and Ares. But it was perhaps not so much the debauchery of the Greeks, and above all of the Romans of this period, which led to Christian prudishness, for there are debauchees in all periods, but the profanation of Artemis, disaffection from the family (Hera), and ignorance of other Gods and Goddesses. Demetrius of Phalere, for example, not content to honor courtesans wherever Aphrodite had her rightful place, provoked a puritanical reaction by installing them in a temple of Athena, another Goddess of strict virginity, and by issuing to dancers who were part of his retinue the same crowns that adorned the head of the statue of Apollo.

Worse still, Caligula, jealous of the power of the virgin Goddess (so contrary to his own), profaned the sacred forests of Artemis and cut down the trees to construct his warships. Caligula, who went so far as to force the most modest of married women to prostitute themselves and who imposed his authority by violence and murder, has long represented extreme disequilibrium. In persecuting the Christians, his successors, Claudius and Nero, brought about the revenge of Artemis: she took a predominant

place in the Christian cult of the Virgin, and Aphrodite in turn was excluded.

There was, therefore, at the very beginning of Christianity, a strong reaction against the Aphrodisiacal excesses of the post-classical Hellenistic and Roman period, and we may qualify this reaction as "puritanic" or as "Artemisian," for Artemis here is acting as a counter-weight to Aphrodite. This opposition can be the source of a wholesome tension between the two values, both acting in a positive way and both having their moments in the lives of persons and in periods of history. But when Artemisian values are expressed *against* those of Aphrodite, or inversely, when Aphrodite revenges herself cruelly for her great neglect, the state of disequilibrium simply passes from one extreme to the other, from debauchery to puritanism and from puritanism to debauchery.

This is the drama of Hippolytus, who adored Artemis and scorned Aphrodite. His old servant, nevertheless, had warned him that no more than humans do the divinities suffer disdainful treatment without taking vengeance: "What is detestable is the pride of those too sparing in their friendships." This Hippolytus, who prefigures the Christian preference for Artemisian spirituality, is the only Greek hero whom the Christians have transformed into a saint, even though so rigid a purity led to tragedy. In the eyes of a Greek, his moral rigidity was probably the subject of ridicule. But in the eyes of a Christian, such absolute chastity was admirable. Moreover, it was the Council at Ephesus, the city of Artemis (as Corinth was the city of Aphrodite), that decided upon the virginity of the Virgin Mary and the absolute celibacy of the Catholic priests.

This insistence by the Christians on values counter-balancing Roman excess may be understood as a wholesome reaction against decadence. But insofar as the refusal of Aphrodite took precedence over the positive choice of Artemis, this movement led to another disequilibrium. The cult of the Virgin and the preference for chastity having dominated Christendom until the end of the Middle Ages, the need to rediscover sensuality sprang forth at the time of the Renaissance. Paintings and sculptures of the Virgin Mary, which had remained chaste and pure during the Middle Ages, were remarkably transformed during the Renaissance: Venus reappeared, sensuous and fleshly. She not only reappeared in the secular world but also within the Church. The Renaissance al-

lowed the return of a style of life in which pleasure and feminine beauty had their place. But once again, what was in the beginning a tendency towards equilibrium spilled over into excess. Popes and bishops had mistresses everywhere; the Madonna began to resemble the courtesan; and the child no longer had its place. Intrigue, love affairs, and gaming had too much weight in politics, and the Renaissance, which had led to the florescence of sensuality, was cut short by a return to strict monotheistic Christianism.

Where do we now find ourselves in this movement of the scales? In a society such as ours, where all tendencies co-exist, it is almost impossible to say "in general" where we are. We notice a certain disenchantment with the so-called sexual revolution and the re-emergence of the purifying ecologism of Artemis. But insofar as our society is very individualistic, each social group, each person, has his own history, his own phases, his dominant and his decaying myths. Nevertheless, it appears to me that a rebirth of Artemis would be vivifying, not only for our ecology, but also for our adolescents, who would find a positive value in reserving their sexuality rather than plunging into a series of premature experiences, which are often imposed by a group norm and are nothing but rigid inversions of the ancient values attached to the virginity of maidens.

Opposing the solitary austerity of Artemis to the joyous union inspired by Aphrodite must not let us forget the benefits of solitude, the significance, for the contemporary personality, of Artemisian chastity.

Since, from the beginnings of Christianity, most examples of the solitary meditative life have been offered by monasticism, it is relevant to establish the bond, at once historic and mythic, between the cult of Artemis and the solitary life as lived by the religious orders of Christendom, in order to discover the positive elements of both Christian and Artemisian seclusion.

However, we must distinguish the chastity of the monk or hermit from that of the secular priest, for they did not have the same meaning, nor the same effect. We have spoken sufficiently of the misogyny of the Fathers of the Church who, while appropriating to their own advantage the power of domination over others (particularly over women), refused to grant the least power to the feminine sex. The chastity of such men, who were men of power rather than of spirit, often and unfortunately implied disdain or

dislike of women. When chastity is defined more by negation—rejection of the other sex—than by a positive choice of a way of life, its experience is corrupted. Anxiety towards the opposite sex and a solitary life are two realities which should not be confounded.

In fact, if one goes back to the beginnings of Christendom, the monk's retreat into monastic life did not at first scorn woman but refuse a masculinity which had become too bellicose. The first Christian monks, retired into the desert or into a monastery, were often Roman soldiers who refused military service. Their refusal of battle was at first a rejection of a virility of the Ares type. For both the monks and the hermits, excluding the other sex seemed to be a way of avoiding the pair Aphrodite–Ares, as if in shunning the one (Ares) they had to deny the other (Aphrodite). One may easily imagine the insupportable competition that would have occurred between monks inhabiting the same space and submitting to the same rules, if one had introduced the Seductress. Similarly, in the feminine order, the alliance of women excluded seductive behavior. Artemis, like the monk, excludes children, family, sexuality, and general sociability. The only rapport possible with a man is that which one may have with a brother, such as between Artemis and her twin Apollo. In fact, extreme or exclusive identification with the Artemisian archetype often expresses itself as an incapacity to have any other sort of man–woman relationship than that of brother and sister.

The first communities of monks or solitaries, as marginals refusing the dominant values of their society, had other things to do than to found a family. Their refusal of relationship with the opposite sex was perhaps above all a refusal to identify with the paterfamilias and the conqueror mentality associated with virility. For the nuns, chastity might have been a way to escape the biological destiny of maternity and a way to live in a female hierarchy of power. In fact, certain monks gave the impression not only of venerating nature and the feminine principle but also of identifying with the style of life proper to women: they wore robes, tilled the soil, and refused to fight wars.

The chastity of the first Christian monks thus resembles the castration of the priests of Artemis, who emasculated themselves voluntarily to enter the service of the virgin Goddess, approaching her through mimesis. Contrary to this, the priests of the ecclesiastical orders identify with a hierarchy of power that is strictly

male and that clearly seeks to keep the priest from feminine con-
tagion. The pyramidal organization of ecclesiastical power resem-
bles that of an army, whereas the rules and values adopted by the
religious orders—such as the Franciscans, the Benedictines, or the
Cistercians—are much more similar to the cult of Artemis and of
nature than to the rest of the Church. The equilibrium of manual
labor, contemplation, and intellectual work, their cult of nature,
and the importance accorded solitude and silence—all these aimed
to develop contemplatives and not soldiers of Christ.

The theme of solitude is important with respect to personal
mental health, because one's presence to oneself is a prerequisite to
the presence of another. Further, the existence of places and times
of solitude for the individual also influences the quality of group
life: the need for retreat becomes all the more pressing as the life of
the group (or family) becomes more intense. The energy of
Artemis and her fierce independence preserve the individual from
too absolute an identification with the group, or what the
Gestaltists call "confluence," which weakens not only the person
but his associations.

When social life absorbs one's energies completely, it is time to
penetrate the deep forest of Artemis and allow nature to replace
human relations. It seems to me that there is a very evident link
between a life rich in relationships and the need for solitary retreat
in which the ego receives no stimulation. In my personal ex-
perience, solitude only became important during and after five
years of intense and nourishing communal life comparable to a
group session of thousands of hours! This communal experience
so "nourished" me with relationships that, when it ended, I needed
a whole year of solitary life, listening to the wind in the trees and
the fire in my stove, to digest this experience and re-kindle the
desire for human companionship. This same need for solitude re-
appeared several years later when, my two children having at-
tained a certain independence, I needed to be alone (for more fre-
quent and shorter periods), rejoicing each time at not hearing the
sound of my name for several days.

Certain women may give the impression that they do not know
what they want: more profound contacts or greater independence?
More intensity in a relationship or more space for themselves?
This apparent confusion may be explained by the bond between
these: true contact implies also moments of complete solitude,

and, vice versa, to really taste solitude, one must be at peace with those important to us and leave them with a light heart. The woman who seems to be most confused is often the one who is both denied a profound contact with husband and friends and deprived of solitude and time for herself because she is the mainstay of her children. Since all children tend to treat the mother as a domestic commodity, she is, most of the time, not really alone and not really moved by a deep relationship. She dreams at one time of Aphrodisiac ardors and, at another, of going her own way and following the path of Artemis.

Every woman and every man, saturated with relationships and contacts, finds that the presence of others hinders one's presence to oneself and is attracted by the asceticism, simplicity, and naturalness that characterize Artemis. Then solitude appears as one of the ways of entering into her world.

The frustration of the need for solitude, by overstimulation, can lead to depressive reactions as surely as the inverse frustration, that of the need for intense and significant human relationships. Need for retreat is less evident in a society where human contact is normally of weak intensity; here the gregarious impulse is stronger than the desire for seclusion. Just as it would be ironic to recommend fasting to the undernourished, it is prudent, in speaking positively of solitude, to distinguish between the solitude which is chosen and desired from that which is involuntary and experienced painfully as a privation in no way agreeable or creative. The isolation of old people abandoned in a hospice, or the social privation of the single mother cut off from adult social life, leads in general neither to creativity nor meditation, but to depression. Isolation experienced as a void is the opposite of that solitude which brings intense self-presence. The casteless—or, in sociometric terms, the rejected and the loner—should not be confused with another solitary figure, that of the hermit, who withdraws from the world, not because his heart is empty, but because it over-flows with love for all creation. Such a one has reserves of love that permit him to retreat.

The hermit or the religious contemplative is generally a person who, far from being disliked, was earlier in life deeply enough filled with contacts and relationships to have been, in a way, "cured" of the compulsive need to be liked and surrounded by others. Contrary to the misanthrope who is isolated by his hostility

towards humanity, the hermit and the contemplative maintain a positive inner relationship with those who inhabit their thoughts. Let us not forget that it is they who prayed most for humanity.

One need not commit oneself to a convent to experience "holy peace." There are ways to retreat without estrangement. When our reclusion is only occasional, for a week or a holiday, the best solitudes are those that follow a warm "farewell" rather than a door slamming or a rupture. I believe, in fact, that as our need for solitude becomes more conscious and more legitimate, we can spare ourselves many of the quarrels whose principal aim is to bring about a desired separation.

The solitude which one finds in the presence of Artemis is not negative: it excludes others only because it excludes the speech and behaviors linked to social requirements. Neither the contemplative nor the hermit is self-enwrapped or hostile. On the contrary, their state is perhaps so greatly open that the presence of the "birds and the lilies of the fields" amply suffices for the one who wants to see them.

Doris Lessing has written a short novel, *Room 19*, that wonderfully describes the tragic need for solitude.[3] It concerns a woman who had everything to make her happy, that is, everything she thought she wanted: nice children, an affectionate husband, a beautiful home, a housekeeper, the opportunity for employment. But she lacked the ability and the opportunity to find her own self in solitude. She did find a way to be alone and in silence but could not protect her solitude against the invasion of incidental companions. So imperious was her need that nothing that had given meaning to her life up to then could hold her, and her failure to find true solitude in which she could listen to the voice within led her to suicide. Death was her ultimate hiding-place.

Though one could imagine a more optimistic ending, in which the heroine would have succeeded in giving herself the precious hours apart from civilized society, Doris Lessing's novel nevertheless illustrates the strength required to procure necessary solitude for oneself. Her character found it easier to yield herself to death. Solitude is an inner space which must be defended, and because that implies our learning to say "no," and "not now," and "I am not available," all those who have learned the opposite, particularly women, must surmount the obstacle of guilt. Men have, in general, less difficulty in posting the "do not disturb" notice. It is

most often the archetype of the Mother that makes the situation so difficult for women.

There is a legend which may aid the meditation of those who must defend their solitude against all kinds of invasion. When Hippolytus died, the myth claims that Artemis saved him at the last moment (as she was said to have done for Iphigenia) and transported him magically into Italy, to a sacred forest, where he constructed a temple to the Goddess. He would thus have been the first of a long line of hermit monks, similar to the first Christian hermits, alone in their wild woods. This priest of Artemis kept his place until a successor took it from him by killing him. The hermit had, therefore, to exercise an extreme vigilance, for at the same time as he preserved the forest of Artemis from intrusion, he was protecting his own life. In this I see an illustration of a rather frequent psychological situation, that is, the necessity of repulsing the invader, even violently. Whoever wishes to know solitude should protect himself or herself from any kind of intrusion, physical or psychological, and the person who too easily opens his arms, without demarcating the unapproachable ground, cannot know of Artemis.

In the last days of paganism, these priests of Artemis were often escaped slaves who had placed themselves under the protection of "the Goddess who refuses the yoke." Caligula sent gladiators to kill these priests, protectors of the sacred groves, prefiguring, it seems to me, the aggressiveness of modern bulldozers, which have destroyed all the wild places, or the psychological violence of information overload by the media.

In terminating the theme of solitude, I should like to relate an anecdote. Five or six years ago, I lent to a young woman I scarcely knew, a small, rustic cabin that had served me as a shelter during the construction of my house and which continued to provide a "retreat" for friends thirsty for solitude. This cabin, located on the mountain, is very isolated; one has to walk on a path to reach it. A woodstove, a cupboard for food, a bed, a table, and shelves for books furnished its single room. It is somber and without comfort. But the great trees surrounding it, the view of the mountains and of the setting sun, and the incredible silence satisfy those who like complete solitude. The day after her arrival, I went to visit her to see if she needed anything and to assure myself that the silence was not frightening to her, since the reaction of many who had stayed

at this spot was to flee after the first night. Most often, when someone says she wishes to be alone, this does not exclude television, radio, newspapers, automobile, mail, etc., that is, all those things that make us feel that communication has not really been cut off. There is none of that in this cabin. Nature alone is present, and many could feel this presence to be too strong and the human isolation too radical. But this was not the case with this young woman, who seemed perfectly content to be there.

Outside the cabin, she was throwing branches, one by one, onto a fire, as well as clothing, which she seemed to have brought in a huge laundry bag: skirts, fluttery blouses, high-heeled shoes. All this clothing was typically "feminine," almost new and of good quality. She told me then that she had just resigned from her position as a receptionist for a prestigious business. She had kept this job for five years; her work site had been on the twenty-second story of a commercial building, in a kind of transparent bubble of plastic and chrome, exposed to the view of waves of impertinent humans, delivered by eight elevators every three minutes.

All this clothing she was throwing in the fire represented for her a way of life that did not suit her. She added that she felt she was herself when with nature and in solitude. She did not like dresses, beautiful clothing, nor any form of sophistication, and her work had required much too much human contact and a style of clothing that exasperated her. She looked upon these clothes as a sign of her alienation, and the idea of burning them brought her such pleasure that it was worth the waste. When all had been burned, she did the same with her supply of makeup, and, in the end, cut her hair very short (almost shaven) and threw her mop of hair on the fire with glee. During those moments that I shared with her, this young woman was happy. A savage joy, that of liberty renewed, signaled the presence of Artemis.

She remained in the cabin for a month, regaining her health, jogging on the mountain, developing her breathing powers and her autonomy. Subsequently, she left for a destiny unknown to me.

This story seemed so filled with Artemis that I had the feeling of hearing her refusing, in front of Zeus, to wear the long tunic and jewels worn by women, choosing instead the short tunic, liberty, and sylvan peace.

CHAPTER ELEVEN

Abortion as a Sacrifice to Artemis

The function of Artemis is to preserve the purity of life. She guards life so that it will not be diminished, wounded, or degraded. But she who has the power to aid the woman in childbirth has also the power, by her whistling arrow, to bring sudden death.

We may wonder how this Goddess, both protector of life and giver of death, expresses herself in our time. What does the arrow of Artemis, which kills the animals she loves, mean to the women of our day? Why does she bring death to women, children, and animals? Artemis here is close to Hecate, and through her, women become conscious of the power of death, its inevitability and its necessity. Martyrdom, the sacrifice of one's life for a great cause, or suicidal heroism suggests in certain cases the superiority of death over life. But abortion also has been a constantly repeated choice of death over life.

The priests of Christianity, which has always been a sacrificial religion, have unvaryingly sacrificed the mother rather than the child. We must admit that the mother has never had the freedom to decide for herself whether or not she will be immolated on the altar of maternity. Male priests, therefore, sacrificed, without their consent, thousands of Christian mothers who could certainly have been saved if the doctor had had the authority to proceed with abortion, the sacrifice of the child. This is an extreme case, to be sure, for it entails a tragic choice between the mother and the child.

By withholding from women the power of choice and the power to destroy, two powers of which men make great use, the Church betrayed its fear of all feminine authority. Given that no force, no power, is uniquely positive, as soon as feminine power was amputated from one pole, all feminine power was held at its lowest possible level.

To affirm the importance of the child *against* that of the mother is a fundamental position of the Catholic Church, even if the choice is not often a matter of life or death. An unwanted pregnancy may destroy a woman psychologically, socially, intellectually, for it is difficult to undergo one or many pregnancies against one's will and still struggle to preserve the unity of one's personality.

We know that women who have died in childbirth, just as soldiers killed in battle, can, according to the Church, go to Heaven even without priestly benediction, the mother because she has sacrificed herself in giving life and the soldier for destroying it. Religious tradition has proposed to us ad nauseam the model of the sacrificed mother, to the point that it has become almost a cliché that therapy of married women so often begins with the need of relieving the woman of her sacrificial resignation.

There are many ways of considering this choice of the child *against* the mother. In the eyes of religions with a matriarchal tendency, it seems aberrant to sacrifice an adult mother to a newborn child. Artemis, while inspiring respect for animal and vegetative life, permits the hunt, provided that we respect the rules and rituals that justify the human in nourishing himself by the sacrifice of animal life. This same reasoning applies to a fetus in most religions pertaining to the Mother Goddess, because it seems self-evident that she who has the power of giving life should also have the power of giving death. Exercise of this power is obviously accompanied by restrictions: there is a limit to the time in which the decision can be made as to whether or not to bear the child. Beyond a certain point of delay, which varies according to cultures, whoever kills a newborn commits the worst type of murder, even more grave than that of killing a stranger, for it has become the murder of someone who has been admitted into the family clan. Our society also has its rules and taboos which, in countries where abortion is allowed, apply from the time the fetus has become viable, that is, between the third and fourth months of preg-

nancy. But we may understand that in older cultures a child was considered viable only if the mother nursed it and if the clan extended its protection by naming it.

Those who claim today that abortion indicates egocentricity in women and couples, as well as those who proclaim that these fetuses are sacrificed to the basest values of our atheistic materialism, probably express a partial truth. If one looks more closely, however, only a tiny percentage of abortions belongs in this category. The majority of women who abort do so because they have enough respect for the child not to give it a diminished life. They know that the unwanted child, born in constraint and misery, is wounded even before being born. Artemis forbids the hunter to wound an animal instead of killing it, leaving it to go its way limping and suffering. In the same way, if one values the integrity of life, one must sacrifice the fetus already marked by the rejection and hostility of those who should receive it with love.

If we follow the spirit of Artemis, the case for abortion could benefit from the two following strategies: 1) the change from a defensive to an offensive attitude, and 2) the recovery of the religious aspects of contraception and abortion.

Taking the Offensive

The offensive would consist in attacking the opponents of abortion on their own ground by proclaiming that *it is a sin against life*, the child, and the collectivity not to abort when necessary. Since the failure of contraception leads to abortion, and since the error is human, it is inhuman not to accept abortion. Most of the time abortion does not express the egotism of women and couples, but their sense of responsibility. I find much more immoral those who force others to reproduce *without assuming the responsibility* for these lives. Perhaps we should send all our unloved, undernourished, prostituted, delinquent, suicidal and battered children to the Vatican, because "*El Papa*" obliges couples, from the height of his moral authority, to bear little ones for whom he assumes no responsibility.

Perhaps the thousands of single mothers, crushed with solitude

or poverty, should go and occupy the spacious and comfortable residences of the priests? Perhaps we should begin to demand that the Vatican open its coffers to nourish "its" children?

Because the bond between mother and child is the most intimate of all, forcing a woman to bear and raise a child against her will is an act of violence. It binds up and degrades the mother–child bond, sowing hatred where there should only be love, receptivity, and welcome. The child is compelled to inhabit a body that is hostile to it: can we imagine any worse reception into the universe? Life is too valuable to allow the play of domination to pollute its flowering. Even from the "humanistic" point of view, who can say how many of these unwanted children have become forces of death? How many, by despair or accident, have taken away their lives or those of others? It is dangerous to bring a being into the world when he is already marked with refusal. The child's purity calls for as great a purity in our desire for him.

Is this the respect for life of which the opponents of abortion are speaking? It seems more like a decadence of the reproductive function, at the service not of love but of domination of one sex over the other, domination of a religion of the father over a one the mother.

> Strange, when we examine the behaviour of the two sexes in regard to procreation: women, by a great majority, love children incomparably more than do men. . . . Now, of the two sexes, it is the one who loves the child the less who imposes his will on the other.[1]

The irresponsibility of the Christian priests (as of the Jewish patriarchs, the Mussulmen, the Hindus, etc.) as regards birth control is dangerous. The epitome of derision was attained by the Pope when he spoke against the use of clinical tests to determine mongolism and other congenital handicaps, because they would lead to abortion. He thereby proposes to add several million cases to the already large number of miserable children and unhappy parents.

Contraception and abortion pertain as much to individual behavior as to collective morality. The equilibrium of the whole ecosystem is actually threatened by religious concepts that are unrealistic, inhuman, and infinitely more cruel than abortion. Overpopulation begins the moment that one child is unwanted, when

the mother no longer feels able to give the best of herself. Overpopulation occurs when, in spite of all goodwill, the resources available cannot guarantee the child the minimum of care, space, attention, and love without which no human being can live in dignity.

Francoise D'Eaubonne brings out four facts that are so simple and so overwhelming that we are forced to take another look at the demographic problem:

1) Women have always, long before overpopulation, been concerned with limiting births. Even in the most repressive societies, they have often succeeded in finding the means of contraception and abortion, even at peril of their lives. In fact, contraception has never been a technical problem, but an ideological or religious one, because human beings have always been able to prevent conception. D'Eaubonne recalls that, at the beginning of civilization, the Hebrews had already discovered the fecund days of a woman's cycle, using this knowledge to increase fertility. The patriarchs have always wanted more sons to increase their power.

2) If women want to limit births, it is because they are the first to feel any disequilibrium between the available resources and the children they bring into the world. Whatever costs are represented by an excess of births, whether by a family or by a nation, it is the feminine Atlas that feels them deeply and from afar. It is in our bodies, in our homes, in our hearts, in our minds that overpopulation begins.

3) Like abusive exploitation of the planet's resources, the excessive use of women's fecundity brings about ecological catastrophe. The patriarchy's appropriation of the feminine womb destroys the power of self-regulation that belongs to the mothers, since they are the first and fundamental element of this regulatory system. D'Eaubonne includes in her "worst negativities" those women educated by the patriarchy who, in a behavior characteristic of the oppressed, continue to defend the patriarchal morality of childbirth, even when they no longer believe in it. "If a woman becomes conscious even once in her lifetime, the backlash is such that nothing will stop her."[2]

4) Feminism and ecology are therefore conjoined in an essential way. The universal wish of women to control births coincides with the new consciousness that the survival of the world depends on our capacity to put a stop to demographic insanity. At the same

time as D'Eaubonne takes note of the link between feminism and ecology, she demonstrates the bond between patriarchy and demographic imbalance.

I believe it is time to abandon the defensive posture, to stop trying to show that abortion is not murder, and to denounce the criminal attitude of the anti-abortionists. The moral position of the official Church bears the worst kind of death that humanity could imagine: the crowding, brutalization, and degeneration of human beings which deprive each person of his humanity. Everyone is aware, for example, of the close links among overpopulation, overcrowding in the cities, unemployment, delinquency, the increase of suicide, rape, poverty, etc. In fact, overpopulation appears to be one of the most "inhuman" of scourges, for it turns people against one another and annihilates all respect for life.

This absurd Christian morality, so full of irony, is applied just where children and women are most rejected and impoverished, victims of the irresponsibility of the Pope, who is so far from women and from life that he does not even see the evil for which he is responsible. Darkened by its own shadow, the Catholic Church, because of its natalist policy, is actually a force of death and decadence.

Let us speak of love and of respect for life to our Pope and ask him if he is ready, beyond making speeches, to give something more than prayers and parades for our children. What resources is he willing to assign them, and what space does he intend to give them? With the ecologist John Livingstone, we must ask to just what "banquet" Paul VI invited the children of the earth when, in 1965, he requested the United Nations not to sanction birth control, so that the children might come to the "Banquet of Life"? Perhaps His Holiness would like to consider the following figures cited by Livingstone: between year 1 of Christendom and year 1650, the rhythm of growth doubled the population.[3] The Black Plague then became a powerful agent in demographic control. Between 1650 and 1850, therefore in only 200 years, the population was again doubled, and it doubled once more in the hundred years that followed. Today, we estimate that the population could double in thirty-five to forty years. In this context, what kind of social values does the Church then represent? Whom must we accuse of bringing death?

At this point we must return to Artemis, for it is her intran-

sigence that suggests that we do not give life if our gift is not pure. Speaking of an "offensive" strategy obviously suggests images of combat. But there are no other "arms" than words, spoken or printed, and the most sure and effective medical instruments so that words may be accompanied by action.

The Religious Aspect of Abortion

What happens to the woman who leaves the modern abortion clinic? She returns home and cries. With whom does she share this event? How should she behave before, during, and after the abortion? So many questions are so generally left unanswered in a cultural, personal, and religious void, leaving the couple, the parents, and the woman floundering in guilt, shame, and desolation.

Several months ago, I received a telephone call from a young man who asked me to receive him immediately, together with his girlfriend, who had just come from the abortion clinic. She did not regret her decision, but she felt "quite bizarre" in simply returning to the office the following day as if nothing had happened. I received them, we talked, and she cried; and she laughed; and he cried, and he laughed; and finally, since it had become more and more clear that this couple knew they had made the right decision, I suggested that they "go and celebrate it." Since she had eaten nothing since the night before, they went to a very good restaurant. She dropped me a line later to say that for the first time she had experienced her right to make a free decision, and that the feeling of melancholy had been assuaged by this celebration of their "freedom of choice." They both had felt much too young, too economically dependent upon their parents, and too uncertain of their budding relationship to have a baby. Both were primarily preoccupied with developing their professional identities as a means of economic survival. A baby would have been a catastrophe, and abortion appeared to be the way of avoiding this drama. Our encounter was an occasion for them both to grasp the serious nature of the creative power and to celebrate the *conscience* with which they wished to exercise it.

Since the laicization of sexual morality, attitudes towards abor-

tion seem to have polarized into two camps. Those who favor abortion tend to trivialize the event or to consider it from the clinical point of view, as if it were the same as removing a tooth. This group treats the decision to abort as something *private*, relating to individual morality. At the other pole are those who are fiercely and *collectively* against abortion, as much for themselves as for others, who think of this question with great emotion and from a collectively religious point of view. On considering this polarization between permissive and individualistic atheism, on one hand, and on the other, a religious and collective opposition, one may imagine two other ideological positions that have not had occasion to be tried in the case of an unwelcome birth: 1) to be against abortion and birth control discreetly, living according to one's own principles but not forcing anyone to share them, and 2) to favor abortion while recovering its ancient religious aspect and its collective significance.

This latter attitude is the one in which I am interested here, because it re-introduces the spirit of Artemis. Knowing the repercussions that such a choice may have on the psyches of women, on the equilibrium or disequilibrium of a family, and on global ecology, one may indeed wish that the acceptance of abortion include its religious aspect. It is, after all, a meeting with death and a conscious use of one of our most powerful instincts.

That birth control has always been a vital preoccupation of women, but that the exercise of the power of decision has been treated as a sin rather than as a responsibility, is probably one more consequence of a religion which has become dissociated from all the mysteries of the feminine sex. There is an evident refusal to see that the practices of birth control and abortion may be highly developed forms of feminine conscience, upon whose exercise and refinement the equilibrium of the entire human community may depend.

A religion that valued the feminine contribution would accept the collective assumption of this sacrifice and associate with it a ritual to express its terrible and necessary dimensions. At the present time, the fetus is sent down the sewer, without any form of farewell, and the operation obeys the rituals of medicine. In many places, abortions are serial operations, and it may happen that not one word is addressed to the woman, except to verify that she has

fasted and has filled out four copies of the bureaucratic forms. Perhaps she does not even see the doctor's face, for she has already been given sedatives. She is stretched out on her back with her legs apart when the doctor, passing from one table to another, proceeds with the next abortion. He opens the neck of the uterus, often provoking a flood of emotion to which no one pays any attention; then one hears the noise of the suction pump, and it is over. A few moments later, one is seated in an armchair, and goodbye, here is the bill. This ritual may vary in its details, but its principal quality is to be as bureaucratic as possible, clinical, and aseptic of all emotion. What happens to all the fear, the guilt, the pain, the solitude and the suffering? The guilt, and sometimes revolt, may be crushing and unjust, insofar as the woman bears alone a burden that belongs to all of us.

It is nevertheless encouraging to note that, wherever women have had some leadership in the abortion clinics, they have organized, parallel to the clinical event, a system of psychological support (in groups or one-to-one) and have managed the place, the sequence of operations, and human relations in such a way that women may go there and not feel like pariahs being cleansed of their "fault." This support group truly "teaches" in showing the way towards a veritable respect for the feminine functions and for human sexuality.

Many women who abort already love this baby that they might have had if. . . . Often men have difficulty in understanding that one may unconsciously, animally, physically wish to have the baby and yet, from the point of view of feminine conscience, realize that it is best not to have it. As a psychologist, I have observed how women surmount the difficulties associated with abortion: those who handle it the best are often the ones who have let themselves feel both the love and the impossibility. All those whom I have assisted love children and are tempted to keep their baby, but their woman's ethic incites them not to behave as irresponsible laying hens.

This situation is not too different from all the other times in our lives when we are confronted with an impossible love or a broken friendship, sacrificed to reason or to necessity. The pain of renunciation is the same. In almost all cases, one aborts an impossible love, not a hatred. The child is sacrificed to a value that one judges

at the time to be more important: either the children one has already borne, those one will have one day, or one's own psychological, economic, or physical survival.

The early Christians refused a life that appeared to them as a negation of life, love, and justice. In the name of his spiritual life, the Christian claimed martyrdom; he preferred death to a life of compromise.

I believe it is time to sacrifice to Artemis the fetus to which we are not prepared to give the best of ourselves and our collective resources. Just as there are certain levels of physical pollution we should not tolerate, there is a limit to the psychological and social misery into which we should introduce the gift of life.

The universal unconscious has always utilized different methods of reducing population when space and resources are deficient. The most obvious is war, which comes about when population expansion has become explosive and the social climate is deteriorating. The "sacrifice" of lives then takes place through men rather than through women, but the victims die at random, and the power of death is unleashed in all its fury, and beyond reason. It is clear that we are at one of these dangerous moments in which tensions of the collective unconscious could lead to a mega-tantrum of aggression, accompanied as usual by the myth of "war as purification." But perhaps we should no longer have faith in an all-male collective *unconscious*, instead developing as quickly as possible a collective *consciousness* which would establish a new sharing of the powers of death between men and women.

CHAPTER TWELVE

Adolescence: The Shy Age under the Protection of Artemis

When quite young, Artemis rebelled against the image of the "nice girl": she desired neither an attractive dress, nor trinkets, nor any of the things thought to delight the young girl who is becoming conscious of her femininity. What did she want, then? Liberty! Freedom to climb the mountains, swim in the rivers, ride horseback, hunt, and race with her hounds. Today, we would call her a sportswoman. Or, because we no longer recognize how natural this energy is for girls, we would call her a "tomboy," although she is the archetypal young girl not yet oriented towards the femininity of Aphrodite. Such femininity, directed towards the other, seemed to young Artemis a seduction that would deflect her from what she truly wanted to be. She therefore asked a favor of her father Zeus: never to have to wear the long and cumbersome dress of women nor their burdensome ornaments. She preferred the liberty of movement allowed by the short tunic, just above the knees, and solid and flat-heeled sandals. She wanted, like her brother Apollo, a sheath of arrows, not jewelry.

A parent or a teacher can easily recognize this mood in a girl, when suddenly she starts to rebel like an unbroken filly against all that pertains to culture and official femininity. If Artemis had more place in our values, it would be easier for girls to express and develop their own strength rather than employ all their resources in learning, too early, the subtleties of Aphrodite or the responsibilities of Demetrian motherhood.

One of my students, the mother of an adolescent girl, told me that her daughter was in full Artemisian revolt against anything that seemed restrictive, particularly the "good manners" that our culture associates with femininity. The girl was very enthusiastic about the idea of a steam bath capped off with a run, naked, through the snow, but her mother had to argue with her to take a weekly bath. To wash, primp, and perfume herself in the bathroom struck her as insignificant, and, further, she justified herself in saying that she preferred her animal odors! She refused under every circumstance to give up her usual uniform of jeans, t-shirt, and running-shoes, and the idea of wearing a dress bothered her to the highest degree. On her birthday, her grand-mother, hoping to see her adopt a less primitive style, gave her some beauty products, choosing with care the strictly "natural" (honey soap, shampoo of wild herbs, etc.), a skirt woven by an artisan, and comfortable leather shoes. The young woman appreciated the craftsmanship and "ecological" qualities of all this and thanked her grandmother politely, but the following week she had traded her birthday presents with a college friend for a new wheel for her bicycle and a knapsack with a light frame! Boys interested her, but only in the brother–sister (Artemis–Apollo) type of rapport. As soon as the relationship hinted of sexuality, she withdrew swiftly.

The Greek Artemis symbolically protected young girls and boys from the age of nine, the age at which one is detached from the mother's apron-strings, until the age of adult responsibility, citizenship, and marriage, which at that time was as young as fourteen for girls.

The night before marriage, young girls consecrated their tunics and their youthful belongings to Artemis, as a farewell to their youth and as an initiation into their life as women. This was also the passage from Artemis to Aphrodite, the beginning of sexual life, and the discovery of the subtleties between men and women. Since it is a transition between mutually exclusive Goddesses, the demarcation must be quite clear, and ritual marked out the territory between one and the other.

The age of Artemis, which the Freudians have called "latency," effectively put sexuality in abeyance. Artemis not only demands a short tunic and liberty of movement; she wishes to remain a virgin eternally. This marvelously symbolizes the desire to belong to

oneself. Such a period is necessary, a period of solitude marking the end of physical attachment to the mother before the beginning of sexual fusion. The only interest Artemis shows in the body of a child is to grant him or her a healthy body, one that is strong and straight, a proper foundation for a vigorous adolescence. She was invoked for the child's development in vigor and independence, and Artemis hastens to mark the age of separation from childhood.

The capacity of the adolescent to leave home is often accompanied by a refusal to enter the structured and ordered world of the city, for this would be too early an acceptance of the halter. Artemis, who dislikes the restraint of animals, offers youth the time and space to be wild. Flight into the forests of Artemis and joy in a young body, just liberated from Mother's skirts but not yet admitted to the adult order, are under the protection of this Goddess. P. Ellinger correlates in an interesting way these two aspects of Artemis—protectress of the wilds and Goddess of adolescence. One may indeed see this period of life as the most refractory as regards the learned civilities and the role of responsible adults. Moreover, Artemis delimits the frontier between the city and the wild; where the territory of Artemis begins, the city ends. She assumes these symbolic functions in delimiting youth, which ends at the moment of initiation into society:

> Far beyond the city are the wild places. The cultivated land is the space of adults, citizens, their work, their battles and the wars in which they engage to defend it. . . . In contrast, the "eschatia," the marginal zone and the zone of passage from the cultured area to the totally uncultivated, symbolizes and also is another kind of transition, that from childhood and adolescence to the adult stage, the transition from the wild and "thorny" to cultivated life and "ground corn". . . .[1]

Together with the hound, the horse, and the dog, the bear was one of the animal figures frequently associated with Artemis. The female bear is one of the most difficult animals to domesticate. We may make a circus bear of the male animal, but the female is much more recalcitrant. The expression "act like a bear" signifies in French refusal of any elaborate social life and refusal of the conventions and customs of human relationships.

In the city of Brauron, in ancient Greece, there took place a festival for young girls, either on the mountains or on the grass-lands, where girls, sometimes clad in bearskins, played at "acting the bear." They actualized in dances, gestures, and growling mimicry the awkward, rough, grouchy and uncultured aspects of a recalcitrant age. These festivals were occasions for the exterioriza-tion of raw energy and consciousness of the body other than by sexuality and maternity. We must notice the solid feet, the strong limbs of the statues of Artemis. In the language of bio-energetics, one could say that she was represented as firmly grounded, her posture showing large feet firmly planted and her body in sound equilibrium. The occasion to play the bear, and all the variations that we may imagine of the need to express this primitive, bodily energy, may be an essential step in the development of feminine energy and physical strength, without the interference of Aphrodite. To get entangled in Aphroditic complexities at the age of fifteen, to learn to be pretty and pleasing when it is the age for running, having a row, and feeling like a free animal—this is a premature development. One must then return to and recapture the Artemisian archetype.

The bear cult and the rituals in honor of Artemis were occasions for girls to be together. Nowadays, since co-education has mingled the sexes, girls have lost most of the structures of feminine leader-ship. The necessity of activities "for girls only" (or "for boys only") has now re-appeared as a psycho-social need to which one must re-spond, without, however, losing the benefits of mixed education. Not so long ago, a girl, before going to university, was for fifteen years in an educational context of only women and girls. The whole hierarchy and leadership were entirely feminine. I myself ex-perienced the shock of arriving in a university where all the leader-ship figures, the professorships as well as the student association, were suddenly mostly masculine. Fortunately, this has now changed, and we may hope that mixed education becomes, over the years, something more than "permission" for young women to go to a boys' school and a men's university.

The idea of a truly mixed education is slowly making its way, but it would perhaps be interesting, parallel to this, to compensate women's great loss of a feminine leadership structure by reserving places exclusively for women. We must take a look at what is ac-tually happening in colleges. Would not a sociometric survey

reveal that the network of masculine leadership, the boys' team, has persisted throughout mixed education, whereas the network of feminine leadership has been undermined by the institutional integration of men and women? Shall we not have to invent other places, other rituals, where girls may find themselves among girls? There is some danger to the young girl's identity when she begins to chase boys too early. Where may the girls go who honor Artemis rather than Aphrodite? A girl must have a chance to experience the giddiness, the adventures and pleasures of a group of girls, for otherwise boredom will ravage her adult life.

The present popularity of teaching wen-do results from more than its appeal as a technique of self-defense. It is, in fact, an Artemisian ritual that satisfies a profound and urgent need. I have taken the example of wen-do because this discipline is quite explicitly for women or girls. The leadership of the wen-do mistress adds a psychological dimension that helps to identify femininity with physical strength. As in Sparta where, beneath the statue of Artemis, girls learned to fight in the nude, their bodies slick with oil, modern wen-do develops the Amazonian attitude and strengthens the body, which Artemis wishes to be strong and healthy.

Feminism has attempted, by many means, to give women back the vigor and audacity of their bodies, qualities which are then translated throughout their personality. In Montreal, in a feminist play written in 1980 by Pol Pelletier, the author makes her character "Torregrossa" express the pleasure and importance of this energy:

> First step: physical warm-up. This warm-up will be done in battle, or fights, or a brawl, if you prefer—yes, brawl is more precise. Since I am personally and totally frustrated at being deprived, by reason of my femininity, of that absolute and carnal encounter between two opposing bodies, which create and find their form precisely in their opposition—which every little boy knows from his earliest childhood—I propose that you advance in pairs over the velvety moss, each in your turn, facing one another. It is not a matter of injuring one another—no, not at all—but to find out who will bring the other to the ground, without low blows or injuries. Who will pin whom to the ground, face up, without harm, who will find themselves pinned to the ground by the sheer weight and will of the other?

> The idea of competition is not involved, although, paradoxically, it is a competition. Winning or losing is not the question. The question is—you'll never guess: aggressivity! The aggressive impulse and disposition so tenaciously held in the hearts of half of humanity. Did you know that "aggressive" means, etymologically, "to have tension towards"? Tension towards . . . the definition of life itself. Of survival.[2]

That wen-do was developed as a reaction against the bewildering increase in rape only reinforces its relation to the myth of Artemis. The Goddess was never violated, did not accept being touched nor even seen, let alone being seen nude! Actaeon, the hunter-voyeur, wanted to contemplate the splendor of this Goddess whom no man had ever touched, and the reaction of Artemis was without pity: she transformed him into a deer, and he was devoured by his own hunting dogs. Many other myths insist both on the effectiveness with which she defends her virginity and the violence with which she revenges the rape of young girls.

Perhaps through the development of Artemisian strength, we shall soon see groups of modern Amazons who, because of the default of our justice system and police regulations, will find other, more effective, and certainly more savage ways of revenging the constant rape of girls and women.

The wen-do schools are but one example illustrating the defensive powers of Artemis. But we may also see the expression of this energy in activities that are athletic rather than warlike, for Artemis is the patroness of women's sports. She is a tireless racer, a champion swimmer, and, obviously, a gifted horse-woman.

Adolescent girls have often an inordinate passion for horses and riding. Since I often ride myself, I have visited most of the riding-schools in my district. And I was not surprised to find, in almost all of them, that the number of girls exceeded the number of boys. Last year, I went to register my children at one of these schools. The monitors were girls, from fourteen to sixteen years of age, and the owner was a rider of exceptional ability, a magnificent Artemis. In one riding-school, girls could ride the horses without charge, provided that they helped give the lessons and take care of the horses. Some of the girls spent all their leisure time there, taking much pleasure in talking to the beasts, some with a certain vulgarity which the dung seemed to excuse, and others with a cer-

tain haughtiness. They all appeared perfectly at ease in this animal world and happy to demonstrate their endurance and physical courage.

Even though adolescence is a peak for Artemis, we should not limit the expression of this archetype to any time of life. As with all other archetypal figures, one may approach her and retreat from her often during a lifetime. One may return to Artemis whenever the body demands a general purification, or when suddenly one has the impression of being ensnared in Aphrodisiacal complications, or simply when one has need of a taste of youth. Sometimes an encounter or a trip exclusively with women becomes an occasion for re-activating our "puella," that is, the little girl who still inhabits us. Here, one understands the friendship that links Artemis and Hermes, boy and girl. The return of Artemis is frequently an effective therapy for boredom, because she re-activates corporeal energies which revive the puella. The women's movement has often given women of all ages the chance to regain contact with this primitive femininity, developing physical as well as psychic independence. To feel the carefree nature of the doe, the power of the she-bear, and the trembling nostrils of the riding-horse, a woman must change her high heels for flat shoes, forget the civilities, and disinvest the city persona.

Development of physical strength and the passion for independence, which are graces of Artemis, lead us to speak of the Amazon, the extreme figure of feminine separation.

CHAPTER THIRTEEN

Artemis the Amazon

The myth of the Amazons has always been popular in all cultures, for it seems that it is a universal myth. The radical and isolationist feminism of the seventies re-activated this myth at the conscious level where it provoked, as it always has, both scandal and admiration, curiosity and hostility, relief and fear. The world of fiction also took up this popular myth, proposing Wonder-Women of all kinds, whose prowess pleased the young women and attracted the admiration of the boys. Amazonism, although extreme, is as important in forming the identity of girls as it is in modifying masculine prejudice, by pressing as far as possible the reversal of roles in order to show their relativity.

The readiness of Artemis to defend her independence, her physical strength and agility, her bow and arrow, her familiarity with horses—all of these have always been associated with the Amazon. The Greek poet Pindar (521–441 B.C.) attributes to the Amazons founding the temple of Artemis at Ephesus. Pausanias, a historian and geographer of the second century B.C., reported this opinion, but believed, for his part, that the Amazons only took refuge there when they were in flight from their defeat at the siege of Athens. However it may be, the Amazons felt at home with Artemis. But, although it is clear that the figure of Artemis belongs to myth and not to history, how shall we consider the Amazons? Did they "really exist"?

They have been presented as a historical reality in Homer (*The*

Iliad, 3.189 and 6.186), Aeschylus (*The Suppliants*, 287), Herodotus (*The Inquest*, 4, from 110), Hippocrates (*Atmosphere, Water, and Places*, 17), Diodorus of Sicily (111, 58), Apollodorus (2.5.9), Strabo (6.5.17), Plutarch (*Theseus*, 26), Pausanias and Tacitus. We have no reports concerning direct witness of these Amazons, and they are always presented as barbarians (which meant "not Greek") and as far away. There were two races of Amazons, the Libyan and the Numidian in northwest Africa, and later the Thermodon Amazons, in the northeast, from the region of the Black Sea, who were led by Penthesileia at about the end of the thirteenth century B.C.

We therefore find that rumor and tale have as much place in the history of Amazons as in other accounts of heroic exploits and warriors; myth and history are here inextricably interwoven. But that a given reality be mythic as well as historic does not diminish its power. The persistence and universality of the Amazon myth are proof of its importance, at least as a myth. This entanglement of history and myth is only embarrassing when we try, at all costs, to hold to the facts rather than to the spirit. Thus, for example, the belief that the Amazons mutilated their right breasts in order to improve their archery seems to be an error of linguistic interpretation:

> This mutilation of the Amazons, which is a pure product of language (the Greeks translated "a-mazo" as "without breast"), is without example in figurative representations. It appears in the Fifth Century B.C. in a text by Hippocratus, in which physiological rationale subserves ideology: "They burn the right breast so that the whole force and tension is borne by the shoulder and the arm."[1]

Not by chance did this linguistic mistake give rise to such a belief. From the mythic point of view, it is right to believe that the Amazon refused anything of the feminine or sexual that would handicap the defense of their autonomy. It is therefore probable that this fable of the "mutilated" breasts was historically false but symbolically true. Both the myth of Artemis and that of the Amazons center around the same themes: autonomy at any price, sacrifice, intransigence, and rejection of the sexual bond. The myth of mutilating the right breast quite adequately symbolizes the system of values attributed to the Amazons.

Another, much older ambiguity of language also has great significance. Homer, when he briefly mentions the Amazons, uses the expression *antianeirai* (*Iliad*, 6.186), which may mean both "resembling men" or "equal to men," as well as "enemies of men" or "opposed to men," according to the two possible meanings of *anti*. (Other translators employ the expression "virile women" or "virile women warrioresses.") But this ambiguity of language corresponds to a veritable and profound ambivalence present in Homer as well as in all the other authors: are Amazons enemies whom men must fight or equals with whom they may rightfully associate? In a patriarchal society, is it inevitable that any group of women who show a forcible desire to separate and establish well-defended boundaries be considered a threat? Moreover, why did the power of these women prove to be such an irresistible attraction to these warriors? They seemed to find in them their alter-ego, warrioresses similar to themselves, and at the same time odd strangers, since they were women. Desirable and dangerous, they always posed the same dilemma for men: should one destroy them or allow oneself to love them?

The myth of Achilles' slaying of Penthesileia expresses a tragic and frequent double bind. Achilles, the heroic warrior, measures himself in combat with the Queen of the Amazons, Penthesileia, before the gates of Troy. But to fight against her makes him aware of all her qualities: she is a powerful warrioress and, like all warriors, Achilles appreciates a worthy adversary. But, on top of that, Penthesileia is a woman, and a beautiful one. At the moment he kills her, Achilles falls desperately in love with her. Like so many men who at the same time love and fight the "Amazon" in the woman they love, Achilles finds himself destroying his lover. He dominates her by his greater physical strength, but his victory is at the same time his defeat and a tragic loss.

On the part of the "Amazonian" woman, the double bind occurs when she falls in love with a man. The more she resists, the more he admires her, for it is the Amazon in her that he loves. But if she yields to him, she is no longer an Amazon, becoming instead an "ordinary" woman: she loses his love the moment that, through love, she becomes vulnerable. She has no choice but to fight or be overcome. In any relationship where one or the other of the partners conceives of love as a submission to the partner, the myth of the Amazon is present. The man confronting her admires her, but

becomes an adversary. The Amazon cannot approach love without risking defeat or scorn. The only way out consists in untying the knot between love and submission. But how difficult that is, perhaps more difficult than dying in combat! Phyllis Chesler, in her essay interpreting the myth of the Amazon, writes: "Sometimes Amazons fall in love with their male adversaries, drop their arms, and become wife and mother. But Greek men fall in love with Amazons only when these women have been wounded and are dying."[2]

However, we must add to this remark, otherwise just, that the Greek men who approached the Amazons, far from being ordinary, were very typical heroes, assigned to battle with the barbarian women. Therefore, more than other men, they were involved in the myth of the hero, who must win at all costs and never yield, above all to a woman. Things might happen differently were the Amazons to frequent other types of men, non-Greeks like themselves, younger and less competitive than the heroes. Herodotus relates such an encounter, and even if the passage is very long, it deserves to be quoted entirely for the numerous details it gives about the Amazons. In this story, even though the Amazons end in taking a liking to the men, they still abduct their husbands.

> About the Sauromatae there is the following story. In the war between the Greeks and the Amazons, the Greeks, after their victory at the river Thermodon, sailed off in three ships with as many Amazons on board as they had succeeded in taking alive. Once at sea, the women murdered their captors, but, as they had no knowledge of boats and were unable to handle either rudder or sail or oar, they soon found themselves, when the men were done for, at the mercy of wind and wave, and were blown to Cremni—the Cliffs—on Lake Maeotis, a place within the territory of the free Scythians. Here they got ashore and made their way inland to an inhabited part of the country. The first thing they fell in with was a herd of horses grazing; these they seized, and, mounting on their backs, rode off in search of loot. The Scythians could not understand what was happening and were at a loss to know where the marauders had come from, as their dress, speech, and nationality were strange to them. Thinking, however, that they were young men, they fought in defence of their property, and discovered from the bodies which came into their posses-

sion after the battle that they were women. The discovery gave a new
direction to their plans; they decided to make no further attempt to
kill the invaders, but to send out a detachment of their youngest
men, about equal in number to the Amazons, with orders to camp
near them and take their cue from whatever it was the Amazons then
did: if they pursued them, they were not to fight, but to give ground;
then, when the pursuit was abandoned, they were once again to en-
camp within easy range. The motive behind this policy was the
Scythians' desire to get children by the Amazons. The detachment of
young men obeyed their order, and the Amazons, realizing that they
meant no harm, did not attempt to molest them, with the result that
every day the two camps drew a little closer together. Neither party
had anything but their weapons and their horses, and both lived the
same sort of life, hunting and plundering.

Towards midday, the Amazons used to scatter and go off to some
little distance in ones and twos to ease themselves, and the Scythians,
when they noticed this, followed suit; until one of them, coming
upon an Amazon girl all by herself, began to make advances to her.
She, nothing loth, gave him what he wanted, and then told him by
signs (being unable to express her meaning in words, as neither
understood the other's language) to return on the following day with
a friend, making it clear that there must be two men, and that she
herself would bring another girl. The young man then left her and
told the others what had happened, and on the next day took a
friend to the same spot, where he found his Amazon waiting for him
and another one with her. Having learnt of their success, the rest of
the young Scythians soon succeeded in getting the Amazons to sub-
mit to their wishes. The two camps were united, and Amazons and
Scythians lived together, each man keeping for his wife the woman
whose favour he had first enjoyed. The men could not learn the
women's language, but the women succeeded in picking up the
men's; so when they could understand one another, the Scythians
made the following proposal: "We have parents and property. Let us
give up our present way of life and return to live with our people. We
will keep you as our wives and not take any other." The Amazons
replied: "We and the women of your nation could never live
together; our ways are too much at variance. We are riders; our
business is with the bow and spear, and we know nothing of
women's work; but in your country no woman has anything to do

with such things—your women stay at home in their waggons occupied with feminine tasks, and never go out to hunt or for any other purpose. We could not possibly agree. If, however, you wish to keep us for your wives and to behave as honorable men, go and get from your parents the share of property which is due to you, and then let us go off and live by ourselves." The young men agreed to this, and when they came back, each with his portion of the family possessions, the Amazons said: "We dread the prospect of settling down here, for we have done much damage to the country by our raids and we have robbed you of your parents. Look now—if you think fit to keep us for your wives, let us get out of the country altogether and settle somewhere on the other side of the Tanais." Once again the Scythians agreed, so they crossed the Tanais and travelled east for three days, and then north, for another three, from Lake Maeotis, until they reached the country where they are today, and settled down there. Ever since then women of the Sauromatae have kept their old ways, riding to the hunt on horseback sometimes with, sometimes without their menfolk, taking part in war and wearing the same sort of clothes as men. The language of these people is the Scythian, but it has always been a corrupt form of it because the Amazons were never able to learn to speak it properly. They have a marriage law which forbids a girl to marry until she has killed an enemy in battle; some of their women, unable to fulfil this condition, grow old and die in spinsterhood.[3]

This story is very rich, and one has the impression that a simple tranposition yields a very contemporary scenario. Women do not want husbands who lay down the law, they do not want a patriarchal or patrilocal type of union, and they do not want work "reserved for their sex." They do not want to give up fighting their own battles, but they want to enjoy men, in broad daylight, and even to live with them if they will join them in all "independence," bringing their share of possessions. As for the young men of the ancient tale, they are at first disconcerted and then seduced by women who are so different from their own tribes. An association with them would surely bring strong children! But finally, a compromise appears most satisfactory: neither at your place nor at mine, but "elsewhere."

On leaving Artemis, it would be helpful to add a few distinctions

between the Amazon-warrioress and Athena, also a Goddess of war, but of a very different kind. The Amazonian formations of radical and separatist feminism have been very important in preserving strictly feminine spaces and values, in which the alternative of a life "among women" is kept alive, ready to arise whenever, for any woman, compromise is no longer possible. Contrary to this, the archetype of Athena personifies the combativeness of the feminine figure in the world of men. This feminism represented by Athena is essential to women's participation in male power-structures. While the Amazon fights wildly with physical and passionate élan, Athena, to win a war, calls upon the resources of her "civilized" mind, her intellectual powers and her self-command. Many feminists think of Athena as the archetypal token-woman, but I—as a feminist—would argue that no archetype is all-negative. Theirs is a typically monotheistic, manichaean attitude.

The ancient Amazon (living in bands of women) rarely mixed with men, but did not necessarily refuse sexual enjoyment with a man when the occasion presented itself, either for pleasure or reproductive necessity. In contrast, Athena was represented as very close to men, having a very friendly relationship with them, but nowhere in the myth does she seem tempted to enjoy them sexually. Both Artemis and Athena are archetypes of autonomy and combativeness which, in a pluralist vision of feminine identities, would have their places and moments of expression.

Sometimes the Amazonian myth re-appears in its tragic form: these women are destroyed, physically or psychologically, socially or politically; but they are always re-born wherever feminine separatism becomes the only way of escaping the domination of one sex over the other. Literary fiction, comic strips, theater and television from time to time go back to this myth, because it concerns the unconscious of both men and women.[4]

> I sing of burning Artemis of the golden arrows, the
> adored Virgin, the Archeress who with one shot strikes
> the stag, the true sister of Apollo of the golden
> sceptre, she who, on the shadowy mountains and the
> wind-swept peaks, draws her bow of pure gold and shoots
> death-dealing arrows in the joy of the chase. The summits

of the high mountains tremble, and the shady forest
holds the frightened cries of the beasts of the woods;
the earth trembles, as well as the seas, filled with fish.
The goddess of the valiant heart springs forth on all sides,
and sows death among the race of wild animals.[5]

PART THREE

Hestia

CHAPTER FOURTEEN

The Warm Hearth

Hestia is represented as almost completely veiled with clothing, very straight, both imposing and discreet, and of a remarkable immobility. Seated or standing, she indicates no movement. Calm and dignity emanate from her.

Although few stories and myths surround Hestia, one must not believe that she is of less importance than the other Olympians. She is less brilliant and is not much talked about, but by the place she held in daily life she was one of the most often honored. That there are few stories relating to her underlines the fact that she likes neither change nor adventure; there is, therefore, little to "spin yarns" about, because nothing much happens to her. If, in this book, she takes up less space than Aphrodite or Artemis, it is not because she does not merit the attention, but because her role is so central that we understand immediately how her power is exercised and the function she performs in the home.

Hestia is the center of the Earth, the center of the home, and our own personal center. She does not leave her place; we must go to her. Robert Graves says of her: "The mildest, most upright, most charitable of all the Olympians."

The home of the average Greek of antiquity was in the first place a hearth, around which was built a house. The domestic space was organized around a hearth, and Hestia *was* this hearth. There was only one word to designate both the hearth and the Goddess who inhabited it. Just as "orgasm" is designated in ancient Greek by the word "Aphrodite," so the hearth fire is designated as "Hestia."

This was the heart of the home, the place of intimacy for the group or family, a shelter from tumult, for Hestia protects, receives, and reassures. When a stranger was invited in the area of the hearth, he was protected, for this place was sacred. The temple of Hestia fulfilled this same function for a town. Whoever entered it enjoyed a political and social immunity resembling that of a guest received before the hearth, for it was a sacred asylum where one could take refuge. Quarrels and fights could not develop in Hestia's presence, because the hearth was a place of peace and security. As Plato remarked, when the Gods quarreled, only Hestia did not take part.

The Hestia of a town or city was also the community fire-center, for the use of all the citizens. Over a very long period, when cities were administered by the archons (old wise men), it was the custom for the people to gather around the city fireplace (the prytane), which was consecrated to Hestia. With the Romans, this symbol took on an even greater importance, and the Vestals, or priestesses of Vesta (Hestia), were responsible for keeping the sacred fire of the city. The Roman Vestals received the respect and consideration of all.

If Hestia's fire went out in the home or in a city of ancient Greece, the significance was tragic, and there were complex rituals for relighting it. Thus, when the Persians laid siege to Athens and extinguished the sacred fire, the Athenians, after defeating them, sent for fire at the great temple of Hestia at Delphi to re-kindle the fire of their own city.

The Hestia of a home was always extinguished on an occasion of mourning, if the latter signified at the same time the end of a household, the death of a family, the abandonment of a location, and the dispersion of those who had formerly constituted the household.

Since many women today are getting out of the house, it is not easy to speak of the real nature of Hestia, the Goddess who is honored in the home, without thereby giving rise to more arguments about "retrogressive sexism" which would confine women to staying "in their place." But I believe that a study of the Hestia archetype could enable us to understand why women had to leave home in order not to be depressed in it, for one must not stay in a house in which the fire has been extinguished. To know Hestia is

also to understand that in a disquieting number of homes the central fire is dead. There is no sense in remaining alone in a lifeless home until the cold of psychological death overcomes the survivor. The flame that will re-animate the house must be sought elsewhere. It is significant to compare the cult and the respect formerly accorded Hestia with the sarcasm and deception which today color such expressions as "housewife" or "Mistress of the House." These expressions have not always had the derisory meaning that they have acquired since the interior life of the home has been diminished and the wife has become a servant in her own house. Maybe it was necessary for women to leave the hearth so that the community might perceive the need for new values associated with Hestia and the home, the district, and the city. Maybe there is a renewal of Hestia in what Roszak calls "the practical sacrament" in a chapter of his book *Person/Planet,*[1] and what Betty Friedan describes as part of the second stage of contemporary feminism.[2] Here the values associated with home and family would be renewed, not under the impulsion of sexism which would return women to their frying pans, but from a shared desire to re-invest the center and to honor human relations through Hestia.

Where Is the Hestia of Our Houses?

The architectural possibilities for houses are multiple, and we understand why Diodorus of Sicily (first century B.C.) attributed to Hestia the invention of domestic architecture.

Several years ago, I studied architecture in order to build my country home. This excursion into a specialty not my own was both a fascinating and shocking experience. Fascinating, because it was the occasion for realizing to what extent the use of space reflects and influences human relationships. Shocking, because I found that modern architecture, such as it is, is dominated by male values. The womb and the house, gynecology and architecture: both territories alienated from women, both requiring to be re-conquered and re-inhabited by women.

If we have had a feminism that caused us to get out of the house, is there not also room for a feminism that would bring us back

home, so that our homes would reflect ourselves and would once more have a soul?

An architecture inspired by Hestia implies a special layout developed from a center. Modern architecture, particularly in postwar America, is oriented outwards in such a way that most of the so-called "family homes" are in fact anti-family. This is increasingly true the more the exterior environment (the street, the automobiles, the noise, etc.) is hostile. The interior of the home is impoverished and the facade is made to "be seen."

The living-room, which serves more for social than for family life, is in some houses more spacious and luxurious than the rooms used by the whole family. As for the kitchen, still the domain of women and children, only recently have the architects, decorators, and the women themselves given it as much attention as they have the more "noble" rooms of the house.

There are houses which are only decor or crash-pads, and those who evolve in them feel indeed that their home is without life. Inevitably, in such homes the woman is considered, and considers herself, a servant rather than a Hestia.

Hestia is found wherever the family finds its center. The center of a house is obviously not determined by authority, and certainly the architect should not decide upon it. It seems significant that many women, when participating in the construction or renovation of their home, tend to open a space between the kitchen, the dining-room, and the living-room, because this space is the one for family activities. It is the center of the house and the psychological equivalent of Hestia for the average family today. In some homes, the television set plays the role of Hestia. Others seem to gravitate around the refrigerator or the kitchen; some only show life in the workshop or in the recreation room in the basement, and we may soon see the computer receive the honors of the family altar. Hestia corresponds to whatever is the center of the affections, the needs, the preoccupations and the activities of the family. As an aid in situating Hestia, we may ask ourselves the following question: when we are away from home, what image best represents our "place"? If there is a similar or compatible image for various members of the family, that is the center of the house.

With Hestia, we are in the collective domain. It is Artemis, not Hestia, who preoccupies herself with the needs of solitude and autonomy. What matters to Hestia is the group, the "we," the

familiarity of those who surround her, and the architecture should reflect this collectivity rather than the personality of the architect.

How Do We Honor Hestia?

It is quite natural that Hestia preside over the festivities that cement family life, for the home is the place where people assemble to eat and have a good time. It is not so much with the food that Hestia is associated, for Demeter brings the harvest, but with the communal aspect of these family reunions around the table. The fact of eating together has always had an important place in family and social life. Hestia here conjoins Hera, the Goddess who protects marriage and family structures. However, Hera is more interested in power structures and decision-making, while Hestia is above all concerned with bringing together, in space and time, those who form a household.

With the Romans, where the cult of Vesta was even more developed, she presided over the preparation of meals, and the first draught or mouthful of food was consecrated to her. Instead of the grace said by Christians or lay forms of opening such as "cheers," the formula "to Vesta" was the ritual beginning of their meals.

Since eating together is one of the most important elements of family life, parents and sociologists today have not failed to remark that the institution of fast-food counters, where millions of adolescents have their meals, is as deleterious to American families as is television. But if the family table has been deserted, it is because it now exerts such a weak power of attraction. Many women have given up their position, reducing their role to that of a servant and their home to a kind of free hotel. How can one honor Hestia in such homes? What is happening in many homes is similar to what is happening in the towns, the districts, and the villages, that is, a dispersion, a diffusion, that leaves the center empty. Many families are empty at the core, possessing only a facade of superficial human relationships, in a suburban architecture that has forgotten Hestia.

The archetype of Hestia, just as that of all the other Goddesses,

is uninteresting if one only wishes to imitate the Greek. We have to use it as a focus for questioning ourselves, for creating images. Many analogies may suggest themselves as to the condition of a house and the state of the family inhabiting it. For example, to have a family life that warms us, we must, as with the flame of Hestia, maintain it, watch over it, nourish it, and place it at the center of our attention. Other, less positive images may come to mind. Some homes conceive of a Hestia who is no longer the upright and dignified Goddess, but a vulgar and fiery slut who can no longer be the object of family respect; the center of the home is sullied. Hestia is present, but in her negative form. She is disordered and symbolizes the neurotic housewife rather than the peaceful and far-seeing Hestia.

I had a twenty-year-old student to whom I told the myth of Hestia. He was of a family in which madness and schizophrenia seemed quite atavistic. One day he told me he had visualized his family in an isolated and dilapidated house. At the center of the basement was a Hestia, a fireplace that could hardly contain the flames, which threatened to break out at any moment and "set fire to the curtains." The Hestia was "spitting fire," and, instead of providing warmth, security, and unity, it burned uneasily, causing anxiety. This visualization remained vivid in his mind for several weeks, being for him an important intuition. He came to me only once more, to tell me that he had thought a great deal about the matter, deciding that there was only one thing to do in a home that was in danger of catching fire—flee before perishing in it. He left his family and found employment with the hydro-electric venture at James Bay in northern Quebec. Outside it was very cold, but in the community houses daily life was organized comfortably and kept going twenty-four hours a day. There was always someone keeping an eye on Hestia, and this group life agreed with him and healed him.

Hestia and Organization

Nancy Foy, in a book entitled *The Yin and Yang of Organizations*, explains the importance to an organization of the person she

calls the "spider," that is, the one who weaves the webs, stays at the center, and retains information.[3] This function is often filled by a secretary or by the "mainstay" of any association. Foy opposes this function to those filled by "butterflies," that is, those occupied with public relations and clients who deploy their energies principally towards the exterior in order to obtain clients, resources, contracts, etc.

The spider and the butterfly, as described by Foy, symbolize two types of functions essential to any organization and correspond to the figures of Hestia and Hermes. The Greek myths offer the advantage of being rich, and above all offer a dynamic model of interaction between Hestia and Hermes, whereas there is no necessary link between a spider and a butterfly. This is the advantage of myth over symbol.

Foy seems extremely interesting from the point of view of a symbolic or mythic reading of organizations. Her analysis of several large British and American groups confirms the importance of the Hestia myth (i.e., the "spider") in all organizations that wish to retain their members and permit them to identify with it.

When Hestia is well provided for by the architect and the staff, interpersonal networks are strengthened and multiplied, and information is generally more abundant and less biased than in a less coherent milieu. Following Foy's intuitions, the whole myth of Hestia (that she calls the spider) and the equilibrium it suggests with Hermes (the butterfly) may be employed to the benefit of an organization; for organizations, especially if they are subjected to a decentralized political environment, must develop new ways of concentrating the energies of multiple human networks. Political and institutional decentralization, like changes involving new technologies of communication, may perhaps have the paradoxical effect, not of anarchy, but of a new confederation of institutional hearths, each animated and warmed by its own Hestia.

CHAPTER FIFTEEN

Hestia and Planetary Ecology

The name "Hestia" did not only signify the central hearth containing the fires of the household or the city. It also designated the center of the earth which, according to Greek beliefs, contained our planet's fire. Further, since the Greeks were geocentrists, Hestia was then also the central planet around which all the planets of the universe were coordinated.

Just as there are many kinds of fire, each patronized by a different divinity, so it is with the earth. Gaia, Demeter, and Hestia represent different aspects of it, and in order to grasp what is not Hestia, we must give some outline of the other feminine divinities associated with the earth. Thus, gigantic Gaia—the Earth, the primordial Goddess who brought the first generation of Titans and Titanesses into the world, as well as the first human—is a maternal earth, with the generous bosom always associated with fertility, genetic of everything that springs from the earth.

The same word "earth" is often employed to designate both our planet and the soil in which plants germinate. "Gaia" contains the two meanings, for she is the origin of life. But although Gaia is the original Mother, she is more soil than mother and too huge, too distant to have the characteristics generally associated with a human mother. (Her daughter Rhea, the mother of the Olympians, would be nearer to our idea of the ancestral mother; Rhea personifies a more plausible grandmother than the colossal Gaia.)

As to Demeter, the daughter of Rhea and grandchild of Gaia, she associated not so much with the soil as with its produce, and only with produce resulting from the soil's cultivation and from furrows sown by human labor. She is not associated with the planet Earth but only with earthly soil, which human beings cultivate to obtain food. Demeter is, therefore, quite different from Hestia, who has nothing to do with the cultivation of the soil, but who is associated with the planet Earth insofar as it is our home in whose center burns a fire.

Many historians have restricted the myth of Hestia, explaining that it must be because the Greeks imagined the earth's central fire as an *omphalos*, that is, a fire that has been banked and covered with earth or cinders, permitting the radiation of heat within the house without too much smoke and preserving embers ready to be fanned into flame. This is also the manner in which coal is produced. This fantasy of Omphalos at the center of the earth, it may be said in passing, was prophetic, since geological discovery has confirmed that the center of the earth is effectively a fire covered with earth.

If we now consider, not the center of the terrestrial sphere, but the total surface of the territory, we should know that the ancient Greeks considered the town of Delphi to be situated at the exact center of both the earth and of Greece. It was here that they situated their most prominent temple of Hestia, Goddess of the center, not only of the sphere but also of the terrestrial surface.

The Price of Heliocentrism

The cult of Hestia is therefore linked to the geocentrism of the Greeks. If the archetype of the house signifying a return to the center is one of the important archetypes of our psychological life, it is understandable that the idea of our planet as the center of the universe is just as important in elaborating the collective values associated with "our" planet. We could hypothesize that in losing geocentrism we have lost the feeling that this planet is our home; we have lost a bond with her. It now takes ecology, "domestic

science," to remind us to take care of our planet, as if once she ceased to be the center of our attention she became a peripheral fact, something we could leave after using it.

From any manual of the history of the sciences, we learn that the passage from geocentrism to heliocentrism is not simply a scientific discovery. Religious beliefs, ideologies, choices of civilization, as well as scientific knowledge have all contributed to our loss of feeling for the earth as the center of the universe.

Thus, for the ancient Greek, the fact that heaven and hell are imaginary places which remain within his universe causes him to conceive of Hades as a place beneath the earth, and Zeus, the most elevated of the Gods, is not more elevated than the highest mountain. He may be seen in the clouds, the rain, or the thunder. Life and death, Gods and Goddesses, humans and monstrous animals —all circulate around a common Hestia.

At the beginning of the Hellenistic epoch, when the astronomer Aristarchus claimed that the earth revolved around the sun, he was taken to court for impiety, not for scientific error. Copernicus, during the Renaissance, was opposed for the same reasons. It shocked the Greeks to consider that Hestia could move, turn, and displace herself by orbiting the sun, for this thought threatened a whole symbolic universe.

We well know that the great scientific ideas and discoveries have always reflected an entire period. Thus, we are not astonished to see that, when the old geocentric and pagan world "lost its center," the new Christians wished to leave the old pagan universe completely. More than any other religion, Christianity was to be a religion of assumption, of the sky and the beyond. Terrestrial heroes were replaced by the saints, who rise to heaven and who are, moreover, less and less concerned with life "down here," with the material, Mother Earth, and the body. The Christian heaven is much higher and much less accessible than was the pagan Olympus. The earth Goddesses and mothers no longer find their place, and even the mother of Christ, to merit divine honors, had to leave the earth and ascend.

Souls also no longer remain below, because nothing spiritual remains here very long. The earth becomes a "vale of tears," the place of sin; our body has all its fleshy weight; and there is growing opposition between heaven and earth, high and low, spirit and matter.

Heliocentrism, in opposition to the geocentrism of Gaia and Hestia, returned in full force in the sixteenth and seventeenth centuries. We see two ideas reappearing simultaneously: the first is that the earth is not the center of the universe. The second is that of a departure: one day we shall leave this little planet and explore all other possible ones.

Thus Kepler, as much a visionary as an astronomer, at the same time as he defended the idea of heliocentrism wrote what could be called "science fiction," presented as a dream in which he told how he left the earth, propelled by the spirits. Arthur Koestler gives a résumé of this dream to which Kepler attached great importance.[1] It is indeed quite revealing, because long before the concepts of universal gravitation were known, Kepler showed an astonishing intuition in describing the reactions of his "astronauts":

> The worst moment is the initial shock (the shock of acceleration), for the traveller is projected by an explosion of power.... He must therefore be numbed with opiates beforehand; his limbs must be carefully protected so as not to be flung out and the effect of the recoil spread throughout his body. He will then have new difficulties: extreme cold, and an impeded respiration.... Once this first part of the voyage is over, the rest becomes easier because, in the course of such a long journey, the body no doubt escapes the mathematical force of the earth ... the effect being as if there were no further attraction.

We are tempted to say that this description corresponds to the psychological experience of all those who leave the center of attraction of Hestia and cut the bond that attaches them to Gaia, matter, and the body. After an initial shock, which numbness enables them to withstand, "the effect is as if there were no further attraction." In gestalt terms, we could say that these persons are not "centered" or, to use a bio-energetic expression, that they are not "grounded."

To leave the Earth, leave the Mother, and approach the Sun is the Apollonian ideal, Apollo never being high enough or far enough. Whoever is inhabited by Apollo's spirit always wants to go "higher, and forward." Taking into account the preponderant influence of Apollo and Zeus over the last two thousand years, Hestia has become a Goddess more and more ignored. But no di-

vinity, even the humble Hestia, permits such neglect without avenging herself for her ill treatment. Numerous sociologists and more and more ecologists (by profession or by conviction) have elaborated on the theme of ecological deterioration in the person–planet relationship. Some of the scientifically-minded have given the name "Gaia hypothesis" to an ecological theory which shows how the processes of natural equilibrium of our planet may be understood by conceiving of the earth "as if" she were a living organism or a person, that is, "as if" Gaia actually existed and her breathing, her activity were the process of equilibration of the planetary ecosystem.[2] And we may add: "as if" mythic thought, once again, has intuited what science has discovered by its own means.

Let us therefore act "as if" Hestia truly existed and look at some of the consequences of our neglecting her. One of the first consequences, at the collective level, seems to be that for two thousand years we have been ceaselessly pining to go upward, scientifically, metaphorically and psychologically obsessed by Christian ascension. Even if we avoid falling into a nostalgia for a terrestrial paradise as naive as it is sterile, our longing is evidence of skewed values. To live on the tips of one's toes, the eyes and mind straining towards an inaccessible summit, is an attitude giving little chance of happiness here below.

A second consequence is that we have allowed our planet, our collective household, to deteriorate, the ashes scattered, and everything in disrepair. Why should we do repairs when so many of us live as if we were only temporary "tenants" of this little planet, which we may well leave one day, as soon as our scientific heroes give us the signal? We need only count all the money and all the effort invested in space programs to realize that we have favored quitting this planet and colonizing space more than preserving the earth and rendering it more habitable. The high priests of science do not say much about the quite evident fact that the whole of humanity will not be able to leave. The excluded would be dismayed at the prospect not only of remaining behind but also of doing so on a ruined planet whose resources have been exhausted and whose hearth-fires are extinguished.

One may certainly continue to believe that the earth turns around the sun and that she is only an infinitesimal part of an immensely vast universe. In an "honest" polytheism, Apollo has a

right to his place and to the honors belonging to him. But if there exists nowhere else a type of life or consciousness similar to our own, we are forced, at least at the psychological level, to become "geocentrists" again. Men of science have insisted too much on the relative insignificance of our minuscule planet, and ecologists are just beginning to stammer out a reply: "this planet might be the smallest, but . . . just the same, it's ours. It's our home, isn't it?"

The priests of science climbed higher and higher, as if they wanted to find heaven, or God the Father. One wants to suggest they return to the house. So many scientific, psychological and social tasks await us here, accumulated for so long, since Hestia ceased to be the center of the universe.

If the scientific mentality of the space era turns a deaf ear, it might be because scientists believe that Mama is calling them back to the house! When these adepts of migratory utopia speak of the eventuality of Life on another planet, they generally cease to be scientific and rational and become emotional, passionate, and "religious." All this is really as much a question of religion as one of science: a choice that is religious, passionate, and ideological.

In order not to envisage that we may be alone, unique, and at the center of the conscious universe, those who dream of extraterrestrial salvation are ready to imagine life in quite ridiculous forms. Blue or green, good or bad humanoids of science fiction are given all kinds of attributes, modes of reproduction, communication, forms visible or invisible, etc. Anything seems better than the feeling of being the only civilized center of the universe.

Unlike the maximal concept of the openness of identity, Hestia is extremely careful to delimit the frontiers of the "we," of membership in a precise group with its own territory, its places of intimacy, and its exclusions. This anthropocentric attitude is the opposite of extraterrestrial fantasies, for if life elsewhere assumes the most bizarre forms, where would we be able to stop saying "we" when speaking of ourselves, the humanity of the earth?

When scientists try to convince us that still more money, more research, and more brains should be assigned to the conquest of space, they sell us the same Christian myth which would have it that our real place is elsewhere than on earth (i.e., in heaven, in space, on another planet). All the while, those who are occupied in keeping the hearth fires going, in cleaning, feeding and taking care of the terrestrial household feel a little neglected.

Thomas Kuhn, historian of science, brings out clearly the fact that our adoption of the heliocentric theory goes beyond scientific justification. It was not enough to discover that the earth turns about the sun; we also had to decide to leave the center.[3] This was a decision more than a discovery, and as much a religious as a scientific choice.

This centrifugal movement, which has disturbed Hestia, was the price to be paid for leaving the house. I believe it was necessary, for a certain period, to believe that "our vocation is elsewhere." But just as an astronaut who is lost in space is not very useful for research, should we not now return to the earth much of the energies, subsidies, experts, equipment, and men of science? The ecological problems here below do not seem to be resolvable by the conquest of space, and perhaps the impressive performance of our scientists could now be deployed here at home. Hestia demands it.

CHAPTER SIXTEEN

Security and Stability

Security is usually associated with stability, coziness and familiarity in our personal and social environment. A secure personality comes from a well-assured identity and the capacity to find one's "center" in the midst of upheaval. Incessant changes in social roles, and in the physical and human environment, are contrary to the rootedness that Hestia proposes. The security that she may bring is related to stability, tradition, and the preservation of goods that sustain us when times are hard.

Hestia and Hermes together form an association of opposites, the former refusing to leave the center and the latter being the God of communication and travel. They are not a husband and wife couple, for the territory of Hermes ends precisely where that of Hestia begins (that is, at the door of the house). A conjugal relationship between them would be impractical; the presence of one excludes that of the other. Nevertheless, in the *Homeric Hymn* to Hestia, they are invoked together as two divinities sharing the space inhabited by human beings. Hermes is present everywhere that contact is established with others, whether on the road, in the public institutions, the town square, or the market, whereas Hestia waits for us "at home," where the stranger cannot penetrate and where the universal gesture of "closing the door" assures the intimacy of the family.

Because Hermes is constantly mobile, he appeals to novelty and change, whereas Hestia gives privilege to all that preserves con-

tinuity and identity. Although it is true that change is important, Hestia is there to remind us that it is often important to stay the same.

Both the God and the Goddess had their part to play in the marriage ceremony. Hermes presided over the exchange and over the transformation which made a wife of the young woman. But to honor Hestia, the wife (or the wife's mother) brought with her embers from the maternal fire, so that on lighting the fire of the new home, she assured persistence of the bond with the Hestia of the former home. We have something of this tradition in the custom of dressing the bride in "something old, something new, and something borrowed." Just as symbolic, but at a more practical level, in almost all houses that are "alive" one may observe furniture and knick-knacks which have been kept because they constitute an unconscious cult of Hestia. It may be Grandmother's silver teapot, the cradle formerly in the family kitchen, a rocking-chair which belonged to Grandma, or Grandpa's toolbox or gold watch. These objects are treasured because they are a link with the past, the ancestors, and tradition.

Since Hermes is outside and Hestia in, we cannot fail to remark, along with certain feminist critics, that the couple Hermes–Hestia presents once more the traditional sexist divisions of work and of space. The male Hermes is active outside the house, he discovers the world and gives himself to all kinds of adventures, whereas the female Hestia devotes herself to domesticity and is the faithful presence in the home, never even dreaming of independence. This criticism is quite appropriate if one applies a strictly monovalent interpretation to the myths, a historic rather than a mythic mode of thought. Certainly, we must avoid those obtuse minds who would use the Hestia–Hermes myth as a justification for keeping women "in the house." But whoever, male or female, uses myths to dictate stereotyped behavior to others, to restrict reality rather than deepen it, or to force another person to stay within a restricted space, role or myth that is not natural to him proceeds exactly contrary to mythic thought, which invites each person to recognize the myth that emerges most naturally from his own being and destiny. To use the myth of Hestia in an attempt to convince women that their place is in the home or, inversely, to use feminism to force women out of the home is contrary to the spirit of polytheism and to that of feminism.

Hermes is a masculine God, but, in the domain of archetypes, we must not forget that personification by a God or Goddess does not signify that these archetypal qualities are distributed in function of our biological sex. The personality and the dominant myth in each individual's life determine our connivance with a God or Goddess. There are some men who are very "Hestian," that is "homey," and these family men maintain constancy and continuity, while there are some women who have all the mischievousness and volatility of Hermes or the inconsistency of Aphrodite. For those who still need reassurance that one may be a woman, yet constantly on the move, there is the figure of Iris, who has the same role of messenger as has Hermes and who descends from the sky by sliding down a rainbow (in the same way as children slide down the banister). Her function requires that she have, like Hermes, both wings and a caduceus and that she pass through both air and water, even down to Hades.

The Greeks did justify their sexual specialization of labor by the myth of Hestia, trying to convince their wives that it was neither natural nor honorable for a woman to leave the house. The interpretation of myths permits many projections and may inspire a great variety of social models. In this, mythology resembles ethology: everything is found in nature, just as everything is found in myths, so that one may always find examples to justify quite opposite values. From the study of animal psychology, it is extremely difficult to draw any definite conclusions, and above all to apply them to our own nature, because the diversity of behaviors that covers all possibilities. And so it is with myths and their interpretation. In a system such as that of Greek mythology, everything is represented: a psychological truth may be enunciated, but its contrary will be also. No myth is definitive, because it exists in balance with another.

And so, when one stops regarding the Hermes–Hestia myth as the only possible one, we quickly perceive that the obligation to be a Hestia is only destructive in the absence of any alternative. In polytheistic diversity, if the domestic stability of Hestia does not suit our personality or our energies of the moment, another Goddess, Artemis, presents the pole of independence and vagabondage, beyond the clan and beyond domestic enclosure, and yet another, the powerful Athena, dominates the world of work and competition, far from feminine Hestia. As to Aphrodite, we have

seen that her quasi-delinquent personality inclines her to "go out" a great deal, and neither the bonds of marriage nor those of domestic life can hold her.

The men of ancient Greece certainly fashioned and interpreted the myth of Hestia–Hermes in a way that reinforced the patriarchal division of the sexes. A competent Hellenist, J. P. Vernant, in seeking articulation between the myths and the psychology of the ancient Greeks, had to preoccupy himself much more than we do with the link between a given myth and the social reality lived in the culture from which this myth had sprung.[1] I think that is why Vernant presents the myth of Hestia, in her rapport with Hermes, in its most patriarchal form. But his work in psychological history is intended to contribute to our understanding of the psychology of ancient Greece, while we wish to contribute to the comprehension of contemporary psychology, starting with the renaissance of ancient myths. When we ask, for example, how the myth of Hestia may be useful in symbolizing our daily lives, we must include the contemporary phenomenon of masculine participation in the family Hestia.

When Vernant, more a historian than a psychologist, tries to grasp the link between myth and its actualization in the social models of antiquity, he does not intend to have us take a past culture and dead rituals as a model. Nor do I. It is understandable that he interprets Hestia as the symbol of the patriarchal clan, for the women of the clan were attached first to the household of their father and subsequently to the house of the husband, but never to their own house. We may also suspect that he makes no effort to look at this myth from other points of view, as if patriarchal values are for him the most natural in the world and as if it were self-evident that "the fixed and the mobile, the closed and the open, the inside and the outside" corresponded not only to domestic institutions but more profoundly to the very "nature" of men and women. His research is, moreover, so rigorous and so full of information that one is tempted to use it as a starting-point for asking other questions and formulating more hazardous interpretations. On reading his work, I asked myself if the link so often established between Hestia and feminine space, Hestia and the female womb, Hestia and the key to the storehouse would not be another example of the compensatory function of certain myths, in this case the need to correct legislation that was too rigidly patriarchal by

means of a ceremony of appropriation of the household space by the woman. Whoever has experienced the responsibility of running a rather complex household must suspect that the kitchen and the whole domestic space belong, in a practical sense, to the one who is most often there, for legal possession of a place in no way assures its practical and psychological possession.

The rituals surrounding Hestia do not, perhaps, symbolize the patriarchal order only (which, as Vernant explains, attached the wife to the husband's household) but may also have symbolized the importance of the powers conferred on the mistress of the house, who, in marrying, received and appropriated to herself a space, tools, and slaves, upon which she exercised her authority. Such a power is not negligible, and even today a great number of women do not wish to "leave the house," for it is their only place of real and significant power, despite their vulnerability vis-à-vis a patriarchal legislative authority.

Even in patriarchal Greece, the cult of Hestia could have been a way of "giving back" the home to the one who really inhabited it and of returning to women part of the power (symbolized by the keys to the food reserves) that the patriarchal system had denied them. This "optimistic" (if one is feminist) interpretation of the Hestia myth does not cast doubt upon Vernant's description of a part of the scene, but whereas he has undertaken as exact a painting as possible of Greek antiquity, I undertook to reinterpret the myth of Hestia in the light of present-day conditions. This approach allows us to draw what we wish from the myth, without any obligation to copy history.

In the same vein, one may interpret the virginity of Hestia as a myth of feminine resistance to the patriarchal attitude that "who takes a husband takes a country" and that the wife be installed in the household of the husband. Faced with this, Hestia refuses to budge and refuses marriage.

Her virginity is not so much a refusal of man as a refusal of the upheavals of marriage and conjugal life. I know a few "Hestias" who resist marriage because they do not want to change homes, towns, or jobs. They like their own place, and the idea of sharing their space, their house, and of having to change their place of work makes them extremely resistant to conjugality. No stranger may penetrate their "interior."

There are a few stories concerning Hestia, but two of the best-

known relate how she defended her status as a virgin. Poseidon and Apollo both wished to espouse Hestia, but she asked Zeus to free her from these annoying suitors. Zeus agreed that she remain a virgin and be the first to be served in Olympian feasts. Another myth tells how lusty Priapus tried to abuse Hestia during her sleep, but a donkey cried out to awaken her. Her shrieks were then so terrible and inescapable that poor Priapus fled "in a comic terror." If Hestia succeeded in turning aside the ardor of Priapus himself (whose virile member never knows repose), it is because of her unambivalent determination to avoid sexuality. But Hestia represents neither the fierce hostility of Artemis to the male nor the conquering coldness of Athena, and if she protects herself from the commotions of marriage, she does not refuse social life, nor even family life. If she does not herself found a family, one may think this is because she already has one: the family of her origin, of which she is the eldest daughter. The image of the "old maid" who remains attached to the past all her life, and who enjoys the affection of the whole clan, may be suitable for Hestia. However it may be, we must admit that certain persons, comparing the joys of conjugality and those of remaining in their own quarters, freely choose not to risk marriage.

Moreover, the "old maid" is an image that has become negative only since the end of large families. As soon as the family became "nuclear" and closed in upon itself, and the specialization of labor separated the workshop from the home, the single woman was marginalized and devalued. She has often found herself more isolated or deprived than she would have wished. From this time, the state of "old maid" became synonymous with bitterness and frustration, for all the qualities of these Hestias were found without employment, undervalued and useless.

The Pantry, the Reserves, and Stability

To understand the importance of "Hestia of the reserves," we must remember that the accumulation of reserves of food, wine, materials, and tools was the foundation of wealth in the ancient domestic economy of the peasant. The wife was often the manager

and the boss of all who worked in the household. In a contemporary context, this function is comparable to the administration of a small or medium-sized enterprise, for the home, now only sleeping quarters, was then the place of production. Hestia's qualities today are expressed not only in the organization of a functional and agreeable domestic life, but also in the work environment.

Hestia Tamia, that is, she who takes care of the reserves, may be taken in the literal sense as guardian of the food supplies. There is no Hestia Tamia, for example, in the apartment of a bachelor whose cupboards, refrigerator, and shelves remain empty, for this style of life, favorable to Hermes, is in the long run closer to the life of hotels than of family. Hestia Tamia is honored in homes whose basement and attic, freezer and shelves, workshop and garage are full. There is, moreover, something wrong, and an empty, hostile feeling, when a house is full of people but lacks reserve supplies. One feels that the precarious state of supplies affects human relations, for the fact of wondering each day if the food will be there for the next meal saps the confidence of the group and their feeling of security.

Ten years ago, when I was giving group therapy to adolescents whose parents were alcoholics, they acted out, in the form of psychodrama, scenes depicting moments of family tension or depression. I was astonished to realize to what extent domestic insecurity constituted an important theme, along with the violence or incompetence of the parents. None of these young people had ever really suffered from hunger, for finally someone always went out to buy the food; but for them, this way of living from day to day, as if nobody were convinced that there would be a next meal, reflected the failure of their parents to create a "real family." This absence of Hestia appeared even more cruelly during Christmas festivities, for everywhere else "happy families" had used foresight in providing an abundance of food, which was bought, prepared, and stored, sufficient for the entire holiday period.

The function of Hestia Tamia, like the fable of the cicada and the ant, may be transposed to wherever material security brings into question the qualities of vigilance, foresight, and accumulation. Management of a budget and the care given to one's own affairs in no way exclude either generosity nor openness towards others, provided this does not threaten to undermine the group's internal

security. Families, like businesses, are relatively autonomous units, and if the group does not concern itself with its survival, the center loses its force of attraction and the group ceases to exist as such. Many community groups and small businesses, born of creative spontaneity and living in the here-and-now, have disappeared, having failed to honor Hestia and provide for their material future.

The Greeks had an expression—"One must sacrifice to Hestia" —which signified having their meals as a family without inviting guests to the table, without sharing their reserves. J. P. Vernant interprets this expression as the equivalent of our own homily "Charity begins at home"—that is, in spite of the sacred obligations of hospitality, we must first look after ourselves. Hestia therefore requires that, before inviting others to honor our table, accept our gifts, and enjoy our generosity, we must assure a wholesome internal economy and avoid living "above our means," in putting appearances above foresight.

PART FOUR

Old Goddesses and New Women

Myth and Historical Reality

We may wonder how a religion in which the Goddesses were so important corresponded to a society which accorded so few legal and political rights to women. How may we explain this paradox? Many historians think, for example, that the status of Athenian women in the classical period is among the most restrictive in all Occidental society. Others insist on the fact that Greek classicism has bequeathed us not only its cultural treasures but also a throng of sexist prejudices and a misogynous philosophy from which Christianity drew inspiration. But we may also maintain that few societies have been so little sexist as the Greeks, that they were the first in history to feel guilty for their misogyny and to question it, that they were in fact the first feminists. Nor must we forget that our grandmothers did not vote, that Victorian women were no more free than the women of ancient Greece, and that our new juridical and political feminism has still not reached the majority of women.

There are few societies in human history that have produced so many celebrated poetesses (Sappho, Erynna, Corinna), so many powerful courtesans (Aspasia, Phryne, Lais), a mathematician of genius (Hypatia), and a general (Artemis). Even the greatest sovereign of all times, Cleopatra, was a Greek. A college, like that of Epicurus, received women students, whereas, for example, the principal and most prestigious universities of England were closed to women not so long ago.

To take an example from the classical period, which is said to be the most restrictive, was it not said of Aspasia, the mistress of Pericles, that she was one of the persons who had the most political influence in Athens and was it not she who had the idea of inviting politicians, together with their wives, to discuss the affairs of Athens at her place? If the mistress, or even the wife, of the head of a country today had as great a political influence as Aspasia, the

scandal would certainly be less tolerated than it was in Athens, and this influence would have to be kept secret, be denied, or else quickly come to an end.

Evidently the life of "ordinary" women in ancient Greece was less flamboyant, and it was they who suffered the most from restrictions on their liberty. But, first, this is true in all regimes, and second, it is difficult to judge the lot "in general" of all Greek women. What Greek women are we considering? The cosmopolitan Greek world resembled, in its variety and pluralism, the culture of North America or that of Western Europe: there were as many differences between the daily life of a Spartan woman and that of an Athenian, between that of a Boeotian and that of a Corinthian, as there are today between a rich, highly educated, and intellectual Californian woman and a poor and illiterate Puerto Rican immigrant in New York. One cannot speak of "the" Greek woman, as if speaking of a Goddess or an archetype who persists throughout time and space. Where historical reality is concerned, one must speak of women of a precise period, of a particular city, of a definite social class.

And then even with all our knowledge of ancient Greece, many questions still remain in the stage of open debate. The discussion concerning the lot of the citizeness of Athens is such a case; we know that, juridically and politically, she did not have any more rights than a child, a slave, or a stranger. But the status of the Athenian woman seems extremely ambiguous. Formally without legal rights, she had in fact great power as mistress of the household and of the slaves. She had little legal independence, but in exchange she enjoyed an extraordinary security, guaranteed by the state. It is true that politics were a kind of men's club, but in order to be part of this club one had to be born of a mother who bore the title of citizeness. Insofar as the citizen of Athens was obliged to choose a wife from among the citizenesses of the city in order that his children have the right to citizenship, the women and their families were conscious of the social value of marrying a citizeness. This is but an example, yet it illustrates the ambiguity of her status: should one compare her to a slave, a child, or to the aristocrat, who was said never to touch money? Some women today, if granted the choice, would probably exchange a little independence for a little security, and every generation of women

seek a better mixture of autonomy and security, in the same way we always try to find a better form of government.

In a society which denies its shadow, as does our own, the faults of ancient Greece appear to us to be shocking. It is comforting to believe that we have no more slaves, because no human beings can be bought at the market-place. But we have the "labor market," and even if the employers cannot legally own the person of the worker, nor separate members of a family, nor openly exercise the right of life and death over their employees, how is it that so many men and women have acquired a slave's mentality? Theoretically, we have no slaves, and women are free—they can vote, work and divorce. Our society proclaims its respect for the rights of children: the newborn are no longer exposed, and there is no apparent pro-stitution of children as there was in Greece; to make them work is illegal and to educate them is obligatory. All this should prove that we are concerned with the condition of all our people, that our children and women are better off than they would have been in ancient Greece.

Everything today has such a humanitarian air about it. From whence comes then, this impression that more and more people are pushed into selling themselves "body and soul" in order to sur-vive? And what precisely does the feminist revolt manifest in our times, if not a cry of indignation and despair that has never been heard with such urgency? What sufferings cause so many of our youth to succumb to drugs and take their own lives?

Unnecessary to lengthen the list. My intention here is not to ex-amine how the shadow manifests itself in our society. Others are doing that better than I could. It is simply a question of not confus-ing the myth with the reality and not judging what is known of the socio-political reality of the ancient Greeks with the criteria of an ideal and theoretical feminism that exists nowhere.

One must avoid confounding a Goddess, who is an archetype, with the real, historical, everyday woman. Otherwise, one is as-tonished to read that the women of ancient Greece were not in the habit of going to war and of bearing armor like Athena, nor of traveling the woods in a short tunic with a bow and arrow like Artemis, nor had they all the freedom of manner of Aphrodite.

An archetype may contain the imaginings of men, as well as those of women, and may personify the feminine qualities of a

man in a typically masculine situation, and vice versa. Sometimes, the archetype presents qualities and values whose expressions are no longer permitted: for example, when the Virgin Mary, in countries which were otherwise sexist, such as Spain and Italy, was invested with powerful qualities reminiscent of the pagan Goddesses. The cult of Mary then exceeded by far the place that the official cult and the laws reserved for real women.

Whatever the theories about the status of Greek women, it cannot tarnish the splendor of Greek Goddesses, and it is of this splendor that I am trying to give an account.

The Definition of Power and the Powerlessness of Women

If the women of ancient Greece seemed to have no power even while their religion proposed to the imagination a wonderful diversity of powerful Goddesses; if the married women appeared politically insignificant while Hera, the archetypal spouse and sovereign, exercised a very weighty influence with her husband Zeus; if one may believe that a little girl was of less value than her brother while the cults of Artemis and Athena gave them an importance which our religion has never granted to girls; if the division of labor seemed to follow a rigidly sexist scheme while Athena, the Goddess of warriors and of male artisans, was also honored by women and girls in their daily tasks—perhaps it is because the historians have described power in Greek society mostly from a political, legislative and philosophical point of view. They have given a definition of power that took no account of all the activities in which women were influential.

Functioning as a self-fulfilling prophecy, a definition of power that only concerns men, if applied to women, can demonstrate only their impotence. But if one includes, besides the power of legislature, that of tradition, besides philosophic thought, mythic thought, and besides political power, religious power, the power play between men and women appears in another light.

History leaves us texts about laws and not about the traditions and behaviors of everyday life. We do not know what degree of shame was attached to the husband who used to beat his wife,

what image the rapist held of himself, how others considered a man who abused his power as head of a family, what solidarity there was between brother and sister, between a woman and her slaves, between women of a household. What was the real balance between masculine legislation and feminine tradition, between the power of men to inflict legal punishment on the women and the power of women to destroy through shame the man who failed tradition and its implicit expectations?

If feminism has become a necessity today, it is not only because politics, legislation and culture are dominated by men, but also because all major religions exclude Goddesses. Tradition no longer completes the law, and the means of cultural diffusion have been long dominated by men. The imbalance is therefore extreme. When comparing the place of the feminine gender in our civilization with that of the Greeks, we should take into account not only the secular domain but also the religious and the mythical; then we would see that Greek polytheism is exceptionally egalitarian. It grants the Goddesses an importance comparable to that of the Gods. On Olympus, there were six Gods and six Goddesses, while the Christian Trinity has three to zero! Certainly, we may debate at length whether these six Goddesses of Olympus together have a power 'truly' equal to that of the six Gods, but then we would have to ask other questions about Olympus, since it seems to be functioning at times as an oligarchy, a democracy, a monarchy, a patriarchy, a matriarchy, and so on—everything is there. A debate concerning equal rights between the Gods and Goddesses would be fascinating, for one would have to consider the value of seduction, of persuasion, the effect of ruse and disobedience, and take into account the tendency of certain Goddesses to have their way no matter what. However one finds fault with the equality of rights between Greek Gods and Goddesses, at least the question has been raised. In Christianity, Judaism, and Islam, the problem has hardly been approached. The structure of power is never debated between Christ and his Mother, whereas it is discussed between Zeus and Gaia; it cannot be argued between Christ and Mary Magdalene, as it is between Zeus and Aphrodite. In fact, no feminine figure, mortal or divine, has enough character to argue over a power issue as does, for example, Athena with Poseidon, Aphrodite with Dionysus, Artemis with Apollo, Athena with Ares, Hestia with Hermes, Hera with Zeus.

In the Judeo-Christian religion, God and power are both masculine, and it goes without saying that, if there is no negotiation of power between male and female, there is even less probability of such negotiations between different feminine divinities. There is no equivalent of encounters such as opposed Athena to Aphrodite, or Artemis to Aphrodite, nor of alliances such as those which associated Athena and Hera, or Artemis and Hecate.

In the ancient Greek culture, where religious celebrations were as numerous and important as the manifestations of political life, where mythical consciousness permeated the *polis*, masculine political power was tempered by feminine religious and spiritual influences. Moreover, looking at our own political rights, we can well wonder what our right to vote today really means. Most women are so isolated that they still vote according to their social class or their husband's opinion rather than according to their own gender. If sharp differences should appear between the masculine and the feminine vote, we might perhaps really speak of "women's votes" and of a balance of power.

It is a mistake to reject the Greek myths under the pretext that they were elaborated in a culture which, at least towards the end, was patriarchal; for although we know precisely what roles were officially closed to women, we have no way of knowing the participation of women in the collective creation of myths. It is quite possible, if one looks at the numerous myths in which the Goddesses play a primordial role, that mythology was for women a means of intervening in their culture, a way of expressing their victories as well as their revolts, their subjugation as well as their resistance. There is a contradiction in feminism: on the one hand, it takes exception to the patriarchal culture, declaring that "we have no responsibility in such a cultural disaster," and on the other, it demands that the participation of women in this same culture be recognized as if to say: "We also have participated in the creation of this world."

This reasoning applies to the study of Greek myths. They were transmitted by an oral culture in which women had great importance as priestesses, sibyls, and storytellers. Mythology may have represented for women a survival, an underground culture, a refusal to disappear, a reminder and evidence that power can have more than one definition.

This book is positively oriented and biased by an enthusiasm for

the Greek Goddesses and polytheism, just as other historians are oriented to see only the political, juridical, and social impotence of the ancient Greek women, while ignoring the power of their Goddesses. Even if hopeful, this book does not seek to arouse naive optimism but intends rather to counter the prevalent feeling of crushing helplessness, as if the fact of believing this helplessness to be as old as history had made it irrevocable. Students—women and men, young and not so young—constantly ask questions of hope, having realized that morose depression may wipe out the benefits of feminism, for each gain has cost a lot. I have therefore sought in our cultural past whatever could be useful in nourishing the new gender identity, a renewed set of values for us to live by.

Towards a Polytheistic Feminism

Today our feelings of nostalgia for the Mother, the Madonna and Child have taken refuge in the cult of the Mother Goddess. It may well be wholesome to bring this archetype back to life, and I can appreciate this nostalgic sentimentality that archetypally belongs to the experience of the Mother. The return of the Great Mother is comforting; the Mother has returned; let us wish that she remain, even with her terrible aspects.

But why—even when we are inspired by the past—should we choose a monothcism of the Great Mother? It is not altogether evident that the Cretans and the Mycenaeans had a monotheistic attitude towards their Great Mother. Why must we believe that they worshiped only one Goddess? If she is presented at times as a mother with generous breasts and large buttocks, sometimes as a virgin warrior accompanied by a lion and holding a lance, sometimes as a marine Goddess, and sometimes as a Goddess of trees and vegetation, perhaps these are not the multiple forms of one Goddess, but display an actual polytheism. The names of Rhea, Dictynna, Britomartis, often interpreted as different names of the great Mother Goddess, may have corresponded with different divinities in different localities with different sensitivities—a kind of female pantheon.

Might it be our monotheistic habit which causes us to imagine a Great Mother who requires an exclusive adoration from her faithful? One knows little of the Cretans and the Mycenaeans, but evidently they considered divinity principally under the feminine aspect, and their women had an elevated status. But when one speaks of a "single Great Mother with many faces," it might be a projection of a monotheistic attitude, while if we conceive of many feminine divinities constituting a harmonious interrelation, we open up the possibility of a female pantheon.

Moreover, if the Great Mother were the equivalent of our Almighty Father, have we any advantage in bringing back today this monotheism of the Mother to replace patriarchal monotheism? Since it is not only the Father who is exhausted but monotheism as well.

I do not think of polytheism as superior to monotheism—that would be contradictory to the very idea of pluralism—but I do think that it more adequately represents an already pluralistic reality. I shall not develop here the monotheism–polytheism polemic, with all its psychological and sociological repercussions, but shall content myself simply by questioning the opinion that the diversity of the Greek Goddesses was the result of a fragmentation of the feminine power, formerly represented by the great Mother Goddess of prehistory. In this opinion, there can be no "pure" and "truly feminist" attitude apart from the adoration of the almighty Great Mother of an absolute matriarchy.

This belief is only superficially opposed to Judeo-Christian patriarchy. Actually, it states the same dogma of an almighty divinity; it is the same profession of faith in a single savior, the same Judeo-Christian myth which promises that one day we shall definitively conquer evil, which here takes the form of the male, as Christian fanatics believed that one day they would conquer infidels and overcome sin and passions, embodied in women. This belief can also be compared to the attitude of the monotheists of Science and Progress, who believed they could hold sway over illness, ignorance, and the irrational. Why replace a male monotheism by a female monotheism? And who wants a world of matrons and little boys?

I know, since my years in communal life during the most 'glorious' period of the counterculture, that I, sooner or later, must transform into a daddy's girl when the matriarchy becomes op-

pressive, that is, when the cohesive group threatens to devour my individuality. Both patriarchal and matriarchal values are corruptible and may become decadent. It is the tyrannic, abusive, and degenerative attitudes of the present patriarchy that make us want to change. If one believes in the hypothesis of an absolute prehistoric matriarchy, one should consider that the "male invaders from the North" were perhaps not the only ones responsible for the end of matriarchy. This ancient matriarchy was perhaps exhausted, as our two-thousand-year-old patriarchy is today, as useless to the souls of men as to the lives of women.

If we can let go of the devotion to an original, single matriarchy of the Great Mother (that idea which supports monotheistic feminism), then we can regard the plurality of Goddesses, not as her fragmentation or as her developmental differentiation, but rather as each Goddess comprising an archetypal form of feminism. There are as many feminisms as there are Goddesses, at least.

The effort to contain feminism in a monovalent structure makes fragmentation appear as division and leads to exclusions, excommunications, and the weakening of the whole. If we have felt confined within a single model of feminine identity under the patriarchy, we cannot now be content with a monovalent feminism. A single feminism is not enough, since behind each Goddess there is a unique kind of strength. As our values and behaviors are modified to the extent that we emerge from one myth to enter another, we also change our vision of the world, our mode of communication, and our "feminism" with each Goddess, each archetype who inhabits our minds, hearts, and bodies.

NOTES

All translations from the French to English are the author's and translator's.

Introduction

1. Claude Mettra, *Dictionnaire des Mythologies et des Religions, des Societes Traditionnelles et du Monde Antique* (Paris: Flammarion, 1980).

Chapter One

1. Charlene Spretnak, *Lost Goddesses of Early Greece* (Berkeley: Moon Books, 1978), pp. 57–58.
2. Hesiod *Theogony* 180–200.

Chapter Two

1. Claire Lejeune, *L'Issue* (Brussels: Le Cormier, 1980), p. 178.
2. Paul Friedrich, *The Meaning of Aphrodite* (Chicago: Chicago University Press, 1978).
3. Hesiod *Theogony* 193–96.
4. Homer *Odyssey* 8. 308–28.
5. Titus-Livius, *Roman History XXXIV*, trans. Henry Bettenson (New York: Penguin Books, 1976).
6. Ibid.
7. Friedrich, *The Meaning of Aphrodite*.
8. Alan Watts, *Nature, Man, and Woman* (New York: Vintage Books, 1970).
9. Apuleius, *The Golden Ass*, trans. Robert Graves (New York: Farrar, Straus and Giroux, 1951).
10. Hesiod *Theogony*.
11. James Ogilvy, *Many Dimensional Man: Decentralizing Self, Society, and the Sacred* (New York: Harper & Row, 1979), p. 201.
12. Lawrence Durrell, *Balthazar,* The Alexandria Quartet (London: Faber & Faber, 1962).

Chapter Three

1. Mary Daly, *Gyn/Ecology: The Metaethics of Radical Feminism* (Boston: Beacon Press, 1978) and *Pure Lust: Elemental Feminist Philosophy* (Boston: Beacon Press, 1984).

2. Carolyn Merchant, *The Death of Nature* (New York: Harper & Row, 1980).

3. Maureen Duffy, *The Erotic Lives of Fairies* (New York: Avon Books, 1980), p. 11.

4. St. Paul, First Epistle to Timothy 2:11.

5. St. Paul, First Epistle to Corinthians 41:34–35.

6. Robert Graves, *The White Goddess: A Historical Grammar of Poetic Myths* (London: Faber & Faber, 1952).

7. Werner Jaeger, *Paideia: The Ideals of Greek Culture,* trans. Gilbert Highet (New York: Oxford University Press, 1960).

8. Paul Friedrich, *The Meaning of Aphrodite* (Chicago: Chicago University Press, 1978).

9. Ibid.

10. Geoffrey Grigson, *The Goddess of Love* (London: Quartet Books, 1978), p. 117.

11. Weyland Young, *Eros Denied: Sex in Western Society* (New York: Grove Press, 1964), p. 335.

12. Apuleius, *The Golden Ass,* trans. Robert Graves (New York: Farrar, Straus and Giroux, 1951).

13. *Sappho*, trans. Guy Davenport (Berkeley: University of California Press).

14. Friedrich, *The Meaning of Aphrodite.*

15. Germaine Greer, *The Female Eunuch* (New York: McGraw Hill, 1971), chap. 8.

16. Aristophanes, *Women in Power,* trans. Kenneth McLeish (London: Cambridge University Press, 1979).

17. Spoken by the Emperor Hadrian as he is portrayed by Marguerite Yourcenar, *Memoires d'Hadrien* (Paris: Plon, 1958), p. 20.

18. Quoted by Grigson in *The Goddess of Love*, p. 113.

19. Sarah Pomeroy, *Goddesses, Whores, Wives and Slaves* (New York: Schocken Books, 1975).

20. Catherine Salles, *Les Bas-Fonds des l'Antiquite* (Paris: Laffont, 1983).

21. Grigson, *The Goddess of Love.*

22. Xenophon, *Le Banquet,* trans. (from Greek to French) Pierre Chambry (Paris: Garnier Flammarion, 1967). The translation from French is ours.

23. Friedrich, *Aphrodite,* p. 132.

24. Ibid.

25. Adrienne Rich, *Women and Honor: Some Notes on Lying* (Pittsburgh: Motheroot Publications, 1977).

26. Marie-Louise von Franz, *The Psychological Meaning of Redemption in Fairytales* (Toronto: Inner City Books, 1980).

27. Homer *Odyssey* 7. 266–369.

Chapter Four

1. Homer *Iliad* 14. 168.
2. Apuleius, *The Golden Ass*, trans. Robert Graves (New York: Farrar, Straus and Giroux, 1951).
3. "To Aphrodite," in *The Homeric Hymns,* trans. Apostolos N. Athanassakis (Baltimore: Johns Hopkins University Press, 1976).
4. "To Aphrodite," in *The Homeric Hymns*, trans. Charles Boer (Dallas: Spring Publications, Inc., 1979).

Chapter Five

1. Sue Mansfield, "The Gestalt of War," *Psychology Today* (June 1982).
2. Homer *Iliad* 3. 67.
3. Sarah Pomeroy, *Goddesses, Whores, Wives and Slaves* (New York: Schocken Books, 1975), p. 20.
4. Barbara Tuchman, *The Guns of August* (New York: Macmillan, 1962).

Chapter Six

1. Hesiod *Theogony* 116–22.
2. Euripides *Hippolytus* 1268–281.
3. Marie-Louise von Franz, *Interpretation d'un Conte: l'Ane d'or* (Paris: La Fontaine de pierres, 1978; English edition: Spring Publications, 1980).
4. Erich Neumann, *Amor and Psyche: The Psychic Development of the Feminine,* trans. Ralph Manheim, Bollingen Series 54 (New York: Pantheon Books, 1956).
5. Apuleius, *The Golden Ass,* trans. Robert Graves (New York: Farrar, Straus and Giroux, 1951). All quotations which follow in this chapter are from this version.

Chapter Seven

1. Euripides *Hippolytus* 5–6.
2. Apuleius, *The Golden Ass*, trans. Robert Graves (New York: Farrar, Straus and Giroux, 1951).
3. Esther Harding, *Psychic Energy*, Bollingen Series 10 (Princeton: Princeton University Press, 1963), pp. 127–31.
4. Weyland Young, *Eros Denied: Sex in Western Society* (New York: Grove Press, 1964).
5. Christine Downing, *Goddess: Mythological Images of the Feminine* (New York: Crossroad. 1981).

Chapter Eight

1. Euripides *Hippolytus* 75–76.
2. Mary Daly, *Pure Lust: Elemental Feminist Philosophy* (Boston: Beacon Press, 1984).
3. Callimachus, *Hymne a Artemis*, trans. Emile Cahen (Paris: Les Belles Lettres, 1961).
4. Euripides *Hippolytus* 161–69.

Chapter Nine

1. See, for example, the description given by Pausanias of the annual sacrifice in honor of Artemis (*Guide to Greece* 1. 7. 18, 7).
2. Euripides *Iphigenia at Aulis* 1581–595.
3. Euripides *Iphigenia at Aulis* 1376–384.
4. Euripides *Iphigenia at Aulis* 1468–470.

Chapter Ten

1. Erich Neumann, *Depth Psychology and a New Ethic,* trans. Eugene Rolfe (New York: Harper & Row, 1973), chap. 2.
2. Therese d'Avila, *The Complete Works of St-Theresa of Jesus,* trans. Allison Peers (London: Sheed and Ward, 1946).
3. Doris Lessing, "To Room Nineteen," in *Five Short Novels* (London: M. Joseph, 1953).

Chapter Eleven

1. Francoise D'Eaubonne, *Le Feminisme ou la Mort* (Paris: Pierre Horay, 1974), p. 97.
2. Ibid., p. 101.
3. John A. Livingston, *One Cosmic Instant: A Natural History of Human Arrogance* (Toronto: McLelland and Stewart, 1973), p. 63.

Chapter Twelve

1. Peter Ellinger, on Artemis, in *Dictionnaire des Mythologies et des Religions, des Societes Traditionnelles et du Monde Antique* (Paris: Flammarion, 1980).
2. Pol Pelletier, *La Lumiere Blanche* (Montreal: Éditions du Theatre Experimental des Femmes, 1981).

Chapter Thirteen

1. Jeannie Carlier, on Amazons, in *Dictionnaire des Mythologies et des Religions, des Societes Traditionnelles et du Monde Antique* (Paris: Flammarion, 1980).
2. Phyllis Chesler, preface to the re-edition of *Wonder Woman* (New York: Holt, Rinehart and Winston, 1972).
3. Herodotus *The Histories* 4. 277–79.
4. See, for example, Sally Miller Gearhart's novel *The Wanderground: Stories of a Hill Woman* (Watertown, Ma.: Persephone Press, 1979).
5. "To Artemis (II)" in *The Homeric Hymns,* trans. Apostolos N. Athanassakis (Baltimore: Johns Hopkins University Press, 1976), lines 1–10.

Chapter Fourteen

1. Theodore Roszak, *Person/Planet: The Creative Disintegration of Industrial Society* (New York: Doubleday/Anchor, 1978).
2. Betty Friedan, *The Second Stage* (New York: Summit Books, 1981).
3. Nancy Foy, *The Yin and Yang of Organizations* (New York: William Morrow, 1980).

Chapter Fifteen

1. Arthur Koestler, *Les Somnanbules* (Paris: Calman-Levy, 1960).
2. James Lovelock, *Gaia: A New Look at Life on Earth* (New York: Oxford University Press, 1979).
3. Thomas S. Kuhn, *The Copernican Revolution: Planetary Astronomy in the Development of Western Thought* (Cambridge: Harvard University Press, 1957).

Chapter Sixteen

1. Jean Pierre Vernant, *Mythe et Pensee chez les Grecs: Etudes de Psychologie Historique,* vol. 2 (Paris: Maspero, 1974).